3

The
Complete Artist

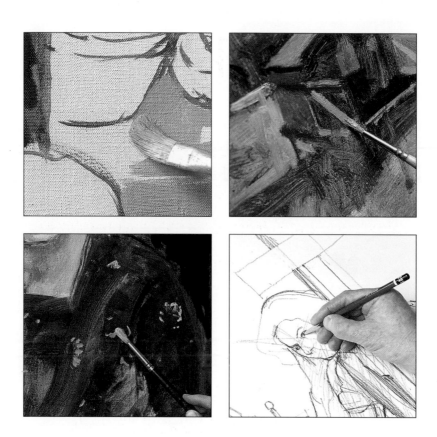

The Complete Artist

*Painting and Drawing Better Landscapes,
Still Lifes, Figures and Portraits*

Edited by

KEN HOWARD

WATSON-GUPTILL PUBLICATIONS/NEW YORK

First published in 1991 in the United States by
Watson–Guptill Publications, a division of BPI Communications, Inc.,
1515 Broadway, New York, New York 10036.

Conceived and produced by
Swallow Publishing Ltd,
260 Pentonville Road, London N1 9JY

Library of Congress Cataloging in Publication Data
The Complete artist : painting and drawing better landscapes,
still lifes, figures, and portraits / edited by Ken Howard.
 p. cm.
 ISBN 0-8230-0771-5 (cloth)
 1. Art—Technique. 1. Howard, Ken, 1932–
N7430.C58 1991 91-27663
751.4–dc20 CIP

Note: Throughout this book, American terms are signalled in
parentheses after their British equivalents the first time in
each chapter they occur. In paper sizes, the nearest
available stock size is given. In frame and artwork measurement,
height always precedes width.

Printed in Singapore
First printing, 1991
1 2 3 4 5/95 94 93 92 91

Contents

Foreword by Ken Howard

'Has that man got a magic paintbrush?'
These very flattering words were uttered by a small boy who was standing with his mother and watching me paint a landscape. There is indeed an element of magic in painting, and most people will stop and watch when they see someone at work. I sometimes go down to the beach to work, and have noticed that when children become tiresome, their parents will often say 'go and watch the gentleman painting'. They will then sit quietly enthralled for a long time, watching what I am doing: to children there is indeed magic in seeing blobs of paint suddenly create an illusion of space and form and atmosphere.

Ken Howard
'Via Cavour'.

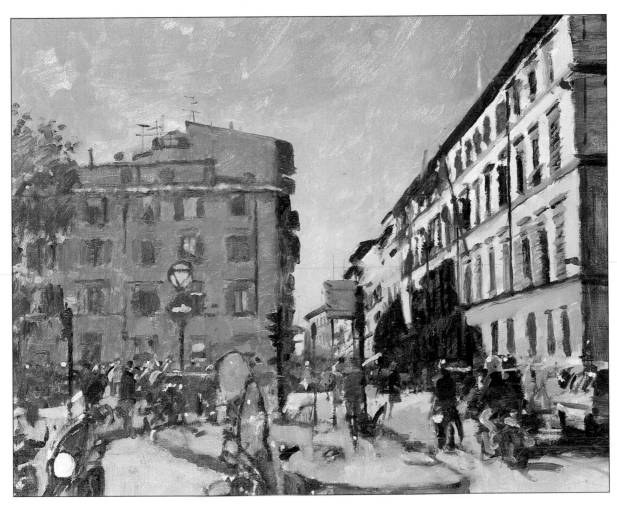

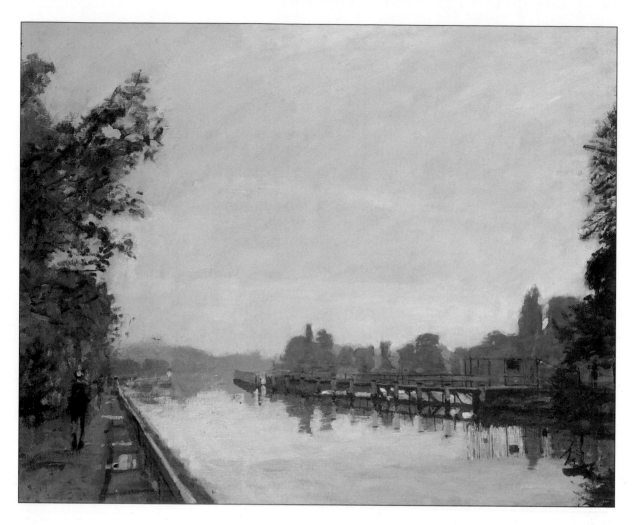

Ken Howard
'Teddington Lock'.

When I was a young man I used to paint on the local railway sidings at Neasden in north London. One morning a railway worker stopped to watch me work. After some time, he said to me 'You know, I have walked this way every day for thirty years, and yet today for the first time, I have seen that this railway yard is beautiful.' That, for me, is the magic of painting – the power to open people's eyes and help them see. And that too is what makes the demands painting imposes worth while.

Amateurs often start to paint because they want a hobby, something to practise, and amuse themselves with at the same time. Why painting and drawing rather than fishing or tennis? This can only be because there is a small seed of the artist in all of us, and that seed is asking to be nurtured until it is brought to fruition. It may start as a pastime, but once the seed starts to

germinate its nature changes and it becomes an obsession, and there is no satisfaction from then on. Ultimately, however, there are those few truly magical moments when the marks you make on your canvas or paper really do seem to relate to the sensation you are receiving from nature, and at that moment the times of despondency and pain are all suddenly worth while, as you have the sensation of giving birth to something, giving life to something.

The Complete Artist is concerned with the specific areas of study of landscape, still life, the figure and portraiture. During the last thirty years, there has been a tendency in art schools to drop the intense study of the craft of drawing and painting, particularly drawing which had always been the basis of art school teaching, in favour of more emphasis on free expression. The idea being expressed has become paramount and the means of expression less important. I have always believed that the starting point for all creative work must be the idea. This may come from within or from outside you, although in fact even those more abstract ideas that come from within the artist are initially fuelled from experience of the natural world. In art there is very little 'making up', but there is a great deal of abstracting. A good rule that I learned as a student, which I think still holds true, is 'leave out, but never add'.

The idea then must be the starting point: the image you see in your mind's eye or in nature generates the excitement and thus the energy to make the painting. Without such excitement there is no point in starting and without such excitement you cannot finish a work. But what is the point of having an idea, something you want to express without the tools that enable you to express it? By tools I mean the crafts and skills with which to work. Just as the musician cannot compose, even if he hears sounds in his head, without an understanding of the basic language of music, the fitting together of notes, and the writer cannot put down his ideas without some command of words, or of language, so it is my belief that the artist cannot express himself without the knowledge of and practice of the basic language of his art – line, shape, tone, colour and texture. These are the artist's equivalent of notes and words. Ideas cannot be taught, but the skills that you need in order to express them can be, and that is what this book is intended to do.

Practice is everything. Just as dancers must train their bodies, and musicians their fingers to do what they want to when they want to, so painters must train their hands to express what they

want to say. At the same time, of course, they must train their eyes and tune their hearts, but this is done through practice with the hands. The more you practice, the more you see and the more you tune your sensibilities; this of course means that you need more finely developed skills. To a great extent the degree to which you practice will dictate your progress in expressing yourself. Anyone who has started painting has the seed of an artist within them. That seed may grow into something creative and wonderful or it may be somewhat limited but we cannot know the extent of our potential unless we develop it to the full.

Drawing and painting then are first and foremost about seeing and all four contributors to this book stress the importance of really looking at what you are trying to draw or paint. Merely look at something and you will see it very superficially – as indeed most people see it. But draw or paint it and the natural world will be revealed to you, you will really begin to see it in your own personal way, and maybe share your vision with others.

Of the four areas of study covered in *The Complete Artist* probably the most complex is the figure. All early art was principally concerned with this subject. The portrait, which glorified the individual followed, then came still life which celebrated man's material world. Landscape was a relatively late subject for artists, not finally coming into its own until the work of the Impressionists. Richard Pikesley, who contributes the section on landcape to this book, was in fact one of my students some years ago and it has been interesting for me to watch his development as an artist. He works on many subjects, but more and more in recent years landscape has dominated. His work is principally about light, without which of course we would experience nothing visually. Landscape can easily become hackneyed – it is always easy to settle for the standard green subject – but Richard Pikesley at all times opens our eyes to the world around us, encouraging us to go to the landscape and see it for the first time.

You may be familiar with Charles Bartlett's work and highly developed teaching abilities from his contribution to *Art Class*. As President of the prestigious Royal Society of Painters in Water Colours, he is obviously a respected watercolourist, but he is also an eminent print maker, draughtsman, and painter in oils. His contribution to this book, on still life, is full of enthusiasm and encouragement to look at still life in as broad and exciting a way as possible.

Opposite: Ken Howard 'Marika and the Orpen Paint Box'.

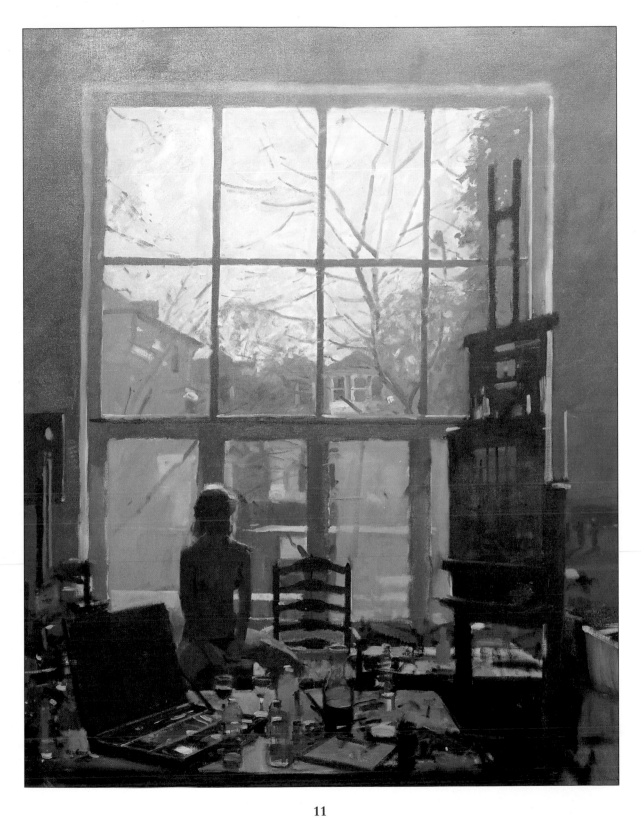

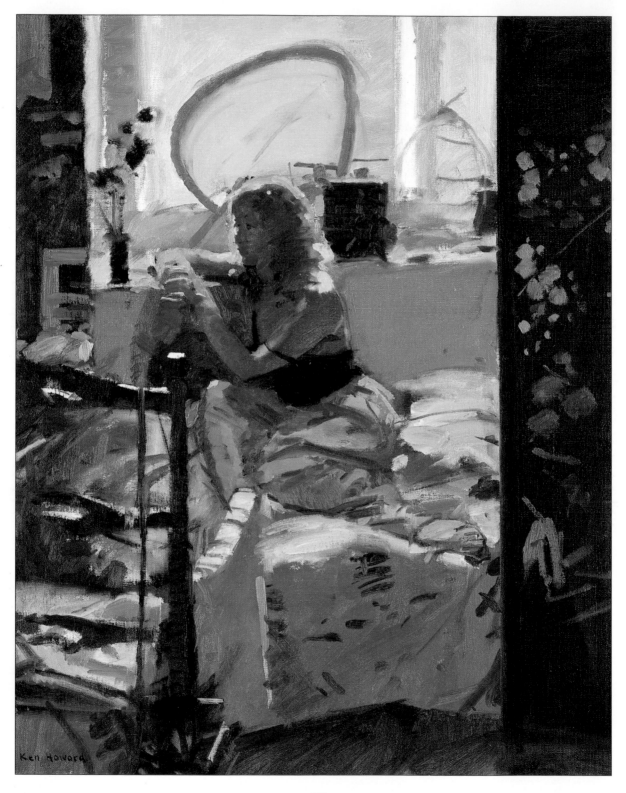

Trevor Willoughby is a draughtsman and painter I have admired for many years. His directness and economy of line are the culmination of a lifetime devoted to the study of the human figure. Follow all that he says, go to classes where you can study the nude, paint your family in a variety of clothes, colours and textures and, above all, draw yourself, the most patient model of all. Practise hard, for it is only through practice that you will finally discover the freedom and fluent command you find in Trevor Willoughby's work.

Drawing the figure naturally leads to the study of portraiture, one of the most difficult disciplines. If you draw well, you will get a likeness but the problem with portraits is that everybody sees the sitter in their own way. I'm sure we have all imagined that our parents or loved ones never age, because we see them through our total experience of them, rather than in the moment. This is the problem that every portrait painter faces. Jane Stanton takes us through all the fundamentals we must address if we are to get anywhere near an objective analysis of the head: the underlying structure, the anatomy, the individual elements, but most of all she shows that a head is a whole, not a collection of bits. She demonstrates that a facile likeness is not enough to make a good portrait; above all a good portrait must be a good painting.

I believe painting is about celebrating human beings, natural and man-made forms, and the landscape around us. It is also, however, about self-discovery and the celebration of one's own emotions. Read this book, be guided by the four writers and their enthusiasm and find your own personal way forward into worlds of experience which I hope will be a revelation to you as painters.

Ken Howard
July 1991

Opposite: Ken Howard
'Lorraine, Yellow and Black'.

PART ONE

Landscape

Introduction

Visit any mixed painting exhibition and you will soon realize that landscape is the favourite subject of a great many artists. As painters, landscape has a strong grip on our imaginations: so strong that as soon as an abstract painter makes a horizontal line across the picture plane, we want to read the painting as landscape, with foreground at the bottom and sky at the top.

Painting and drawing landscape is in one way different from other genres, and in other ways very much the same. The *difference* is that in no other type of painting are you so conscious that you are recording sensations in the eye — brought about by combinations of distance, atmosphere and light acting on the elements of landscape — rather than just 'things'. It is the *same* in the sense that as a category it should be allowed to run into the idea of interiors, or figures, or still life, elements of all of which landscape might contain; and in the way that the same elements of drawing may be applied to each.

Looking out of the car window I spotted this roadside gate with its view towards the sea. Returning the next day at about the same time I made this little oil study of the view that it frames. The path beyond the gate is an invitation to explore further.

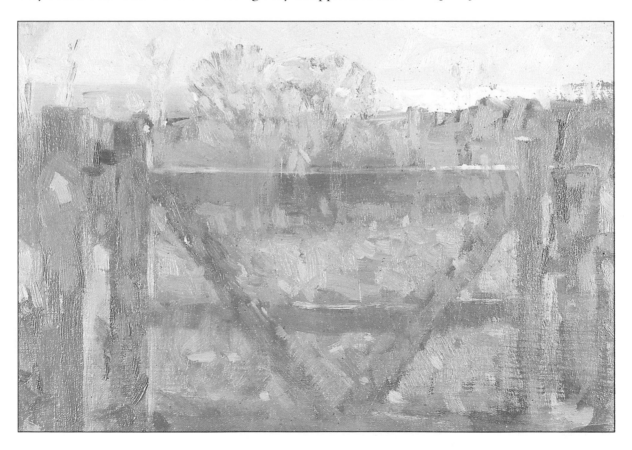

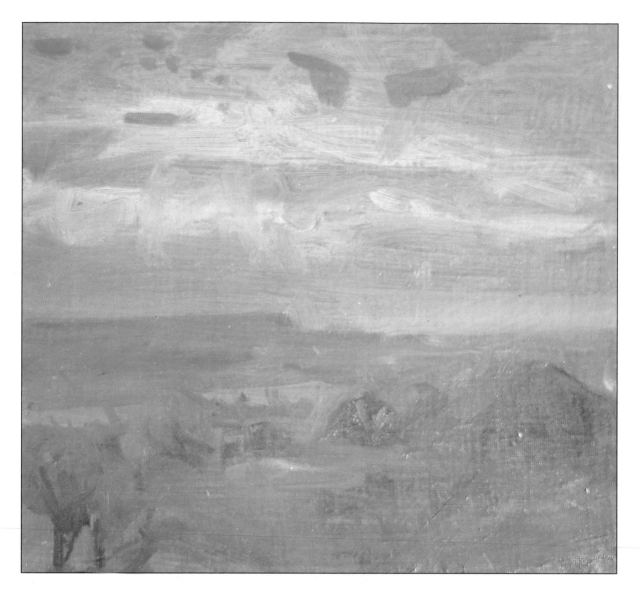

Landscape is all around us. As I lift my head from writing this I am lucky enough to look out through a window over my garden and a green field surrounded by mature ash trees in full leaf, beyond which I can see a glimpse of roof-tops and rolling hills. Above all this is a wide sky of clouds with gaps big enough to allow the occasional shaft of sunlight. It has rained all night after weeks of dry weather. It is a view full of promise for any painter. The chemistry of the permanent features of the landscape interacting with the transient ones of weather, season and habitation is enough to have me reaching for pencil and paper, brushes and paints to begin to record what I see.

Travelling light, there's always something interesting to record around the next corner.

Getting started

What do you need? Well, not much, and to start with at least it may be best to avoid using anything that is too unfamiliar. Going into a good artist suppliers' brings out in me a strong urge to buy that extra colour, or to try out two or three unfamiliar papers. It is an urge that I have learned to suppress: not only can it be very expensive but it can lead you away from what matters. For example in using watercolour, each paper has different working characteristics, so it's an enormous help to work with just one or two that you know and understand well. It's much better to become totally familiar with a rather limited range of materials within each medium that you use.

A palette in watercolour
- ☐ Cadmium Yellow
- ☐ Raw Sienna
- ☐ Cobalt Blue
- ☐ Prussian Blue
- ☐ Cadmium Red
- ☐ Burnt Sienna
- ☐ Alizarin Crimson
- ☐ Viridian
- ☐ Burnt Umber
- ☐ Paynes Grey

What you will need

Whatever medium you choose, keep it simple. There is no virtue in working in a complicated way for its own sake. In oils, for example, I like to use much the same range of colours whether I am working in the studio or outside. If you regularly have to walk or cycle miles to find your subjects, you soon learn to limit the amount that you carry.

My basic kit for watercolour, an assortment of brushes, tubes of watercolour (though this could be pans), pens, ink, a large natural sponge and a pad of watercolour paper.

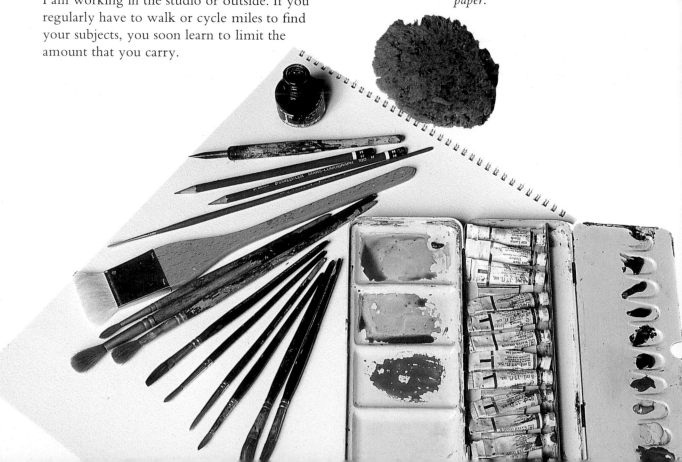

The following list of materials should cover most eventualities without overburdening you unduly: watercolours in pans or tubes; graphite pencils, various grades B–6B; willow charcoal; Conté crayons; bottle of Indian (India) ink (black or sepia); dip pen (pen holder) with selection of nibs (points); Chinese white watercolour or white gouache; eraser; craft (utility) knife or steel pencil sharpener; brushes for watercolour – the best quality you can afford, a no. 4 pointed and a no. 10 or 12 pointed are all you will need; oil paints; brushes for oils; watercolour paper, stretched if necessary; panels for oils (see page 49); a small sketchbook; spray fixative; a bottle of water (distilled if you are using it to dilute Indian ink).

Another advantage of limiting what you carry with you is that you can work quite unobtrusively without having to set up a sort of travelling sideshow every time you want to paint or draw outside. One more thing, the small sketchbook in your pocket is to enable you to work through possible viewpoints or compositions before starting to paint, or to make a brief note of the interesting view or unexpected incident so that you can return to it another time.

A basic palette of oil colours	
Titanium White Yellow Ochre French Ultramarine Burnt Sienna	These colours alone give an extraordinary range of colour combinations, even though rather limited in intensity.
Cadmium Yellow Cadmium Red Alizarin Crimson Viridian	These colours extend the range and allow a greater variety of mixtures to be produced. (Alizarin crimson is very powerful on its own, and mixed with viridian produces lovely greys.)
Raw Sienna	A transparent yellow/brown.

Brushes, tubes of colour, a trowel-type painting knife (but used as a palette knife), a dipper (palette cup) and a favourite old palette.

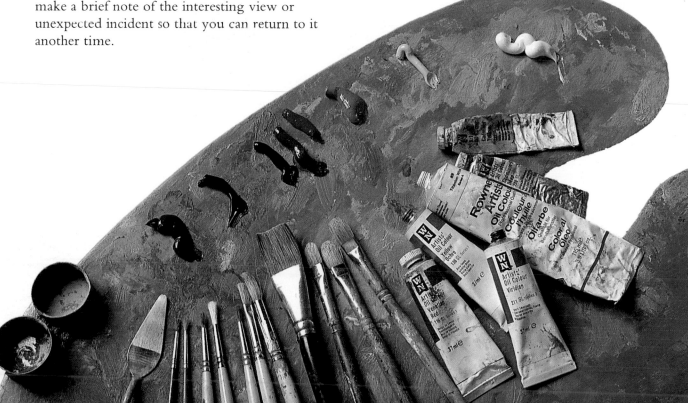

Working in mixed media

There are often good reasons to use two or more media together. Each medium that we've considered has its own characteristics, but you may want to combine their virtues. For example, touches of pastel or Conté may be used to crisp up a watercolour painting, or an ink wash might be just what's needed to widen the tonal range of a charcoal drawing. The illustrations here show some of the possibilities of combining media, but try others for yourself.

Choice of medium is very much up to you. I have generally tended to work directly in oil paint when working out of doors on a small scale, but more recently have found it stimulating to work in several media. At its most basic level this approach enables me to collect information that can subsequently be used to develop paintings in the studio. A wealth of information can be compressed into a small pen and wash drawing.

Another reason for using a range of materials is that we tend to 'see' through the medium that we use. For example, I have been working today on a pen and watercolour drawing of an old brick kiln in deep woodland. The subject is essentially linear, with contrasts between the exposed geometry of the broken kiln and the delicately balanced growth of the spindly trees beyond, and also transparent, the trees and undergrowth receding into the soft veiled light.

Watercolour flows across the page and is ideal for momentary light effects.

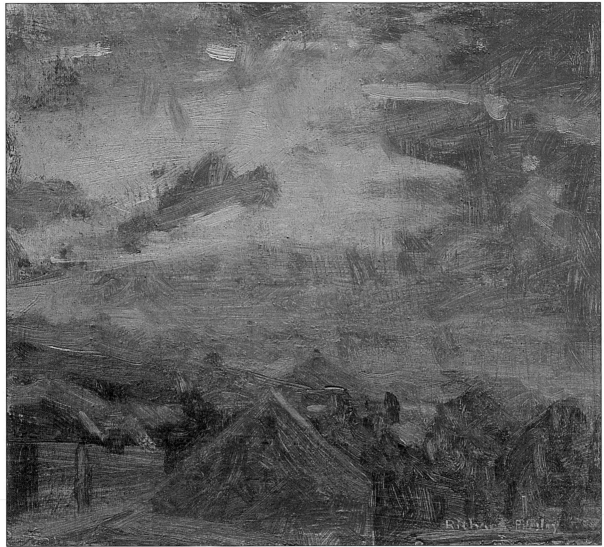

A similar subject in oil, although its slower pace meant I had to start before the light reached this stage.

These characteristics *could* be brought out in oil paint but can be exploited and emphasized more readily using pen and wash. I would recommend, within the above limitations, that you use a range of media so that you become familiar with the practical and expressive possibilities of each of them. For example, some materials lend themselves more readily than others to working at speed or to making modifications when the situation that you are trying to draw is constantly changing. I hope that the contents of this section will be equally applicable whatever medium you decide to use but it may be helpful at this point to look at some of the possibilities.

High or low key
You also have the choice between drawing or painting in a high or low key. Painting out of doors, in a situation where there is a great deal

of light it can be tempting to paint the subject up in tone in an attempt to convey a sense of light. This will seldom be successful as it tends to result in the colour becoming thin and chalky as well as leading to difficulties in getting the highest tones into order. Pitching the tone of the painting a little lower will help you to solve most of these problems by letting you keep colour in the lights but still resolve the highest tones satisfactorily.

Choosing a subject

What are you going to paint? Well, landscape of course, an unnecessary question, or is it? A very little thought will show you how all-embracing a subject landscape can be. Your first thought is probably of a rural idyll, with a high bright sky, trees waving in a gentle breeze and probably a few cows. Instead, think of a train journey. What might you see as the journey takes you across fields, through forests and shows you 'back door' views of the familiar urban scene? Imagine yourself in the centre of a

busy town, or by the sea, or inside a house looking towards an open window with a view beyond, or looking at close range at grass and flowers growing in a hedge.

Imagination applies first of all to where you choose to look. Try to cultivate the habit of looking at everything as a potential subject and sure enough you'll start to see subjects everywhere. Often this may mean turning your back on the wide view and searching out something more intimate, for while the former may look impressive through its sheer size, think how it's going to reduce down to the confines of a small painting.

Above all, remember that there is no single way to tackle a particular problem. In landscape painting in particular, you will always be confronted with a wealth of information and a degree of selection is inevitable. This being the case, everyone will select from the available material in a slightly different way. Over the course of time and without needing to be forced, your own manner of painting will produce a sort of 'handwriting' in your work,

As my interest here is mostly centred on the luminous evening sky, I have chosen to paint it using a full range of tones. This means that the land has to be simplified and the tones in this area somewhat compressed.

which is much more satisfactory than a self-conscious 'style'.

One further point stems from the development of landscape as a subject for artists. Landscape originally provided a supporting role only, usually to religious or historical subjects. It is still a fact that many of the most interesting paintings are not *just* landscape in its more obvious sense but may also involve other aspects of the visual world.

Adapting to the conditions

Weather conditions will sometimes dictate where exactly you choose to paint and consequently the nature of the subject. For example, on an overcast day in summer when everything looks rather flat and dull I will often choose to work under trees where the light filtering down through the leaves will give me much brighter colour than if I chose to work out in the meadow beyond the wood.

Where you paint will also often depend on how brave you feel! Putting an easel up in a busy place may make you feel self-conscious at first but most people respect the fact that you're trying to work and will leave you alone. Incidentally, if you work standing at an easel, the higher eye level has the effect of opening up the foreground far more than if you were sitting to draw the same subject.

There are times, however, when you need to work discreetly and without any distractions.

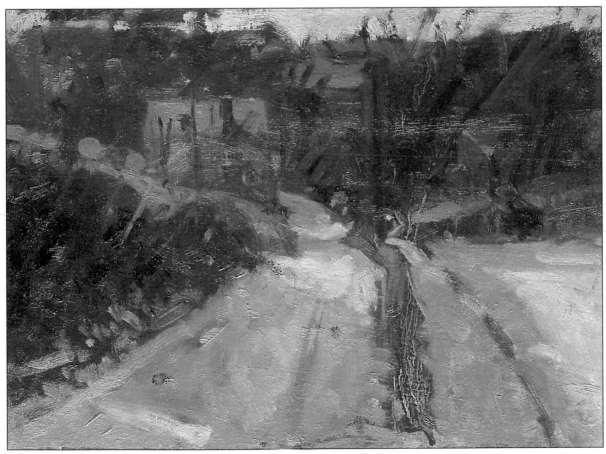

A snowy landscape with houses in the background provides the subject here.

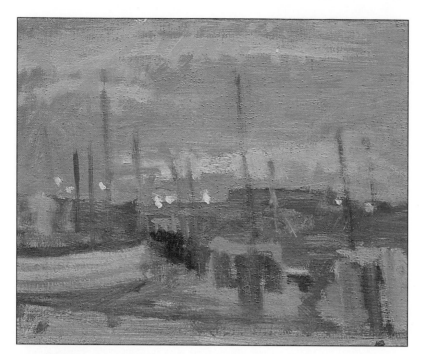

A jumble of boats on a quayside and the sky beyond are the subject for this quick oil sketch. It had to be painted in just a few minutes while there was still enough light to see.

Below: Don't forget the people! They are often there but tend to be ignored by the landscape painter. The beach is a marvellous place to find people at their most relaxed and still enough to be drawn or painted.

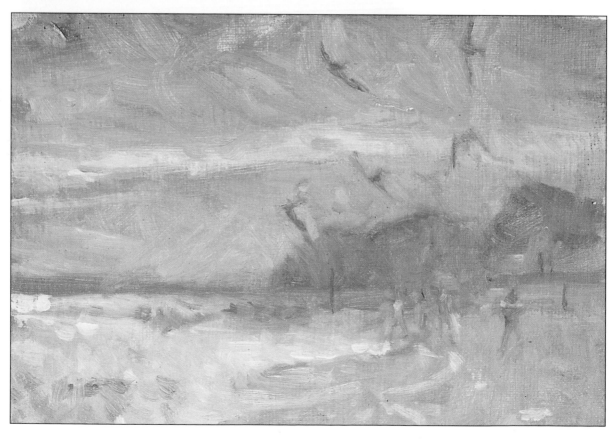

On those occasions, try drawing in a small sketchbook. Even in busy public places, you can usually pass un-noticed.

On the day that we did the second project, it was so cold and windy that we had to find a sheltered spot to work and in doing so I think we found a more interesting subject than the one we had originally planned.

A simple exercise

You can do the following exercise using any drawing medium that you feel happy with and that you can use quite quickly – pencil, charcoal, and pen and ink are all very suitable. First, set yourself a very strict limit on where you are going to work. For me, it might be 'I'm going to limit myself to one hundred paces from my back door'. (If this is not a practical limit, decide what is sensible for you.) The idea

is that you are going to produce six drawings within this very confined area. So that you don't determine the composition of each drawing in advance, select your first position and start drawing at once. Allow each drawing to settle into its natural shape by starting near the centre of the paper and allowing your composition to grow. (Make sure the paper you are using is large enough for you not to spill off the edge.) Try not to worry about finding a 'picturesque' subject, and don't think too much about finding the 'best' view. Simply walk around your chosen area stopping to draw from any viewpoint that catches your eye.

By the time you have made your six drawings you will be thoroughly tuned into your subject and will probably be aware of several other viewpoints that you could draw from that you haven't yet used.

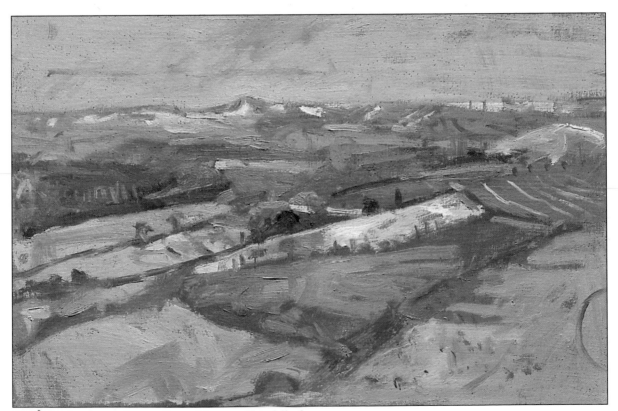

This open landscape is transformed by a sudden fall of snow.

Walking around a subject

You'll see from the sheet of wash drawings opposite that I will nearly always walk around a potential subject making quick little sketches. These not only seek to explore the nature of the subject but also give me the opportunity to look at ways of framing the view. Questions like 'How much of this can I get in?' and 'Is this a horizontal or a vertical composition?' can be decided very quickly on paper before you commit yourself to what might otherwise be a false start. Even for these quick drawings, it's worth using a tonal medium such as wash or charcoal as this makes it much easier to 'see' the finished effect in your mind's eye.

Ways of working

You'll need to give some thought to how you're going to work. Some people prefer to work only on the spot, while others do all their finished paintings in the studio after making notes while in front of the subject. This is partly a matter of temperament but also one of scale and method. The most usual reason for choosing to paint from drawings and notes rather than painting directly is scale: small drawings are made as preparation for a larger painting. As you paint you will gradually come to learn what suits you, but let's look at some of the issues now.

A practical demonstration

Try the following exercise. Choose a landscape subject that is very convenient to you. It might be a view from your window or something equally easy for you to get at. On a small sheet of cartridge (drawing) paper make as good a drawing as you can of your subject with no other aim in mind. Then, make the drawing of your subject that would be most useful for you to paint from. The two will be very different. The second one is very unlikely to be the prettiest drawing you've ever done but don't worry about that. What is important here is that you use any means you can think of to

A big 'wide-angle' subject like this needs first to be considered on a small scale otherwise it can be too much to handle. This little watercolour tells me what shape the finished painting will be, gives me colour in general terms, and a note in the margin will remind me what time of day it was painted so I can return in a few days with a stretched canvas and paints.

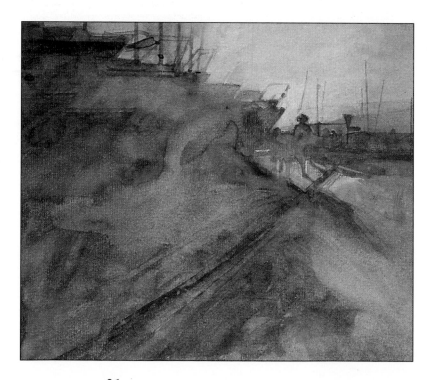

pack in as much *relevant* information as possible. This might naturally be in the form of line, tone and colour but could also include written notes of the time of day, where the sun was, and so on, or numbers to indicate the gradation from lightest to darkest tone.

If you were also to take a photograph of the same view you would probably find the photograph less useful because of the camera's inability to be in the least selective or to record tone and colour accurately over a wide range. In addition, the camera's inability to discriminate between objects close together in the image but widely separated in distance is a considerable drawback when you are trying to work from a photograph.

Size and scale

Historically, painting landscape *sur le motif* has always been limited in size through practical considerations. The most pressing of these is the speed with which our moisture-laden northern climates produce changes of light too fast to be caught on a large scale. Constable's oil sketches done in a few minutes at dusk or recording a passing shower couldn't have been physically dealt with on a much bigger size. Monet, on the other hand, often painted through the middle of the day in the relatively stable lighting conditions produced by hazy sunshine. This tended to mask the movement of shadows and enabled him to paint outside on a surprisingly large scale.

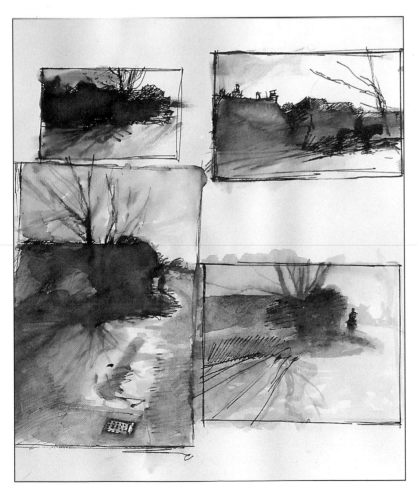

Four views walking around a subject. The sun and shadows on the road surface and the simple masses of the trees and buildings beyond are what got me going here. I've used a fibre-tipped pen of the sort that stationers sell for writing. This one has water-soluble ink so by dipping my finger in a puddle and using it as a brush I can drag it over the line drawing to build up areas of tone.

Depicting space

In 'reading' a painting we respond to many visual clues about the way that space is being suggested. I've said elsewhere that our eyes are so accustomed to landscape that any horizontal division of the picture plane results in the image being read as landscape with the foreground at the bottom. Some ways of indicating space in a painting are discussed here. They include overlapping; relative scale; perspective; aerial perspective; colour; tone; and the angle of view.

Landscape in Western art

One of the reasons why landscape is a comparatively recent theme in Western art is that the theorists who worked out systems for showing depth in drawing and painting found it very difficult to suggest ways of depicting the large spaces that are involved convincingly. Describing depth in an interior was relatively straightforward. The rules of perspective, once worked out, could be applied to a painting without difficulty. Above all, the lighting for a

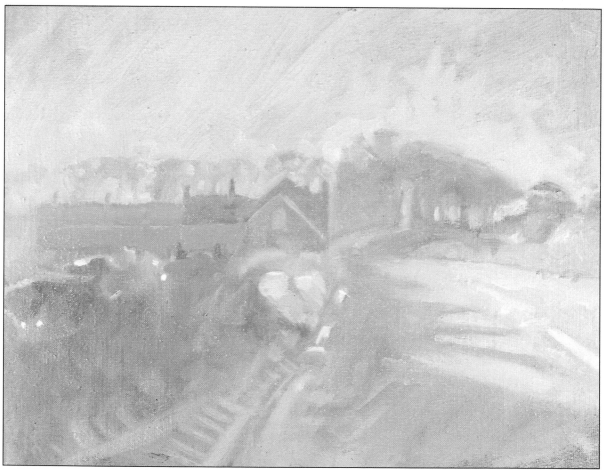

Overlapping, scale, perspective, colour and tone have all been employed here to depict space.

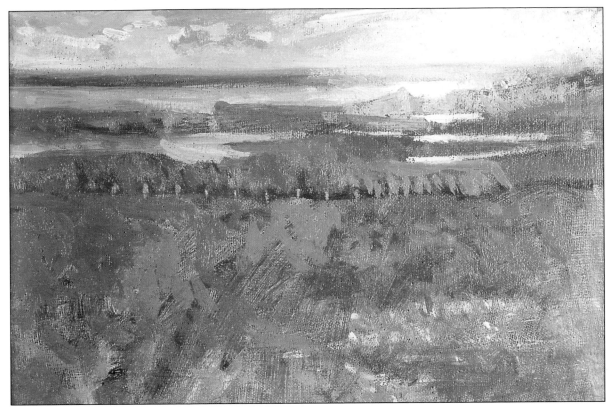

In this painting, looking into the sun, I've tried to use the intense light to describe space.

study could conveniently be controlled in its direction, quality and intensity.

Landscape as a theme started to gain in popularity in seventeenth-century Holland, partly as a reaction against religious subjects following the Reformation, and partly due to the rise of the merchant classes who provided a ready market. It took artists several generations, however, to work out the combination of factors that had to be considered if great expanses were to be described within the narrow vision of the picture frame. Some of these factors are described below.

Many paintings of landscape made by novices (probably because of their artists' lack of confidence) remind me of a room in which all the chairs have been pushed back to the wall. It is much more exciting to use the space within the painting rather than being afraid of it.

Overlapping

This is one of the strongest visual clues and a simple method of explaining depth in a painting. As soon as one thing is placed in front of another, rather than arranged frieze-like across the picture plane, you are beginning to create a feeling of depth. The effect is strengthened further if you allow objects to bleed off at the edges of the picture. By allowing the picture frame to overlap with the contents of the painting, you automatically push them back in space.

Relative scale

Even if use of linear perspective isn't appropriate you will find that faithfully recording differences of scale will immediately

open up the picture space. At first, everyone tends to underestimate the relative sizes of different objects and it is worth making some drawings in which such differences are a major feature in order to learn to recognize and use this effect. Try this exercise. Seek out a subject in which you are looking through something in the immediate foreground that does not completely obscure the view beyond – a fence or gate is ideal. Use only line to produce an accurate drawing of what you see. You will find that it is quite easy to relate the scale of the parts of the drawing because you are seeing the background and middle distance *through* the foreground motif. Use the shapes between the edges, the so-called negative shapes, to help you establish the correct position for each mark.

Now go on to tackle subjects where the different scales of the component parts are more separated.

Perspective

The full complexities of perspective would take more space than is available here and it is worth anyone who wishes to spend a lot of time painting landscape trying to learn more about the subject. To begin with, however, a grasp of the basic rules, combined with an understanding of measuring techniques, should suffice. It is theoretically possible to record all the facts of perspective from observation but a little knowledge of the basics will be of great help when it comes to knowing how to *interpret* what you see.

As soon as you are aware that things appear to get smaller the further they are away from you, you have a rudimentary knowledge of perspective. Everything beyond this point merely systematizes this basic fact. There are two perspective methods of relevance to anyone wishing to paint landscape. These are single-point or square perspective, and two-point or oblique perspective.

Single-point perspective is the simpler so let's start with that. This system works best in cases where you are looking square-on or nearly so at something cutting across your line of vision. A good example of this would be a house in a landscape viewed in such a way that only one wall is fully visible from your line of view. You will see that many of the major lines of the composition appear to recede towards a single point, known as the 'vanishing point'. In this view much of the structure of the building will remain hidden behind the front wall of the building. In the drawing opposite the recession of the path towards the horizon is a good demonstration that the perspective of landscape can often look quite informal.

Two-point or oblique perspective applies when you have a view looking towards the corner of a building or are looking out towards the corner of a field. Only rarely will you find yourself in a situation where a single perspective diagram will explain everything before you. It is useful to gain a good working knowledge of perspective, but use your eyes and common sense when you come to apply it.

Aerial perspective

While linear perspective is about the effect of distance on the way that we see the structure of things, aerial perspective concerns the effect of the atmosphere on the way that we see changes of tone and colour. It is an effect that is easiest to see on a misty day but once you come to understand it, you will see its effect in other atmospheric conditions. Aerial perspective affects both tone and colour.

Tone
Increasing distance has two basic effects on tone. As the distance between you and what you are recording increases, so its tone lightens; and there is also a noticeable reduction in the degree of tonal contrast.

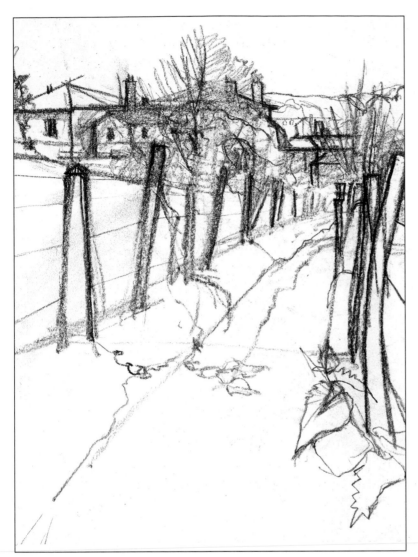

I've included this line drawing of a view along a footpath because it combines three ways of showing space. The fence posts on the right-hand side overlap both each other and the more distant view of the houses. The large scale of the posts and nettle leaves in the foreground bring them very close and the recession along the path is an example of the use of single-point perspective.

Faithfully representing the major changes in tone in a landscape gives a very strong cue to reading depth into a painting. Try this exercise. You'll need scissors and a supply of paper in four different tones of one colour. If you have no suitable paper, paint some up with flat washes of watercolour or poster paint. Working either directly in front of a suitable subject, that is one that shows layers of tone that lighten as they recede into the distance, or from a drawing done previously, cut out areas of paper to correspond to the silhouettes of the layers going back into the landscape. You'll need to simplify, so ignore all but the main changes in tone. Glue these down onto white paper, noting how strongly the resulting picture evokes a feeling of space.

Colour

Colour too is changed by distance. Standing on a hilltop on a bright but hazy day you will see this effect laid out before you in its most obvious form. Look at the colour of the grass beneath your feet and then at the grass on a

distant hillside. You will see that even though
they may be equally brightly lit, the patch of
grass in the distance will seem much more blue.
Ranges of hills one behind the other will show
this happening to an increasing extent the
farther away from you they are. This is another
area where you must sensitively follow the
evidence of your own eyes. I have seen many
inexperienced painters thoroughly muddled
trying to make the 'warm colours advance' in
their paintings without really looking hard

enough to realize that it's all a question of
relative hues and values. In the examples shown
here you can see how I've tried to state
accurately the changing colours and tones across
the picture plane to show the effect of recession
through aerial perspective. In the picture below,
for example, look at the quality of the green
grass in the brightly lit, left-hand foreground.
Now compare this with the grassy hillside
visible above the houses on the right-hand side.
Look at the amount of contrast around the

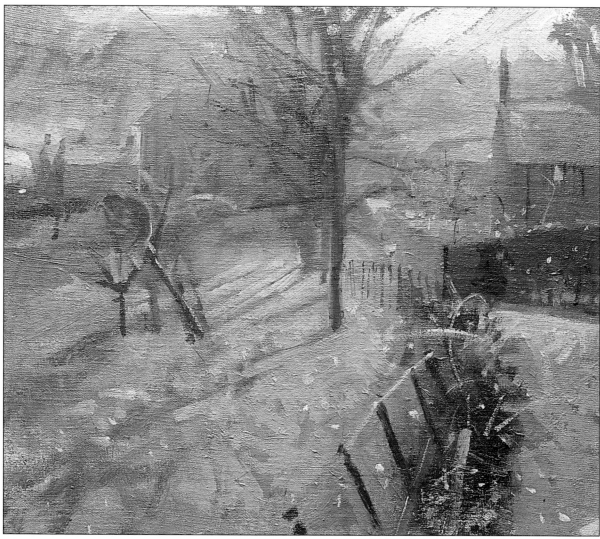

This view could be chaotic, but the space is carefully constructed through colour and tone.

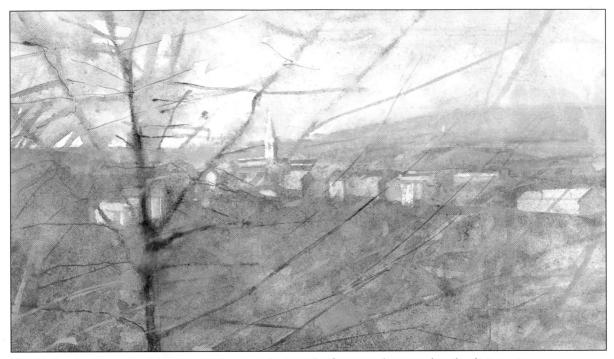

A wide landscape with a hilltop town in Yugoslavia. The foreground tree pushes the distant view away.

fence posts at the bottom of the painting then cast your eye further back and notice how much more compressed the range of tones becomes.

Angle of view

Another factor that can radically affect the way that you tackle painting or drawing a particular landscape is the angle of view that you choose to employ. We all have a natural cone of vision that is quite acute towards the centre and less clear towards the edges. In painting we can choose only to look at the central portion, taking a narrow angle of view, or extend the natural cone of vision by moving our head. The narrow view tends to give a sense of isolation, distancing the observer from the painting. The wider the angle the more we feel included in the picture, the sky towers overhead and the ground comes forward beneath our feet, sometimes creating the illusion that we could

step into the picture. The wider angle seems to be more acceptable on a larger painting or drawing, looking cramped if the scale is too small. Indeed, if you should attempt to make a large painting with a narrow cone of vision, you will find that the scale of the painting may have to be increased to an unacceptable degree to fill the canvas. Taken to extremes, the wide angle approach will lead to considerable distortions of perspective with the edges of the painting seeming to fracture away from the central portion. Although there are some contemporary painters who exploit these effects in their work, they are probably best avoided until you have a firm grasp of how to use more conventional pictorial space.

As you can see there are many ways in which a feeling of space can be created. You probably won't use them all every time you paint, though you will see many paintings in which they are all used. Look for example at works by Jacob van Ruisdael. Painted just at the point where

Dutch artists had expanded their knowledge of
how to represent space beyond the confines of
the interior, his works encompass vast tracts of
landscape. By contrast, note the limited means
by which the nineteenth-century makers of
Japanese prints, for example, could suggest
spatial relationships. The Impressionist painters
were greatly influenced by both the Japanese
print and the snapshot, which exploit the
simplicity of overlapping masses and the way in
which the subject is interrupted by the edge of
the picture. By using these different visual cues
in combination, you can create a powerful
illusion of depth and an awareness of their
effectiveness will help you to choose
viewpoints. We'll talk more about this later.

*The narrow angle of view here gives an intimate feel
to the painting. This painting is tiny and the subject
would look odd on a large scale.*

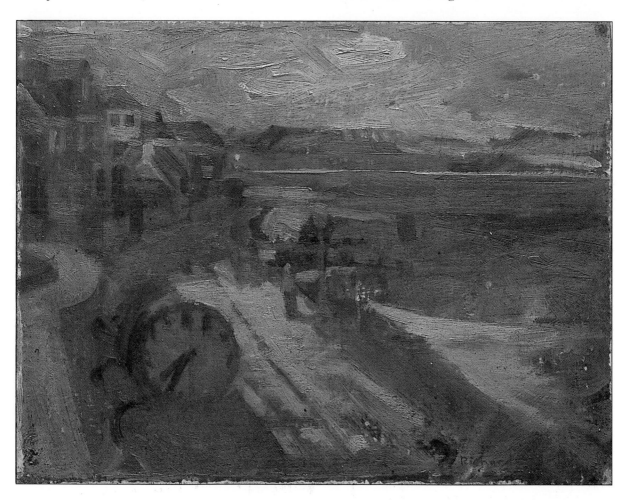

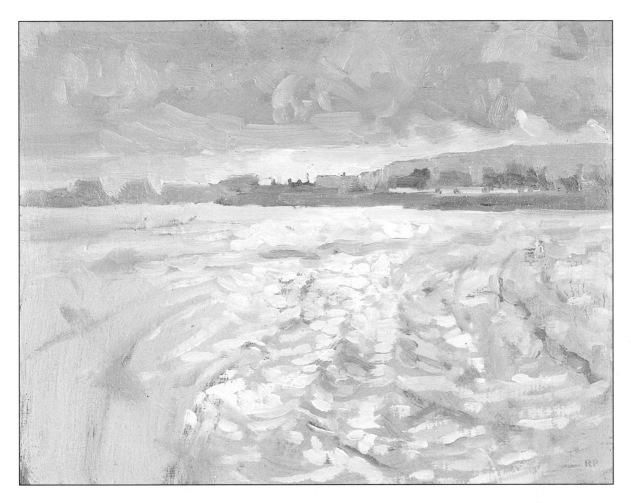

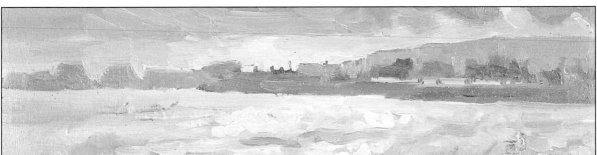

Left: In this painting I've taken in a wide angle of view although the picture itself is quite small. I wanted to have the clock in the foreground with the sweep of the bay clearly visible beyond, as well as the sea and the promenade below. If I had chosen to work with a narrower angle of view I simply wouldn't have got it all in.

Top: Sitting right by the side of the river I became intrigued by the pattern of ripples on the water and painted almost up to my feet. Part of the effect of this is to push the far bank further away and to open up the middle distance. By slicing the middle out of the painting (above), you can see an alternative composition with a much narrower angle of view.

Composition

Composition may be thought of very simply as the way in which the parts of a painting or drawing fit together with each other to make a satisfactory whole. It therefore covers such considerations as your choice of format and how you use it, whether, for example, you draw attention to the two-dimensional surface you're working on, or create a 'readable' third dimension. It governs what you emphasize within your format, either by use of colour, or tone, or by where you place it. And, it encompasses the underlying structure that you create in your work. It is an area where inexperienced painters can easily become preoccupied with 'rules' rather than learning to trust their own judgement. Some general observations can be made, however, and I pass some of them on here.

A stable and relaxed mood is created by horizontal lines and just a hint of a wide-based triangle in the sky.

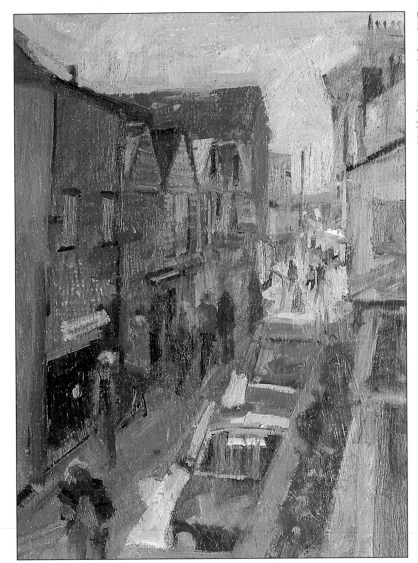

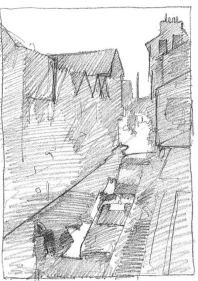

The combination of vertical lines, a wide angle of view and perspective helps to establish a feeling of energy in this painting. Notice how the rectangular shapes of the buildings in the top right-hand corner help to put a brake on the diagonal perspective lines.

Formats and shapes

Generally, a horizontal rectangle appears more stable than an upright one and because its shape approximates to our two-eyed field of vision and also because the dominant lines in landscape are usually horizontal, this is the most usual format for painting landscape. On the other hand a tall, narrow painting, like a tall narrow box can give the impression that it can be easily toppled and looks unstable.

To me, some proportions of horizontal rectangles are more satisfying to work on than others. For example, I have never found the proportion 2:3 particularly inviting, although other shapes very close to it can appear much more dynamic. Perhaps this is because 2:3 divides so obviously into a square and a half, it seems to have an inertia that defies my attempts to make it 'move'.

Within the composition some underlying shapes will help to bring a sense of stability.

Two examples reproduced here show how, for example, a broad-based triangle can do this.

Landscape will often be seen as a series of interlocking rectangles. The horizon and hedges and fields close to the horizon give a cluster of horizontals while trees and other features cut across these in strong verticals. Introduce buildings into the scene and this theme is emphasized further. The varying sizes of these rectangles and spacing between the edges provide the two essentials of good design, repetition with variety. Add to this the interplay between the implied rectilinear pattern on the surface of the picture and the illusion of depth and you've gone a long way towards producing an exciting composition.

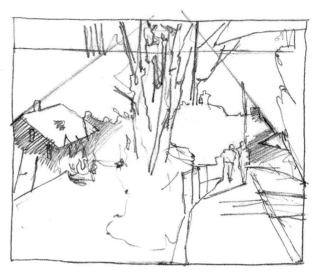

A stable triangle imposes order . . .

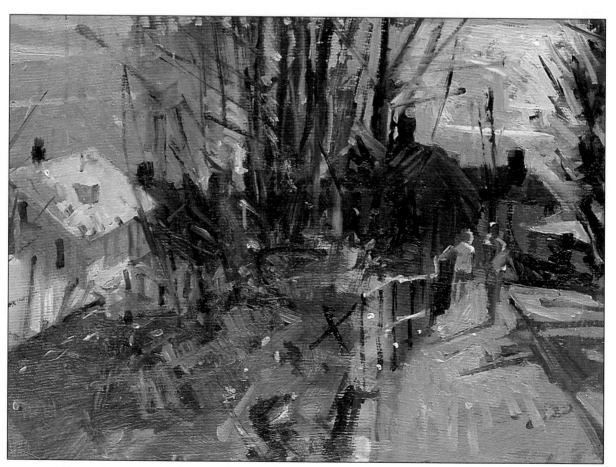

. . . even though the corners of the triangle are out of the picture.

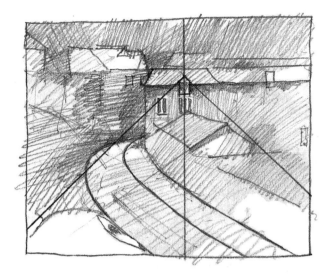

The apex of a triangle formed by the little window . . .

What to emphasize

Another important point to bear in mind is that composition is more about controlling emphasis than making patterns with lines and edges. Remember that when you actually look at a stretch of landscape at any one time only one plane will be in focus and only the area immediately around your gaze will be really sharp. Often you have to decide what you think is important in a picture and play down other areas that become too dominant. Brushwork or the way that the drawing material is handled can be used to break up an edge that becomes too insistent, as well as modifying the degree of contrast between areas.

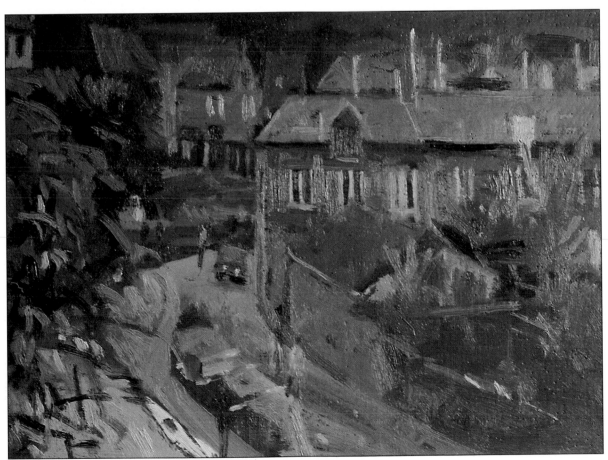

. . . helps to stabilize the curving sweep of the river in the foreground.

Some aids to observation

Precision in recording what you see is largely a matter of constant practice, although the learning process can be accelerated by adopting a few basic techniques that will help you to draw what you see more accurately.

Many students are rather afraid of measuring, thinking it more complicated than it really is. Just remember that you are using it to compare measurements one with another and you won't go far wrong. Here I've picked out two points on the distant view, one on the house and one on the field beyond marked by the top of my thumb and the top of the pencil respectively. Keeping my arm straight and the pencil upright, I move the tip of the pencil down to where my thumb has been, noting as I do so the new position of my thumb. By proceeding like this, I can count off units of height and width and use these to establish the basic underlying structure of the drawing.

Measuring

Drawing is largely about accurately establishing relationships of proportion, scale and tone, and translating these from the three-dimensional world onto a flat piece of paper. Left to their own devices, your eye and brain working together will be fooled over and over again.

The plumb line will always give you a perpendicular line and is of great help in establishing how things line up vertically.

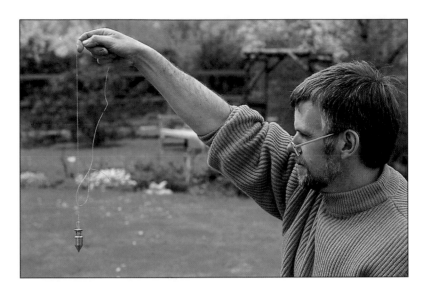

To gain experience of measuring techniques try them out on an easy subject. Find a building that you can sit opposite and draw in comfort: your subject will be the building, acting as a backdrop, and everything between it and your position, parked cars, trees, and so on. Your building should have plenty of windows, doors, courses of brick or stonework visible to help establish a grid. Also, as a landscape painter you'll often find yourself drawing buildings.

Keep your eye still, and holding a pencil upright at arm's length, note the total height of the building in multiples of the height of the pencil, or if it's easier, the distance between the top of the pencil and your thumb. Keeping your arm locked straight and your eye still, rotate your hand through 90° and count off the number of units into the total width of the building. You now have a basic proportion, maybe 3.5:2.5, which when drawn as a rectangle will exactly contain the whole drawing. You don't have to make the drawing 3.5 pencil heights tall: as long as you keep the *proportions* the same you can draw on any scale.

Once you have this basic rectangle, you can break it down further. Measure the height from the top of the roof down to the eaves as a proportion of the total height and record this

on your drawing as a horizontal line. Continue in this way, down through the architectural details. The drawing will gradually emerge from the web of horizontal and vertical lines.

Foreshortening

The most obvious case of your eye and brain in tandem deceiving you is foreshortening, in which your edge-on view of a plane appears to be compressed. If, for example, you were trying to draw the top of a table without using measuring techniques, you would probably over-estimate the height of the receding plane. The way to counteract the effects of foreshortening is always to measure when dealing with receding planes. In landscape this effectively means making key measurements every time, since it's hard to think of a landscape subject that doesn't involve receding planes.

Plumb line

Alongside the technique of measuring, one or two other pieces of 'kit' will be very useful. A plumb line, simply a weight on the end of a length of thread, will give you an instant vertical line whenever you need one. To assess, for example, the precise angle of lean of a tree,

the combination of measuring and plumb line is invaluable. Also, if you are trying to measure the width of an irregular shape such as a group of trees, the plumb line can be useful to carry one edge up or down so that you can measure it horizontally.

Viewfinders

Another invaluable but simple piece of equipment is the humble viewfinder. Using pieces of black card, cut out a hole in each one in the proportions of your most commonly used canvases or drawing surfaces. Thus a viewfinder in the proportion 5:6 will do for paintings 50 × 60cm (20 × 24in), or 37.5 × 45cm (15 × 18in), or 25 × 30cm (10 × 12in). Three or four viewfinders will therefore enable you to work on a variety of shapes and sizes. The viewfinder isolates the view, enabling you to select what to paint as well as allowing you to make decisions about what you see. They can be cut from quite light card and will take up little space in the painting bag although my

preference is that they should be a reasonable size, perhaps large enough to be used at arm's length. I find very small viewfinders hard to use as they must be held rather close to the eye so that you have to re-focus rather a lot to see both the finder and the view. A more sophisticated version could include threads stretched at regular intervals across the 'hole', or lines drawn on acetate film taped onto the surround of the viewfinder.

Relating tones

I've said elsewhere that painting and drawing are largely a matter of establishing relationships and this is nowhere more true than when handling tone. The range of tone available to the painter is very small when compared with the varying intensity of light in nature. The implication of this is that in this area, as in all other aspects of painting, mere copying, were such a thing possible, would be doomed to failure. Of course the painter has to select in order to succeed.

The viewfinder frames the view and cuts out the distraction of having the surrounding area visible. It is very useful in making decisions about what you're going to paint but also allows you to see the relative scale of the parts of the 'picture' much more easily.

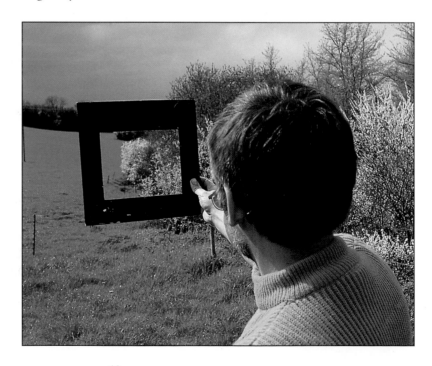

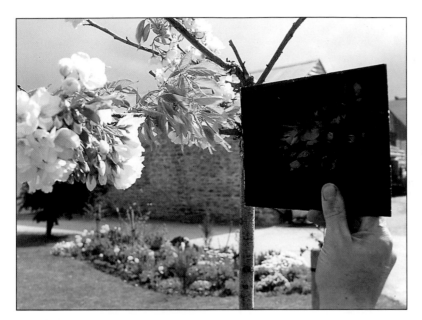

The reflection in the Claude glass simplifies the range of tone within the subject. Using it to look at a bright sky, you'll see how some areas may be significantly lighter than others. Sometimes one's sense of tone can be confused by a pale colour seen in shadow, especially if it is a little way from the brightest part of the painting. Looking at the image in the blackened mirror, colour will be suppressed, making the true tonal relationship clear.

A good example of this would be trying to paint against the light on a bright morning. Imagine a sky piled high with clouds through which the sun breaks. The *whole* sky is more luminous than the land although within the sky are many tones.

You have a choice: you can either to concentrate on the sky, spelling out each tonal step, in which case you will probably have to compress the tonal range of the land; alternatively be guided by the gradations of tone on the land and reduce the sky to a simplified pale backdrop.

At dawn and dusk, with less light slanting on the land, things often appears very much simplified, with a wonderful range of tone and colour in the luminous sky. Such subjects are marvellous for the artist since, although these effects are only short-lived, paintings made then can have a unity that may be hard to achieve at other times.

Claude glass

One way of artificially creating the effects that you may see early or late in the day in terms of tone, is to use a Claude glass. This is simply a piece of glass, coated on the back with black paint to produce a somewhat inefficient mirror. Looking at a landscape subject reflected in the glass you will see the bottom tones compressed while the higher ones are stretched out so that you can identify them in sequence. It can be fascinating to see how, for example, an area of sky that appears dazzlingly bright is composed of a number of tones and colours. Of course, like any other mirror, it reverses the image you are looking at, but having one handy to use when you start to block in the tones can be a great help. Make a less fragile Claude glass in the following way.

Take a small off-cut of transparent acrylic sheet. It should be of a size and shape that can be slipped into your painting bag. Paint out one side of the acrylic with black paint and when this is dry hold the sheet up to the light to check for pinholes of light. Apply further coats until you are absolutely sure that no light will get through. Once this last coat has dried, cover the *painted* surface with adhesive tape such as drafting tape. This will ensure that it doesn't get scratched during transportation and use. The *other* side is the reflective surface.

Project: Line and wash

It is often a good idea to combine the virtues of two or more media, either for practical reasons, as in this case, or because together they can produce visual effects that are not obtainable by other means.

The combination of media I've chosen for this first project is pen and watercolour wash. My reason for choosing this rather than say watercolour needs some explanation. The inexperienced painter, faced with a subject that may itself be very complicated, needs to choose a medium which won't itself add to the difficulties. By using these two techniques together, drawing problems can be solved first, separately from the added complications of colour and tone.

It's a particularly suitable way of working where you have a wealth of structural detail in a subject that can be fully explored using pen before watercolour is introduced. The transparent layers of watercolour wash leave the pen line fully visible in the finished painting.

You will need
- ☐ a drawing board with stretched paper
- ☐ distilled water or rainwater
- ☐ watercolour
- ☐ Indian (India) ink
- ☐ brushes
- ☐ pen

The derelict building and the shadow of its canopy provide a frame through which the distant landscape and buildings are viewed. I particularly like the way the main shapes of the composition lock together.

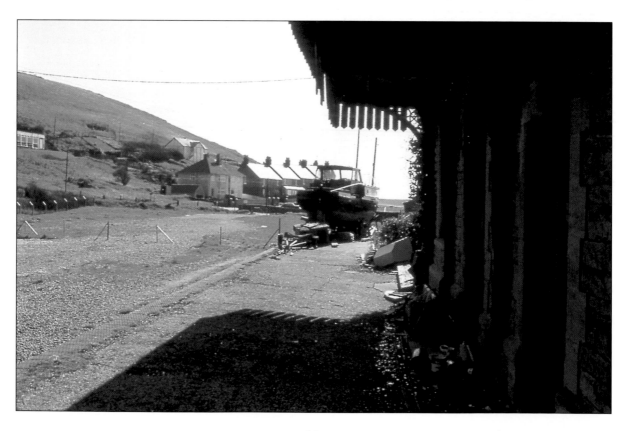

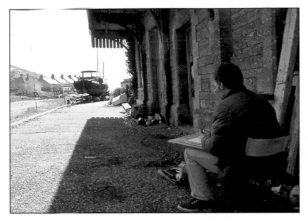

Settling down to work, I start to make decisions about how much of this deserted railway (railroad) station, now used as a boatyard, I'm going to draw.

With the drawing board on my lap and my arm straight I begin to make measurements of the main shapes of the drawing.

Drawing with ink

The key to this project is the use of Indian ink which, even when diluted, remains insoluble once it has dried on the paper. This means that a drawing can be fully worked out before washes of colour are laid over, and that these washes will not blur or distort the drawing. I'm working on a sheet of stretched cartridge (drawing) paper. Its hard surface provides a resilient surface for the scratchy pen and ink and I quite like the way the paint will pool and puddle on it rather than being soaked in.

I use pen and wash a great deal. It's quite flexible: you can either do all the pen work, finishing it as a pen drawing, and then apply a watercolour wash, or alternatively, you can do a bit of pen, then put down some of the washes for the simple masses at this stage, and work back into it in pen afterwards.

I find that the degree of contrast with black ink on white paper can be rather distracting so I dilute the ink with distilled or rainwater – tap water will often cause the ink to coagulate, forming black particles within the ink.

The principal composition lines

The strong sunlight is casting a large rectangular shadow on the old station platform and I have

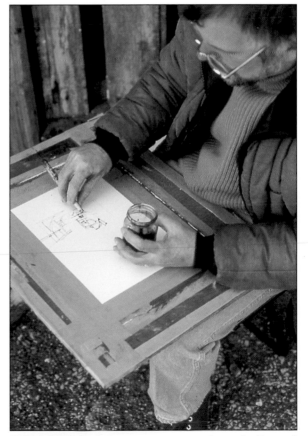

Using diluted ink I start to map out the main lines of the drawing. These marks aren't over-emphatic, but give me a base to work over later.

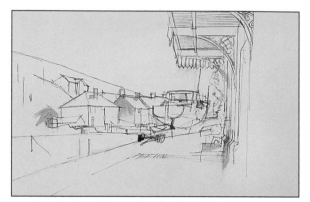

Pen lines in place and ready for colour wash.

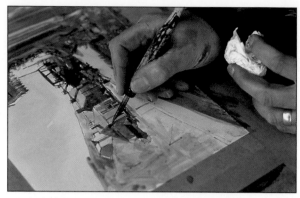

It's helpful to work on stretched paper.

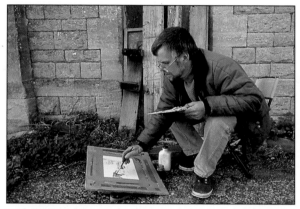

The first washes going down.

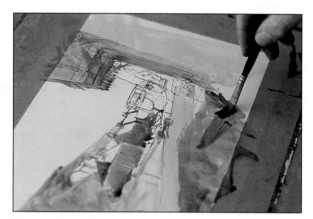

The hard cartridge paper emphasizes painted marks.

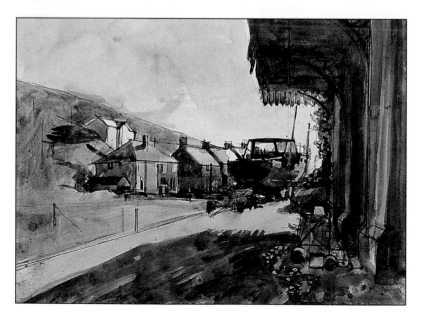

The washes can initially be kept quite pale, the tones being strengthened in subsequent layers as I become surer of the relative tonal values.

Allowing the paper to dry again in the sun I then work back into the drawing with the pen, this time with the ink slightly less dilute so that it makes a more emphatic mark. This in turn can be worked over using a finer brush and watercolour as well as opaque gouache and so the process continues until I am happy with the result.

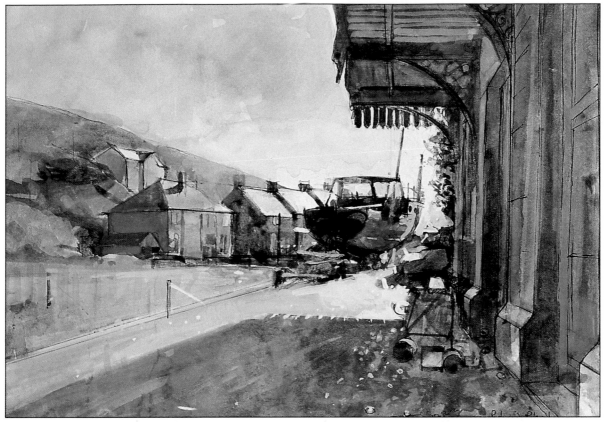

The finished drawing after all these last adjustments have been made.

chosen to sit in this shaded area looking out to the sunlit landscape beyond. It's important to decide how much of the view in front of me is going into the composition, so I place marks on the paper to indicate the total height and the total width of the image. Making further measurements I begin to subdivide the drawing by marking the positions of the main horizontal and vertical lines.

Adding the watercolour washes

Now that I've got my 'anchors' in position I can work freely into the drawing and continue until I have a fairly complete statement of the view in front of me. The drawing is now placed in the sunshine to dry for a few minutes. Failure to do this would mean that the wet ink would run into the watercolour washes. It doesn't take

long – even on a cold day like today – for the ink to dry and I can begin to mix puddles of watercolour on the palette and lay them over the drawing in simple washes with a large brush. I've placed the board on the ground at this stage, propped up at the back by my painting bag, but I continue to sit on the stool to maintain my viewpoint.

The final adjustment

Added flexibility can be gained by using opaque watercolour (gouache). Here I mix watercolour with white gouache to re-state some tonal values as well as to re-work some passages of drawing. While this detracts to some extent from the luminosity of the medium I feel this is outweighed by the ability to adjust and refine what you have done.

Project:
Alla prima oil painting

Oil paint is a remarkably versatile medium and, as we'll see later, one way of working with it is to slowly build up a large painting over a number of sessions allowing the paint to dry between each layer. Another method is to work smaller and complete the work 'in one wet'. Historically, it was the concern of painters in the nineteenth century to get closer to nature that led some of them to take their paints out of doors and paint directly from landscape subjects, rather than through the intermediate stage of a drawing. I work like this every day when the weather allows and always enjoy the challenge of trying to complete a painting in one session. There is something particularly satisfying about not having to go back and revise, and the immediacy of this method can give the painting a unity that can be hard to achieve by other means.

You will need
- [] a hardboard panel covered with muslin and primed
- [] easel with brick
- [] charcoal
- [] a dipper (palette cup) containing turpentine
- [] paints
- [] brushes
- [] palette knife
- [] rag or tissues

Late spring and the light sparkling through the apple trees – a great subject.

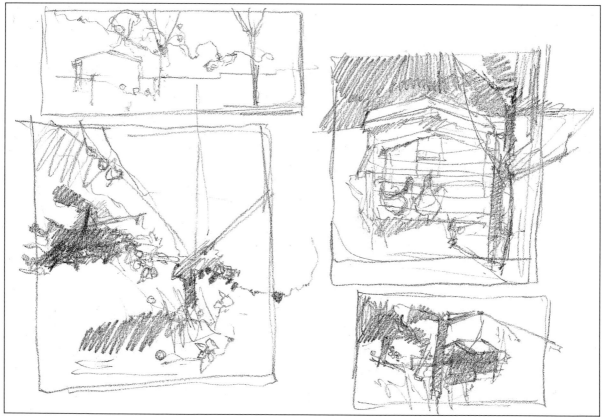

A walk around the subject with pencil and paper – an important preliminary stage.

48

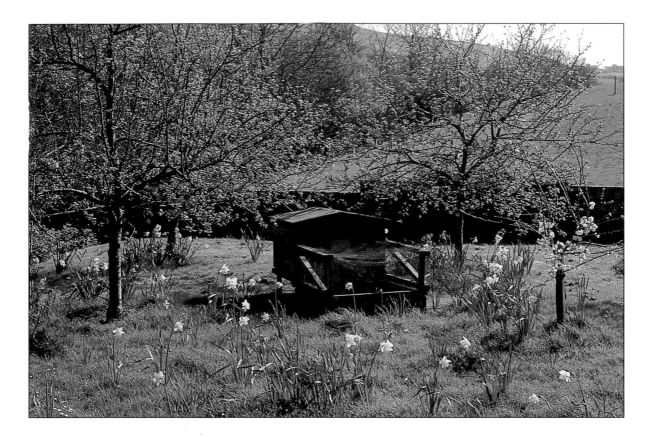

Choosing a viewpoint

The first task is to settle on a viewpoint and a proportion for the painting. Pressure of time once you have actually started on the painting means that these decisions need to be made before you can begin. A walk round the subject with a selection of viewfinders is one way of quickly getting an idea of which views may work best. Remember to allow for the fact that the sun is moving and a delay at this stage may mean that the lighting of your subject will be changed. This can be followed up with a sheet of drawings so that images can be compared side by side on the same page. These drawings should be small enough to be made quickly and I would suggest that you choose a medium that will allow you to put down masses of tone as well as line – a purely linear image can be misleading about where the 'weight' is within a composition.

Preparing a panel

Having made these quick preliminary drawings to try to choose the best viewpoint and shape it's back to the studio to select and prepare a panel. I try always to have a selection of these made up in various proportions and sizes. Usually these would be colour washed already in a variety of tints but on this occasion I chose a white one so that you can see how to execute this stage.

For this painting, I want a transparent ground that is quite pale. I often work on a ground that is roughly the complementary of the predominant colour of the subject so this time I've chosen a pinkish tone, mixing oil paint with turpentine to get the right colour and laying it onto the primed panel, rather like laying a watercolour wash. Once the whole panel is covered I wipe off the surplus and leave it to dry. Sometimes you put on the wash and

it's not quite right, but as long as it's fairly transparent it's very easy to wipe it off quickly and modify it.

The panel itself is muslin, glued down with rabbit's skin glue to a piece of hardboard (Masonite), then primed with two thin coats of acrylic primer. These panels take a while to prepare, but I can make about twenty in an afternoon. I'll colourwash them as I go – I know the range of colours that I'm likely to be working on, so I usually have about five slightly different colours mixed up. I then take a selection of these with me when I go out painting so I can pick whichever one matches my needs.

Establishing a toned ground. Oil paint diluted with turpentine is washed over the panel.

Getting started

Returning to the orchard, I set up a lightweight sketching easel and as it's now quite breezy I hang a brick from the centre of the easel to stop it being blown about. Before I discovered this trick I more than once watched helplessly as my painting was blown away, once into the sea! The extra weight provided by the brick holds the easel very securely and prevents the panel from wobbling around in the breeze.

I start by laying in a few charcoal lines. I don't like to overdo this as the charcoal can become intrusive and difficult to paint over, but a few lines help to map out the composition and allow adjustments to be made quickly. The paint, used rather thinned down with turpentine, continues this preliminary stage and allows things to be kept mobile. Remember, there's nothing definitive about any of these marks, at any stage you can wipe away the paint and re-state. As I become more sure that the main structure of the painting is settled, I begin to paint rather more solidly, using more white in my colour mixtures but still thinking in terms of blocks of colour rather than too much detail.

I work this way a lot – working out of doors you've only got a limited length of time when

After a few minutes most of the colour is removed with a rag.

the light remains reasonably static. The shadows are always moving round. These shadows in front of us, as the sun moves to the right, will swing round to the left, and after a while you'll find that the front face of the little hen house would start to catch direct sunlight. At this point the tonal pattern will change completely. For these reasons you are limited to how long

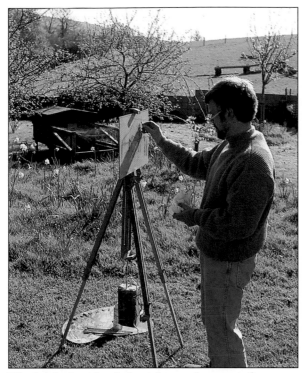

The brick, hanging below the easel, stops it from blowing over in the breeze.

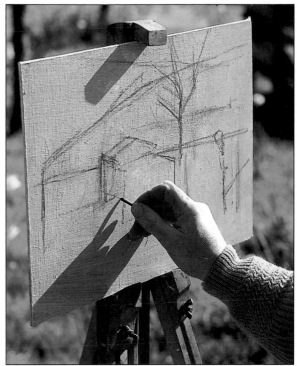

A few charcoal lines on the painting surface to help me get my bearings.

you can work in one session and that translates into a limit on size unless you are able to return another day. That approach, too, creates its own problems. For example, I worked on a large picture very near the spot I chose for this project, over a period of a couple of months. Over that period not only have you got to get the angle of the sun right, to be out at the right time of day, but also to remember that the sun is actually coming overhead higher in the sky, so that when the shadows are in the same direction, they'll be shorter as the year progresses, or they'll be longer. You can't ever rely on getting the same effect twice. That effect is accentuated if you're working by the sea: a lot of my work is seascape, or painted landscape around the edge of the sea. You can go two days running and if you go at the same time the tide will be different, and that will affect the look of the land.

For this painting, done in one 'wet' sitting, I reckon we've got about two hours.

Creating background and foreground

I want to start looking now at this tracery of branches in the tree on the left hand side, which is the one nearest to me. It does make some very interesting shapes and with the light hitting the sides of those branches, they look nicely solid; I want to try to bring some of that out. The other thing I'd like just to hint at is that there are trees beyond this little group of trees. There are more of them about a hundred metres away, and running away from the hedgeline. I very much want to get an indication of those trees to try to open up the space beyond the middle distance. This painting at the moment is all happening in the middle distance so I want to stress the foreground by looking at those daffodils and daisies.

51

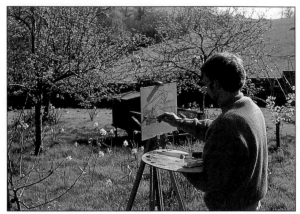

Switching over to using paint I use a few simple tones to cover the whole surface quickly.

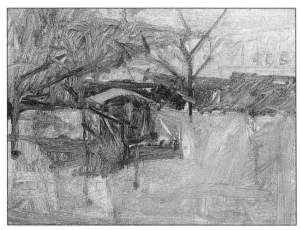

The colour of the sun on the grass is kept warm, allowing the underpainting to show through.

To suggest branches, I paint the lighter sky over the darker colour.

Modifying the composition

I must make any modifications to the composition at this next stage before I go much further. Obviously, if you're working on any painting and you become aware at any stage that the composition isn't right then the simple thing to do is to change it. It's always easier than you think, though I've seen a lot of beginners and inexperienced painters feeling hemmed in by their mistakes. Just scrape the offending area back to a good surface and re-state it. The little tree with its white blossom on the right-hand edge of the composition needs to be developed further, as do the daffodil flowers amongst the grass in the foreground. As I begin to make these changes, the rather unbalanced composition begins to right itself as the bottom right hand corner begins to carry considerably more 'weight'.

I love the layered effect that comes in the spring before the foliage becomes more solid later on. The way that the light is filtered through the mass of twigs and leaves, revealing – rather than obscuring – the landscape, makes this subject a marvellous one for the painter to exploit ways of evoking space and depth through these layers.

Painting the trees

I've got the particular problem with the trees of trying to cope with a very complex pattern of branches, leaf buds breaking, and so on. You can't possibly paint every single leaf and every branch. What you can do is try to create the sort of optical effect that looking through that semi-transparent pattern produces. Looking through these trees, I find that some of the lines of branches in the foreground are fairly prominent, but if I look through and beyond that it becomes a haze of colour and texture. Sometimes it can be very difficult (where the thin, wiry lines of fine branches stand in front of what's beyond, for example) to take a fine brush and draw them with a sense of balance

The trees are a translucent veil of colour at this time of year and I want to keep that quality as the painting develops. The main elements are all here now, that little tree on the right has helped to re-balance the composition and after the frenzied pace of the last few minutes I can slow down a little, though not too slow as the sun's moving round very quickly.

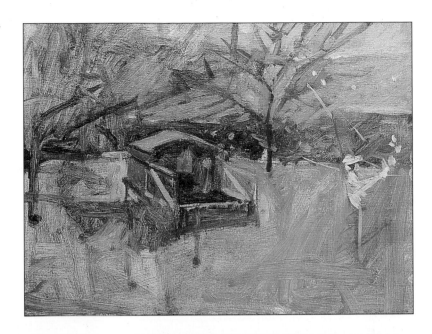

This area's got too dark so I lift some paint off with a tissue and re-state.

Here the surface is rather clogged. Removing the build up with the knife produces a fresh surface.

and poise. Very often it is easier and more satisfactory generally to paint the branch somewhat oversize, and then paint the background over and partly obliterate it. To produce that tracery of branches with a fine sable brush would be terribly difficult and may tend to look separate from the underlying texture of the paint, looking too drawn.

About now I have to make a decision about how light or dark the subject as a whole will be. If I pitch the key very high and try to get the tones in the right sequence I'm going to lose the

blueness of the sky completely. If I pitch it too low, I'm going to lose the luminous quality of the grass. So it's a matter of judgement.

Ordering the tones

The next stage is to go back and start ordering tones and think about where the lightest point and the darkest point are. One of the problems here is that with the sun on the grass we've got this strong lemony colour. The chances are that in a bright sky, the sky will be several tones lighter than the grass. Since the sky is bluish,

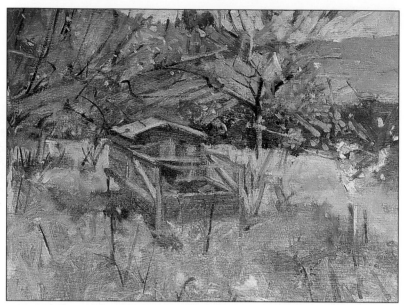

The fine sable brush is good for making drawing marks and adding emphasis.

More work is still needed to develop the appearance of the rough grass and daffodils and the breaking buds and leaves of the trees. The sun continues to edge round: there's not much time left.

and the grass has this yellowish cast on it, it would be very easy to get them the wrong way round and end up with the grass actually lighter than the sky.

By screwing your eyes up to reduce the amount of light getting in you can more easily see the tones in their proper sequence. Alternatively, if you have made one, the Claude glass would help you to do this.

It's a bit like getting map references, you want two or three tonal anchors. As your painting begins to develop you can relate colours and tones to these fixed points. In nature, of course, you've got a terrific range of tones, especially on a sunny day like today. If you look at the tonal range of this subject from the most luminous part of the sky through to the darkest shadows in the wall just beyond the hen house, it's an enormous spread that you just can't duplicate in paint. Because of this, those tonal steps have to be compressed somewhat, and you have to make decisions about where your priorities are and whether you want to get

all the shadow colours faithfully recorded or concentrate on the lighter areas. You can seldom actually do both.

Re-stating the subject

With a subject like this, there sometimes comes a point when I realize that in trying to paint all the little changes in tone and colour that are implied by the word 'texture', that the surface of the painting can begin to appear too busy with too many edges. If this happens and I think it is really distracting I find it can be helpful to gently scrape back with a painting knife to leave a ghost of an image that I can then re state more simply. Alternatively, by gently wiping or flicking a tissue or rag across the area I can just slightly soften the image, allowing a few crisply painted strokes to firm things up again and re-establish a sense of space. An alternative reason for scraping down may be that the paint has just built up too much and the surface has become rather leathery and clogged. In this sort of painting, it becomes apparent that

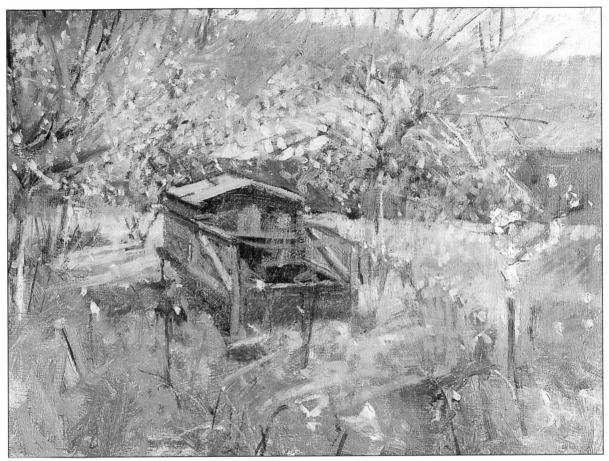

This is about as complete as I can get the painting in one session; the flower heads in the foreground open up the space in that area, establishing the distance back to the hen house.

composition is as much about controlling emphasis across the whole space as it is about edges, lines and geometry.

The final touches

I'm quite pleased with the feeling of transparency through the veils of foliage and this can be heightened in the final stage by just touching in some of the highlights on the branches and buds, over the top of the slightly darker background, pulling them into sharper focus. This is a marvellous time of year for the landscape painter, in a month's time this area of countryside will be a solid wall of green. Now, however, you get this impression of screens and veils, one behind another – it's fabulous to paint. Some trees are still bare – they provide a bit of architecture and also have a lovely pinky-purple colour over there against the more leaden colour behind.

By now the whole surface of the painting has been considered; I always try not to leave one area behind the rest. I can continue to put down touches of colour to develop the image further. At the same time I'm aware that the sun is moving further round and I haven't much time to finish this. A few touches on the flower heads in the extreme foreground help to further establish the ground plane as it runs back towards the trees.

Gathering and using the information

As a landscape painter you first have to find your subject and that usually means going somewhere to paint. I am aware all the time, even when I am not consciously looking for subjects, that I am storing up ideas for future paintings. I have notes in diaries and sketchbooks from years ago that on a particular day I noted the position of the rising sun in relation to a clump of trees. Many such scribbles, either written or drawn, serve to jog the memory when necessary. But in addition to these you will find that you begin to carry more and more possibilities in your head, especially if you have worked around the same locations for some years.

Right: A little sketchbook drawing of a town square in France. The light bouncing off the high roofs got me interested here and the rest followed on. I liked the way the facades of the shops were in shadow, and also the knot of figures in the foreground. Making a little drawing like this really helps you to remember what you saw.

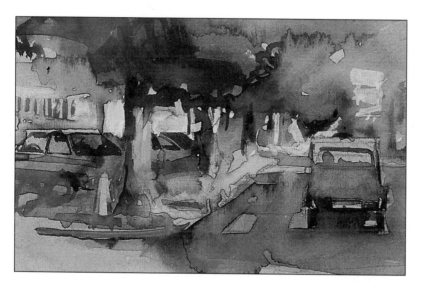

This time the row of lime trees up the middle of the street in a French town provided the starting point. Watercolour and gouache used together on a medium-toned paper provided a quick way of establishing a range of tones. When I travel, I always have a number of little sheets of paper stretched on mini drawing boards ready to use.

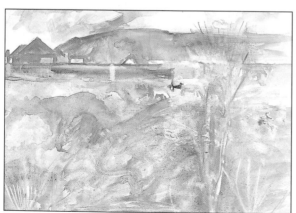

A composition sketch in watercolour.

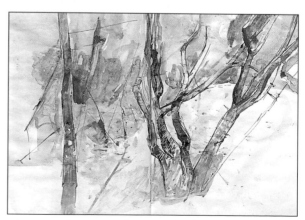

A watercolour reminder to return later.

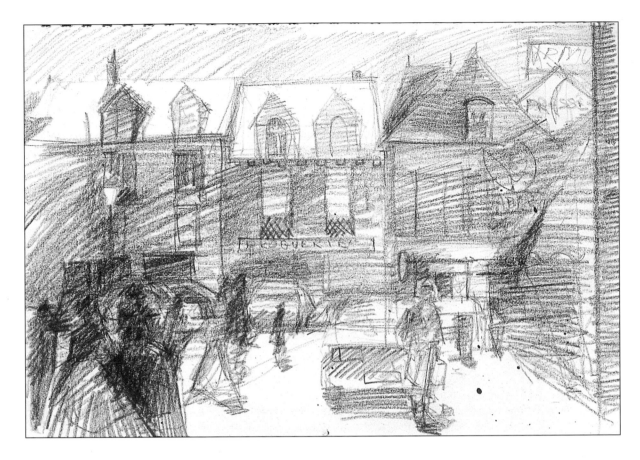

Keeping it small

I am a firm believer in the value of small drawings made quickly in front of the subject as a means of selection. Below a certain size I find that I can draw with a spontaneity that would be difficult to achieve on a larger and, therefore, more time-consuming scale. This allows me to move around my subject rapidly, jotting down any view that interests me. It is all too easy to go somewhere with the intention of painting a particular view and to do it in spite of the weather, light and everything else not being quite right. Often, a mere turn of the head would show you a better alternative but your decision, made away from the subject, stops you from seeing it.

Use any medium, or combination of media, that seems appropriate, and is convenient.

Choosing a viewpoint

Half an hour will give you enough drawings to begin to select which viewpoint is going to be the most effective. While you're doing this, notice the effect that the direction and quality of the light have on the appearance of your chosen location. Sunlight from behind you gives strong colour but little modelling. Side-lighting will produce a strongly three-dimensional quality, whilst viewing your subject against the light will probably be the most dramatic, with tones grouped and shadows running towards you. Try looking at the view through your Claude glass to heighten the differences. Notice too, that even on a bright, sunny day, the sky won't be the same blue all over but will vary between quite an intense blue/violet at the zenith to a slightly greenish tint close to it.

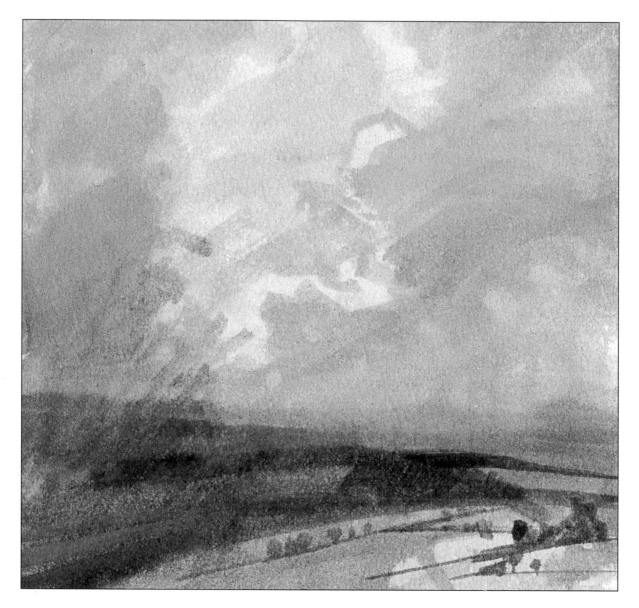

When selecting viewpoints, consider having something in the foreground which, by introducing overlapping and contrasting scale will begin to open up a sense of space. Be aware that an exciting view noted whilst standing up may look entirely different if you sit down to work. Remember too that in the course of making a painting the light will change in direction and intensity, so try to begin work before the light is where you want it to be.

On the spot or in the studio?

All of the above assumes that you are preparing to paint on the spot. I have to say that for me, this remains the ideal. It may be, however, that practical considerations make it impossible to finish a painting *sur le motif*. You may, perhaps, be on holiday somewhere and have limited time, or you might want to produce a larger painting than can be managed on location and

Left: Skies change very fast during the evening. I may make ten or so small watercolours like this in one session.

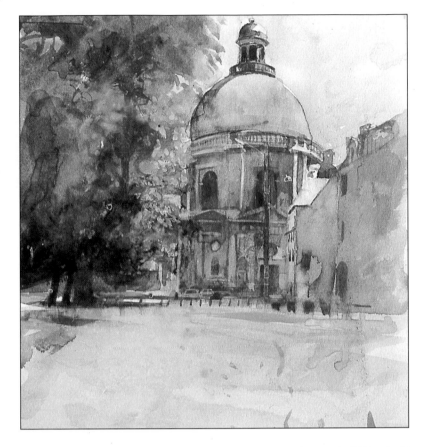

This, however, was a much lengthier session painted in the middle of a hot day. Changing light conditions and the complexity of the subject will tell you how long to spend on each piece. Remember the value of each drawing won't necessarily relate to the time it took.

must therefore complete the work in the studio. The preliminary research is equally valid, whichever approach you favour, but from this point on the working procedures will differ.

There are painters who manage to work from just one drawing when they return to the studio. Many of Constable's large studio paintings, for example, trace back to tiny pencil drawings sometimes made years earlier. I've never worked in this way and I doubt if I could do it really successfully. I find that I need to produce several drawings and colour notes, some more 'finished' than others. In this way I can feel confident that I can save some of the decisions to be made in the studio and escape the drudgery of slavishly copying a single drawing. Also, the more varied notes and drawings I have in front of me, the more my memory is stimulated into working.

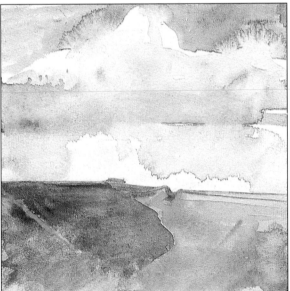

Big subjects can sometimes be most easily captured on a small scale where you can work fast.

Project: The courtyard at Azay le Rideau

You will need
- [] paints
- [] brushes
- [] painting knife
- [] a hardboard (Masonite) panel covered with muslin and primed
- [] a palette
- [] dipper (palette cup) containing turpentine
- [] rags

There are times when it is preferable to work indirectly, from drawings and other information collected on site.

Some months ago I spent two days making drawings in the courtyard of the Château at Azay le Rideau in the Loire valley. I worked in a variety of media and came away with lots of small drawings and watercolours as well as some little oil sketches. At the time I had no clearly formed idea of what I wanted to do with this information, but was content simply to record as much about this magical place as I could.

Developing a subject

Now, back in the studio I spread the drawings and sketches out in order to decide how to develop this material further.

Working in this way, at one remove from your subject, you have to learn to trust yourself and your ability to record and remember. I think now that when you sit down to make a drawing for some future use that you put as much into your memory as on the paper. It still surprises me the way in which a rather slight drawing made years ago can unlock my visual memory of the original encounter. To anyone else, the drawing would not hold all those overtones and messages but to the artist it carries far more information than an outsider could see.

Gathering information

The light was good throughout the two days, moving steadily from left to right with no interruptions from passing clouds. The dappled shade of the trees sweeping across the gravel courtyard was another aspect of the subject that I wanted to record.

As usual, I walked around quite a lot before settling to work on any one particular view. A small watercolour was made outside the gates before I moved inside and worked from other viewpoints. During the second afternoon, amongst the many people who came and went, a group of American cyclists stopped to relax on the seats under the shade of the trees in the courtyard. Fortunately for me they were tired enough to want to sit and recover for some time before going into the Château and it was immediately obvious to me that this would be a good subject with the tangle of figures, bicycles and paniers giving life to the shadow area under the trees.

You have to work opportunistically in this sort of situation and my viewpoint for the little watercolour of the cyclists isn't ideal. I would rather be further to my left, so that the figures and bicycles are between me and the Château beyond, thereby closing up the large area of sunlit gravel. However, I knew that I could move later and look at it from that angle so I was not too worried.

The movement of the sun and the ebb and flow of the crowds of visitors brought a procession of possible subjects and later in the day the piggy-back riders were jotted down in a sketchbook for future reference.

It is often best to go into this sort of situation with an open mind about what you're going to paint and just record whatever comes along. Once, I remember painting in deep countryside when two hot air balloons glided past at low altitude and completely transformed the view.

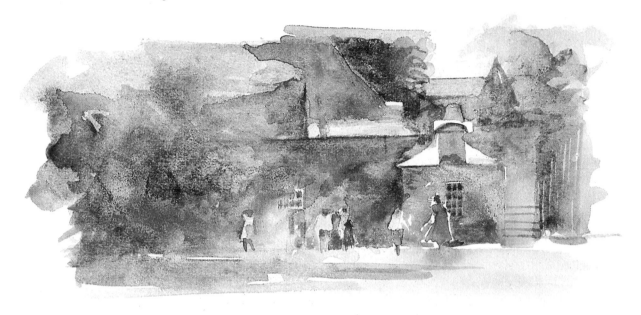

A small watercolour showing the courtyard and the Château beyond.

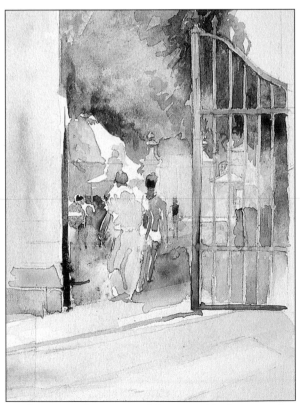

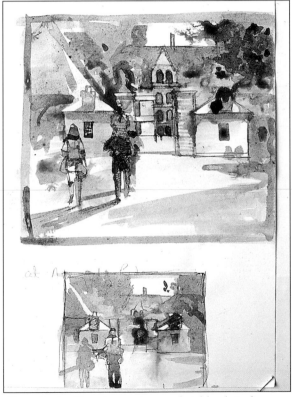

Looking into the courtyard from outside the gates. I had to stand in the road to draw this.

Piggy-back riders drawn in my sketchbook in brown ink, washed over before it dried to produce tones.

Preliminary stages

Now, with all the drawings and sketches spread out on my drawing board, it's time to make some decisions. The little watercolour gives me the positions and poses of the cyclists and their bicycles but another composition sketch moves my viewpoint to the left in the way already described. I have taken the proportions of this drawing and prepared a painting board in the same way as described in the second project. As I want to make accurate use of the composition of this drawing I need to transfer its design accurately to the board. For the sake of the clarity of the photographs in this book I have decided not to put a wash of oil colour across the hardboard panel, although this would be my usual way of working.

Gridding-up a drawing

There are times when having drawn a subject very painstakingly it may be necessary to transfer the drawing to another sheet of paper or a canvas and to change its scale. In these circumstances, knowing how to enlarge accurately and easily is a valuable skill.

There are several ways of doing this, but I think the way I give here is the most foolproof, as well as eliminating the need for a lot of measuring and arithmetic.

To begin with, ensure that the drawing to be enlarged is perfectly rectangular. Rule a line around it to frame it if necessary. Next, use a ruler to draw the two diagonal lines. These two lines establish the centre of the rectangle. A vertical and a horizontal line can now be drawn dividing the rectangle into four. The positions of these lines where they cut the edges of the rectangle must be checked by measuring, but no further measuring is necessary.

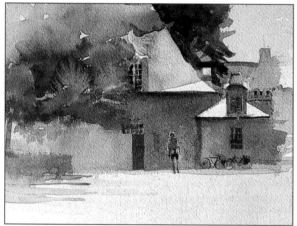

Reflection glares off the steep roofs in high sun.

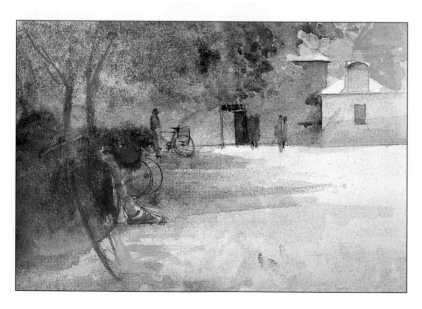

The cyclists relax under the trees, positions not quite as I want but I've got my subject. On its own this drawing wouldn't be quite enough, but in combination with all the others I have enough to work from.

The first stage, a diagonal cross locates the centre.

Keep adding verticals, horizontals and diagonals.

More diagonal lines are now drawn into each of the four smaller rectangles, with horizontal and vertical lines drawn through the intersections.

The procedure is then repeated so that an 8 × 8 grid is produced.

Next, place the drawing onto the bottom left-hand corner of the new surface upon which you will be working. Lay the ruler along the long diagonal of the small drawing and extend it across the new sheet. Your new rectangle can be drawn anywhere on this diagonal line and will be the same shape as the original. Repeat the entire process onto the new surface, copying the section of the drawing contained in each small rectangle into its new space.

On a very complicated drawing it may be helpful to draw more grid lines, but 8 × 8 is usually enough.

In this case I have transferred the 8 × 8 grid and the line drawing onto the muslin-covered board using a stick of charcoal. On completion of this stage I have sprayed it lightly with fixative and then continued with the charcoal, building up the main masses of tone so that I can have a look at it now that the image is enlarged. Now that I've had a chance to assess

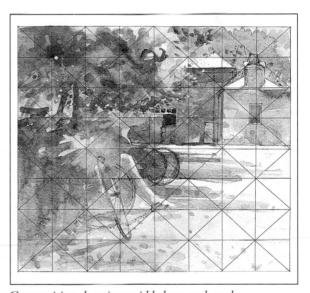

Composition drawing gridded-up and ready.

progress I dust off all the surplus charcoal leaving a faint image on the surface of the board. It's not a good idea to allow the charcoal to build up too much as this would prevent the paint from 'taking'.

The first session

This is the first of several sessions on this painting. I shall develop the painting as far as I

The main lines of the composition drawn on the board in charcoal.

Most of the charcoal is then wiped off, leaving only a faint image.

I start to paint, using thin washes to block in the composition.

reasonably can today, then allow it to dry completely before working into it again. Following the principle of working 'fat over lean' I will only use turpentine to dilute the paint today. Next time I'll add a little linseed oil or painting medium and use the paint more solidly. Remember not to get this the wrong way round; a layer of paint mixed with turpentine over an oily layer could cause the surface of the painting to crack or even disintegrate as the paint will not dry correctly.

I have washed in the shadow areas using rather dilute paint and now I can turn to the lighter areas in the foreground. It's common practice to use the paint as an impasto in the lighter areas and I think that doing this will help me to achieve a sense of the sun glaring on the brightly lit gravel. Also the thicker paint here will help to bury the grid lines!

Try to take advantage of the mobility of the paint at this stage. At no later time will it be so easy to move the paint about and make big adjustments quickly. I use rags or kitchen towel to remove paint or to lighten areas and I don't want the image to get too 'edgy' just yet. I take paint off the surface almost as much as I put it down. If you allow the paint simply to build up it can become very dead, and the areas you've had most trouble with get thicker and thicker. By taking off paint when you want to revise, the surface becomes more lively and enables you to go on working over a longer period.

It may seem rather contradictory that I insisted on gridding up that drawing as accurately as I could and yet I'm keen to get the paint moving now. Whatever adjustments I make at this stage, I can get back to the original composition should I need to as the charcoal lines are still there, underlying the paint. Also, the alteration in scale will make some changes inevitable, and by allowing the paint to move at this stage I can quickly get the composition visible and into a state where I can consider its future treatment.

Developing the image

I think the most important thing is to establish the entire image quickly and to try to develop it as a whole, never being in too much of a hurry to finish a particular area. It has become obvious that the horizontal marking the bottom of the buildings is too near the mid-line and looking back at my other drawings I see that the buildings themselves have become too tall. It is a very easy matter to correct this by moving the line upwards.

As I develop the painting through these early stages, I'm using a somewhat simplified palette which enables me to establish the main tonal pattern: yellow ochre, terre verte, French ultramarine, Venetian red and titanium white are enough for now. I will add other colours as the painting demands.

The grid-like structure of this composition could become rather over assertive, so must be countered by the more broken line of the trees and the tangle of figures and bicycles. Also, one of my watercolour studies shows a lot of green

light being thrown into the shadows, reflected from the trees. I want to try to keep this quality in the oil painting as I feel it gives a degree of unity to the lighting.

There's still a lot to do. I don't want to overdo this and explain too much at this stage but it must make sense spatially. I want you to see that there is a foreground here, that there is a clutter of things in the middle distance and a

Here I am beginning to use the paint more solidly. The lighter areas can be painted opaquely now.

By this stage the main structure of the painting has been blocked in. Adjustments can be made very quickly at this stage as areas can be wiped out or moved.
The base line of the building is clearly too low at this stage and will need to be pushed up.

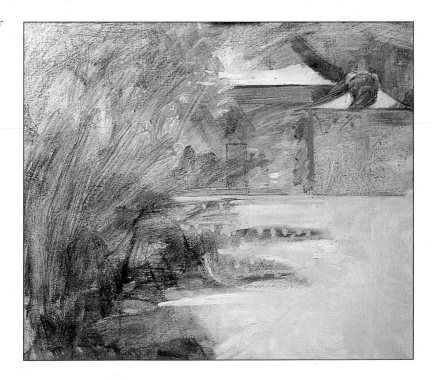

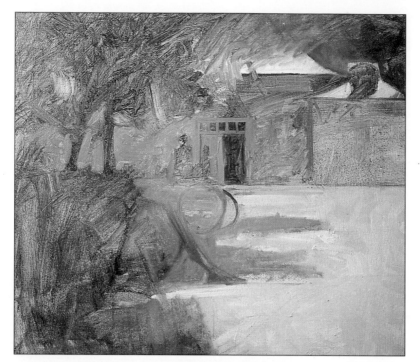

Starting to introduce more colour, I also begin to place some of the more important details such as the position of the trees and figures as well as some of the architectural features of the building beyond. The way the light bounces around within the subject interests me and I am beginning to suggest the green reflected light across the wall on the left.

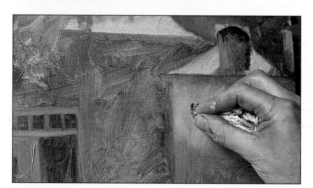

Using tissue to lift off unwanted colour.

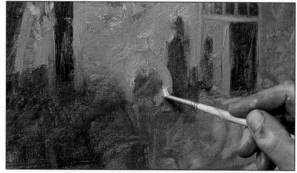

Beginning to define the positions of some figures.

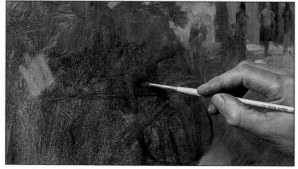

Using a small brush to start to indicate the cyclists

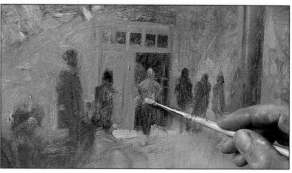

. . . and another figure in the doorway.

By this stage most of the composition is established and from now on the adjustments will probably get smaller. The trees need darkening a little and the shadows across the gravel will be worked on further yet. The figures in the shadow on the left are starting to appear but I don't want them to be too emphatic and to some extent they can remain lost in the shadows.

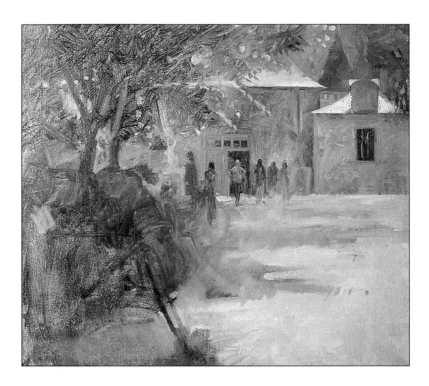

building at the back. I want the space to be as clear as I can get it, without over-explaining all the little details.

Adding the figures

Figures can be put in in a provisional sort of way at this stage. It's more important to decide where they are going than to finish them.

The first day everything goes very quickly, then things slow down, because very often you reach a point where you are 95 per cent there, and if you go too fast, you may overshoot, and then there is a problem of recovery.

The end of the first day

It's impossible to say how long a painting like this will take to complete. In my own case a painting this size is sometimes completed quite quickly, within perhaps three working days. Sometimes it takes much longer, a year or more would not be unusual.

The painting has to be left to dry completely before another day's work can be done. Some

colours dry faster than others. Earth colours dry fairly quickly, but some of the reds take days, and titanium white, for example, is very slow-drying and will need to be left for a week or more after this first day's painting. If you leave it for just a few days bits will be dry, other areas completely wet, and some areas (neither wet nor dry) will be like porridge. In this state, it is impossible to get the paint to sit crisply on the surface beneath. The whole thing moves and drags and starts to tear the partially dry paint. A paint surface abused in this way will look very tired and it may not be possible to re-vitalize it. It's much better to leave the painting well alone and let it dry completely before your second day's work.

'Oiling out'

Two weeks later I have taken the painting down for a second day's work. At this stage I have two choices. I can either start to place individual touches of paint on the by now dry surface or I can 'oil out'.

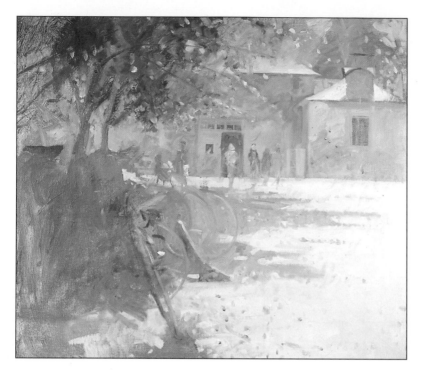

These last two pictures show the development of the painting over the next two sessions. I've tried to indicate the landscape beyond the buildings and the shadows across the gravel have received much more attention. Details like the red tape on the cycle paniers are beginning to tell but the drawing of the bicycles and figures needs further attention, even though they play a subsidiary role.

Right: In the immediate foreground I've adjusted the shapes of the patches of light within the shadow on the ground as these can help to give the composition some movement away from the horizontal.

Oiling out consists of wiping or brushing the oil or painting medium you are using over the whole surface before starting to paint. On this occasion this is what I choose to do. Mixing painting medium from the bottle with a little turpentine, I wipe the mixture all over the painting with a soft rag. The effect of doing this is to mimic the way the painting felt during the first day's painting with the whole surface 'live'.

A gap between the first and second session enables you to look at the work with fresh eyes. Take advantage of this to make decisions about what you're going to do next.

Becoming more precise

During this second day's work I'm trying to make tonal adjustments as well as paying more attention to the figures under the trees and the structure of the buildings and glimpses of landscape beyond. The trees are darkened slightly by applying a glaze of transparent colour, mostly terre verte, across this area. I also want to extend the shadows of the trees falling across the gravel in the foreground to create the feeling of looking through the dark shadow to the light beyond.

I've moved some of the distant figures about, and will go back to my sketchbook to find more. The cyclists under the trees have been drawn out rather more fully but will need more explaining before the painting is complete.

The last photograph shows the painting in its current state. I don't think it's finished yet but I'm getting closer. Remember, leave the paint to dry thoroughly between each layer and work 'fat over lean' and you can continue to develop a painting over many sessions without any loss of freshness.

In conclusion

Learning to paint and draw landscape is largely about developing two complementary skills. On the one hand is the need to increase your awareness of what you are looking at, and on the other is the recording and communication

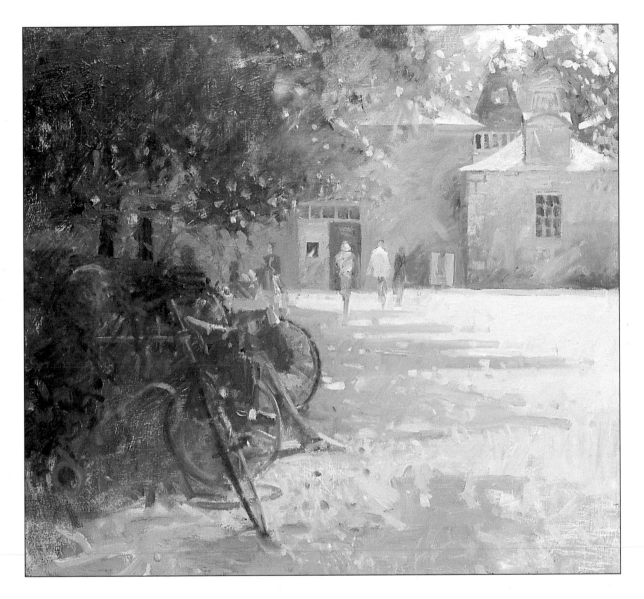

of those sensations through the use of a variety of materials. This section, like the others in this book, has sought to do both of these things through exercises and projects which have been designed to build on what you know, as well as teaching a range of new skills. Above all, don't be afraid to experiment even if at first you find the results rather unsatisfying. Gradually, if you keep practising, things will begin to fit together and you will find that your confidence and ability grow together.

I have always felt that cultivating the ability to look is more important than learning techniques, although the more you begin to see the more ways of recording the information you'll need. To see properly it must be as if you are always looking for the first time. The other day, playing with my children in the garden, I swung my head down and looked back between my straddled legs: one of the most familiar views that I know appeared, upside-down, suddenly alive and mysterious.

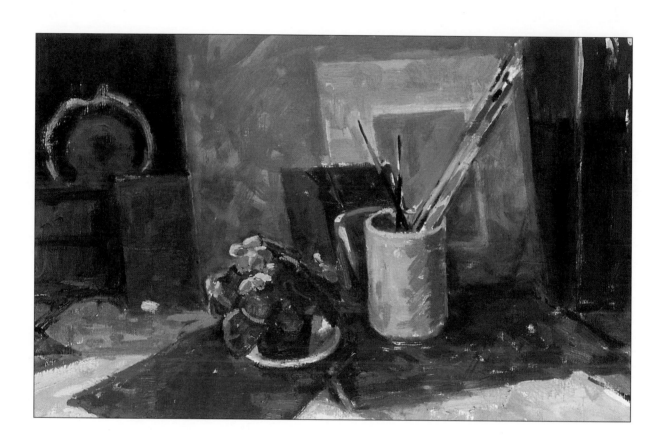

Still Life

Introduction

Still life is an ideal subject for all painters, no matter how experienced or able. It is infinitely flexible, easy to assemble and control, and is one of the best ways in which to study form, space, colour and composition. A still life can be put together from the objects about you in your home – if you look around you now, you will undoubtedly see the components of a possible composition.

In this section, I want to help you to explore basic problems in painting through a study of still life. To get the most benefit you should do the practical work, but don't simply copy the exercises and step-by-step projects. You will learn much more by assembling similar subjects and working through the processes that I describe.

In the chapters that follow I have assumed a basic knowledge of the different media, and of painting and drawing techniques. Although I have used a variety of media for the exercises and projects, and although I discuss the qualities of each medium and give advice where appropriate, media techniques are not my primary concern.

Instead, I deal chiefly with two problems which preoccupy most artists. The first is how to create a three-dimensional space on a two-dimensional surface and I return to this again and again in the chapters that follow. The other is 'composition', in other words how to create a picture which is more than a mere copy of reality, which combines the elements of the painting into a unified whole. In the last chapter I consider still life as a trigger for imaginative and experimental work. Above all, I want to help you to use still life as a way of studying, exploring and understanding the world in which we live and your reaction to it, and in that way to help you develop your own unique artistic vision.

Paul Cézanne 'Still Life with Water Jug' 530×711mm ($21\frac{1}{4} \times 28\frac{1}{2}$in). In this very beautiful painting, the development and composition can be recognized and studied. Successful integration of the various objects to create a balanced whole necessitated some distortion of the elements – the plate on the left for example is not a perfect ellipse, but distorted so that it echoes the shape of the water jug, as do some of the fruit which are similarly 'adjusted' from their true forms. This repetition of shapes in different sizes is underpinned by a grid of related and right angles – a line continued from the knife on the right, for example, forms a right angle with the line to the right of the jug.

An introduction to colour

Colour is probably one of the easiest ways we have of identifying an object. We find it much easier to understand what something is when we see it in colour than when we see it in black and white or tone. The examples on these pages show colour used flatly, without modelling. The point of the exercise which follows is to look at the colour of an object and ignore the tone – it is not recommended as a way of painting, but is simply a project to teach you about colour.

I selected a variety of small and readily available objects for these studies. Because I wanted to look at colour without being confused by form, I chose objects that were flat or that could be sliced. Then I painted them by selecting areas of colour and mixing paint to match those colours as closely as possible.

Using colour

Painting is about colour on a flat surface. You use paint to describe what you see and to express what you feel, but in order to do this effectively you must first learn about the colours on your palette – how they look when you apply them to the paper or canvas and how they can be mixed to reproduce what you see.

There are several aspects to the study of colour. The science of colour looks at the way your eye perceives colour and how your brain interprets that information. This is an enormous subject area, involving many disciplines, including physics and psychology. It is not necessary to get too deeply involved in it at this stage, but we will look at some basic scientific principles when we study the colour wheel and the tonal scale on pages 86–9.

As an artist you also need to know about pigment colour, and about the way paint can be mixed, handled and applied to a surface so as to reproduce what you see, or express what you want to say. At the very simplest level you should become familiar with the names of pigments and the way they look when applied either thinly or thickly. You need to understand how pigments can be mixed to create new colours, and how to achieve particular effects by applying paint in certain ways. Some knowledge can be acquired from books, but most is gained by direct observation, by

painting from life and by doing exercises such as the one that follows. The subject is infinite, and even after a lifetime of study most artists are still learning.

Another effective way of enhancing your understanding of paint and colour is to study the work of the great artists. Ideally you should look at their work in art galleries, but where that is not possible reproductions in books can be an extremely useful and inspiring source of knowledge. Remember, however, that in spite of recent improvements in the reproduction and printing processes, the printed image is never the same as the real thing. Apart from the degrading and distortion of the image which inevitably occur in the complex processes of recreating a painting on the printed page, you also lose important elements like texture and a sense of scale, both of which contribute a great deal to the overall appearance of a work. It is extraordinary how different paintings that are familiar in reproduction look when you actually see them in 'real life'.

Getting to know colour

People who are just starting to paint always hope that there will be a simple formula for success. Perhaps they suspect that their teachers and people who write books like this are keeping something back, that there are a few magic recipes, and if only they could get hold

of them all their problems would be over. I am afraid that is not the case. The secret of success is . . . hard work and practise.

It sounds odd, but it is actually quite hard to see and recognize colour, especially at first. You look at something – take the cauliflower on the right, for example – and you think 'That's green,' then you look at another part of the vegetable and you see another green, so you look back at the first bit and you realize it is actually quite yellow. But painting is like many other areas of endeavour, the more you practice the better you become, and eventually your eye will become quite adept at making fine judgements.

The primary colours are red, yellow and blue. But the variations on these basic colours, and the colours that can be mixed from them, are almost infinite. Take yellow, for example: it can be lemon yellow, cadmium yellow, yellow ochre or raw umber. And there are a tremendous number of 'reds'. Look at the pepper I've painted on the previous page. To paint it you would probably take a spot of vermilion or cadmium red on your brush because these are the 'reddest' reds in the palette. But you would find when you laid it down that the colour was rather too hot because there is actually a little purple in the red of the pepper; alizarin crimson, therefore, would be a much better colour to start with.

It is difficult to make these sort of judgements at first, and you will find that you continually change your mind and have to make adjustments. You need to train your eye to look and to really see, to simplify, identify and sort colours. If you persevere you will find that it gets easier to make quite precise assessments of colour very quickly.

The whole process is made easier if you select a single, simple subject, with no background and no surrounding objects to confuse you. That is what I have done in the studies on these pages and in the exercise that follows.

More colour exercises, again of everyday objects that are simple in form, painted to explore the colours

they contain, and ignoring lights and darks. Take care when mixing – the more colours you mix together, the more muddied the overall effect tends to become.

Project: Simple colour exercise

This is a very easy exercise to introduce you to some of the concepts we'll be discussing later. Start by selecting a small, flattish object – sliced fruit, vegetables or plant forms make good subjects, but you can choose anything that is simple in form. It should be flat because at this stage we do not want to deal with shadows and the problems of rendering three-dimensions on your two-dimensional paper.

You will need
- ☐ a drawing board with stretched paper
- ☐ two jars of clean water
- ☐ paints
- ☐ brushes
- ☐ a white plate or palette

Choosing a subject

I chose a red pepper for my demonstration because it is interesting in both shape and colour, and, because it is small, I could put it near me. I have sliced it in half so that it does not have great depth, yet it has texture, is simple to draw and includes the complementary colours red and green. I placed it close to my board so that I didn't have to move my head much – I could study an area of the pepper carefully, then mix the paint and put it down on the paper without taking my eye away from the subject for very long. In that way I was able to concentrate completely on the colour. You will probably find it useful to have a piece of scrap paper by your side to test your colour mixes on before you commit yourself to putting them on your paper.

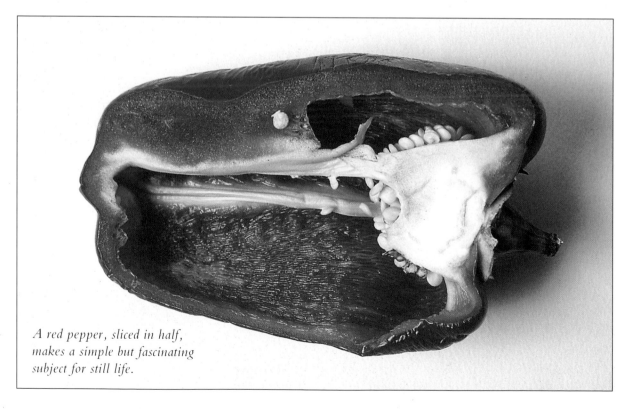

A red pepper, sliced in half, makes a simple but fascinating subject for still life.

Keep it simple

The purpose of this exercise is to get you to look at colour, so it is important to keep your colour fairly flat. At this stage you are not concerned with creating a picture – so don't worry about what the final image looks like. The process itself is much more important than the finished work. Ignore detail, just try to see colour and mix it as accurately as you can. You will not get it absolutely right at first, but try painting the same object several times. When you get bored with that, select another object. Work at this exercise over several days and return to it from time to time so that you become aware of the improvement in your observational skills.

Colour is not a subject which you can hope to master quickly, it is one which will occupy you for the rest of your life. Just as the pianist has to practise his or her scales, or a ballet dancer has to work continually at the barre, so you will have to study and practise to develop your knowledge of colour and the skill with which you handle paint. Colour and colour mixing are part of your basic vocabulary as an artist. Eventually they will become largely intuitive, but in the meantime I'm afraid it is rather hard work – but fun.

For this exercise I suggest you use watercolour, gouache or acrylic paint: acrylic is possibly the easiest medium at this stage as if you change your mind about a colour, you can correct it by overpainting.

You will learn the names of your paints and the way they mix if you are consistent and methodical. For example, start by laying your paints out to an order on your palette or plate; keep to this order until you find it is no longer suitable, then experiment with a different one. There are many theories about arranging the colours on your palette, but possibly the simplest is to work from white to yellow, red, blue, black (the colours you select will be determined by the subject and the medium).

Begin with a light drawing, using thin paint and a small, pointed sable brush, to define the shape of the object. I started using alizarin crimson.

The demonstration here, and the illustrations on the previous pages, are only a guide and are not intended to be copied. Find your own subjects for still life and try to paint the true colours of the subject, to see it freshly, and simply as a shape of colour.

Starting the exercise

A pepper cut in half makes an excellent subject: it is small, the shape is simple and the colour is glorious! Study the photograph on the facing page carefully. It is not just red – there are lots of reds in it, and other colours too. The more you look, the more you'll see.

As you will be painting on white paper it is a good idea to lay your object on a white surface. I have placed mine as close to my painting as possible, so that I only have to move my eyes, not my head. In this way I can really concentrate on the object. I start by making a simple outline drawing using thin paint. My palette of colours and all my materials are close to hand. As you can see, it doesn't take up much space. This is a major advantage of the study of still life – you can set it up anywhere, even on your kitchen table.

Blocking in colour

The whole point of this exercise is to paint what you see, rather than what you know is there. If you do this properly you will often be surprised to find that the colours that you see are really not what you expect them to be. Lay them down exactly as you see them. It's best to limit your palette to just a few colours and really get to know them, to understand how to mix them, and the effects you can achieve with them. On my palette I have primary red (spectrum red), cadmium scarlet (scarlet lake), orange red, cadmium yellow (deep), permanent green deep and a white.

You have to mix colours. You can't expect to have every colour in your box, so mix them on your palette as you go. If you can't get the right colour at first, try again. Test the colours on a bit of scrap paper before you transfer it to the paper. Be prepared for the fact that when you put the paint onto the painting the colour which looked right on the palette may look wrong. This is because colours are affected by the colours alongside them. Getting the right colour is often a matter of trial and error.

I'm using gouache, which is easier than watercolour because it is opaque, which allows you to overpaint. Acrylic is even easier to use because it dries quickly and you don't have problems of paint running that you do with watercolour. Acrylic and gouache colours, however, don't dry as true as oils, for example. Gouache dries rather darker. These are things you will learn as you go along. As with every subject, the lessons you learn for yourself always stay with you more vividly than those taught by other people.

In the pictures on this page you can see that I've started laying in colour – I've used primary red with just a touch of green to darken it. The darkest areas of the pepper are put in later with burnt umber with a little alizarin crimson. This will have the effect of picking the drawing up a little bit as well.

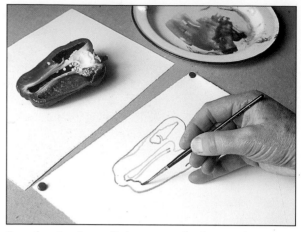

Start by simply outlining areas of colour with your pointed sable brush.

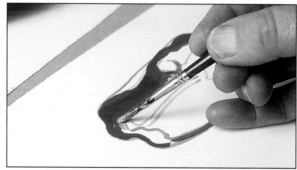

Begin blocking in the largest areas of colour. Use a fairly large brush, a no. 6 for watercolour or gouache, and a no. 5 hog hair (white bristle) for acrylic. Mix the colours as you go.

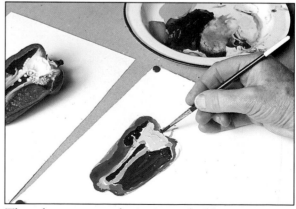

The colour areas are beginning to build up.

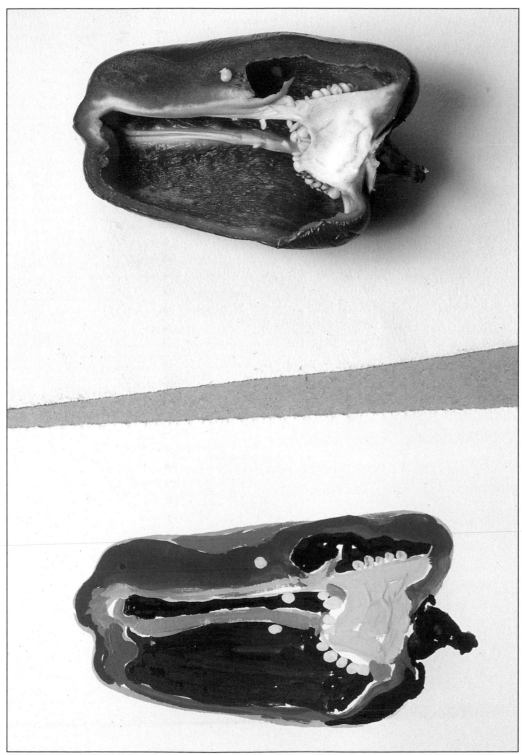

Keep checking the colours in your painting against the colours of the subject.

Finishing the painting

Putting in the final touches of colour will complete the exercise. The warm colour in the lower section of the painting is raw sienna painted into the darker area while it was still wet. The last to be painted were the lightest areas – white with a little bit of pink for the seeds and the pith. The exercise is now complete, and it should have taught you a lot about the properties and use of colour.

Earlier, I talked about different media, and while there are variations in the ways in which media handle, which can affect your painting, sometimes the importance of the medium is overemphasized. As long as you can draw, it doesn't matter what medium you use. Equally, people are sometimes concerned about equipment and materials. It makes sense to use the best that you can afford, but what you do is more important than what you do it with.

For this exercise I used a no. 4 brush, made from synthetic fibres. These brushes are cheaper than sable, and just as good in many ways, though they don't last as long. A word of warning: never use your best sable brushes if you are working in acrylic. It dries very quickly and will ruin them if you are not careful.

Learning to see

When you are doing simple exercises such as this one, probably the most important 'mistake' many amateurs make is to hold fast to the notion that they are producing 'a picture'. You are not: what you *are* doing is teaching yourself to see things in a new way, and what you learn in the course of the exercise is far more important than what you produce at the end.

Remember that in this exercise you are looking for pure abstract colour. Don't worry about shadows, tones or where you place the

The finished painting should resemble the colours of the original subject as closely as possible.

When you paint on a small scale like this, use your wrist, not your arm. Here you see I am using my little finger to steady my hand.

The palette is important – it is where half the work goes on. As you can see, I've experimented and mixed my colours from a very limited palette.

object in space (in other words, composition). Of course, all these factors must be taken into consideration when you are producing a painting, but they are not relevant for this exercise. Try to see not a pepper, or whatever you are painting, but simply an abstract object sitting in space.

Mix your colours and paint broadly. Start with the largest areas of colour and use a fairly large brush. I used a number 4 in my painting, but it is better to work with a brush which is slightly bigger than you would normally choose – it will stop you fiddling.

Remember to keep on cleaning your brush. Use one jar of water for cleaning the brush and the other for mixing with colour.

Avoid the temptation to 'finish off the painting'. Try not to get too enthusiastic over

detail, since the exercise is simply to match the colours of the object. As I've said before, the point of the project is what you learn along the way, not what the finished picture looks like. It doesn't matter if it is a bit untidy and the paint goes over the edges. If you get the idea firmly into your head that this picture is not going to hang on the wall, or even to be seen by anybody else, you will work much more freely. Undue time spent in worrying about the finished object can be a real impediment to doing good and useful work.

Finally, do repeat this exercise from time to time. Not only will you find it sharpens your colour perception, which will ultimately bear results in your painting, but you will also find that it makes a refreshing change from producing a finished work.

Colour and tone

The way we respond to colour is very personal and ultimately an artist has to decide for himself which colour arrangements work in his painting. However, a basic knowledge of the way we see colour and the way colour works will help you to control the colour in your paintings.

Some definitions

It will help if right from the start you understand some of the terms commonly used in the discussion of colour.

Hue is a specific colour, for example, yellow itself. The colour wheel on the next page shows twelve hues.

Chroma, or saturation, describes the intensity or purity of a hue. On our colour wheel the hues are at their maximum intensity.

Tone, or value, describes the lightness or darkness of a colour. Every hue has a tonal value. The tonal value of any hue can be modified, or diluted, by adding white to make it lighter or black to make it darker. Judging the tonal value of a colour is difficult, but with practice you will become better able to make these assessments. Half-closing your eyes will help you to concentrate. If, for example, you study the colour wheel through half-closed eyes, you will find that the yellow is the brightest in tone, red is darker, and purple is the darkest of all.

The uses of colour

The painter works on a two-dimensional surface. One of the many problems of concern to artists is that of creating an illusion of three-dimensional space on the flat surface of the paper or canvas. There are many devices which you can use to achieve this illusion, but some of the most common are perspective, light and shade, colour and texture.

The use of colour to render space and form is described as constructive – the artist uses colour to construct an illusion. An example of the constructive use of colour is aerial perspective (see page 96), in which the artist uses cool colours and diffused forms to make the background of a painting recede, while warmer colours and crisp edges are used in the foreground to bring that forward.

Artists are always conscious of the flat surface on which they are working. Sometimes they may want to draw attention away from the flat surface by creating an illusion of space on the paper or canvas, but at other times they might choose to remind viewers that they are indeed looking at a two-dimensional surface, thereby highlighting the inherent contradiction in this art form.

In the nineteenth century, this contradiction was probably most apparent in the work of Paul Cézanne. He wanted to compose pictures that had a structure of colour and form that was classical in conception. He did this by constantly adjusting his colours so that they matched those of nature, but also within the unity of his own colour composition – since all is in harmony in nature, then all would be in harmony on his canvas. In addition, he often exploited the qualities of brushwork, using small parallel strokes which together gave the impression he was using large square-ended brushes (this is particularly apparent in his many paintings of Mont St Victoire in his native Provence). He used colour and tone to manipulate the construction of objects in space – warm,

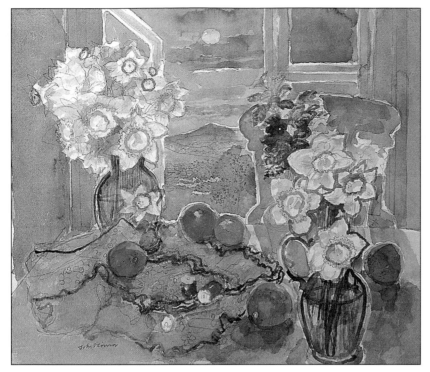

John O'Connor 'Spring Evening' 420 × 480mm (16½ × 19in). This watercolour illustrates the expressive use of colour: the artist is less concerned with space than with the rhythm and feeling of a warm spring evening. He uses a simple colour scheme – orange with blue, warm with cool. The colours used are friendly, the colour itself all-pervading.

Notice the simple, repeating shapes – the circular oranges, daffodils and the sun – and the way they are held within the painting. The artist uses pencil with his watercolour and outlines objects, using colour around the various elements to lead the eye around the images.

pinkish-yellows to pull the areas of his image on which light falls forward, and cool blue-violets to make shadowy areas lie back. This concern with planes, colour and volume is what gives his work its monumental qualities.

Colour can be used, not only to describe the surface appearance of something, but to generate an emotional response, a feeling. This is the expressive use of colour. In the twentieth century the Expressionists used colour and forms to express individual, emotional and symbolic ideas. For this reason, the forms they used are often contorted, and the colours lively and forceful, sometimes even violent.

The Expressionists disregarded the laws of realism, thereby giving artists a greater freedom. Perspective and proportions could be changed and distorted to give a greater truth as understood by the artist. Colour was no longer bound by impressions received by the eye – it obtained a new vigour, because artists often used unmixed colours.

Van Gogh with his brilliant and often tortured use of paint was one of the earliest Expressionists of the modern movement. There are many others, including Munch, Ensor, Gauguin, the German Expressionists like Beckmann and Nolde, and some of the American Abstract Expressionists, for example Jackson Pollock and Willem de Kooning.

These two categories, 'constructive' and 'expressive' colour, inevitably overlap to a greater or lesser extent, according to the temperament of the artist.

Everybody has an intuitive response to colour – some colours make us happy, others make us sad, and we all have our favourites. The more you know about the way colour works, the more you will be able to use it and exploit it for you own purposes. Here we will look briefly at some basic colour concepts which you will need to grasp to be able to use colour with confidence; on the other hand, don't expect to make these ideas your own immediately.

Introducing the colour wheel

Sir Isaac Newton analyzed the composition of light some 300 years ago and identified the colours of the spectrum: red, orange, yellow, green, blue and violet. To explain the phenomenon of the colour, he devised the colour wheel, in which the colours of the spectrum are placed in a circle. (Many artists and scientists since have also used colour wheels to explain colour theory, but the one here is based on Newton's.)

The colour wheel is merely an aid to help you remember colours and sort out the relationships between them. The most important or 'primary' colours are red, blue and yellow. From these an approximation of all other colours can be made by mixing. Blue and yellow make a green; yellow and red an orange; red and blue make violet. These 'secondary' colours are not as intense as the original three. Mixing the secondaries produces 'tertiary' colours. These very subtle colours have similar tonal values.

The colour wheel

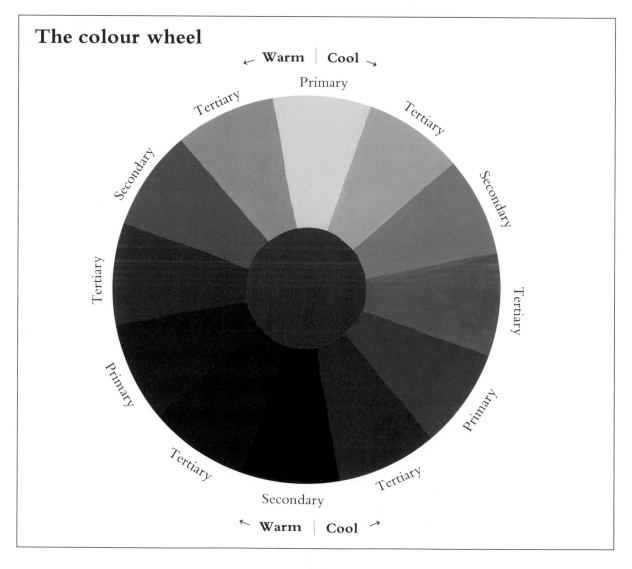

You will find it a very useful exercise to make your own colour wheel with primary, secondary and tertiary colours (hues) – similar to the one shown here. You should also make a grey scale and a colour intensity or chroma scale, as shown on page 89. Making these diagrams will also be good practice in accurate colour mixing.

Warm and cool colours

Draw a line through the centre of your colour wheel, cutting through the yellow and violet. The colours on the left (blues and greens) are known as cool colours; those on the right (reds and oranges) as warm colours.

Both warm and cool colours have special qualities which are extremely useful to the artist. Warm colours tend to advance, that is, come to the forefront of the picture, while cool colours recede, or stay in the background. Skilful use of warm and cool colours enables artists to create illusions of space.

Colours opposite each other on the colour wheel (red and green, for example) are known as complementaries, and they provide the strongest reaction when used together – they can even cancel each other out.

Colour contrasts

Colour theory can become extremely complex and absorbing, but with practice and experience, and the development of your ability to analyse the things you see, a great deal can in fact be achieved by intuition. However, an understanding of the ways in which colour contrasts can be used is important. When you are translating the visual world into paint on a two-dimensional surface, colour contrasts help to create the sensation of space and form.

Colour contrasts operate on several different levels, all of which you can exploit for your own purposes:

(a) contrast of hue
(b) contrast of light and dark (tone or value)
(c) contrast of chroma (degrees of saturation)
(d) contrast of complementary colours
(e) contrast of warm and cool colours
(f) contrast of texture
(g) contrast of proportion of colour area

Contrast of hue and of light and dark

If the pure, saturated hues of the colour circle are placed against one another they will contrast in colour and in tonal value. The light/dark contrast operates as strongly within one area of colour, for example, light and dark tones of blue, as between blue, red and green.

Contrast of chroma

This contrast is between pure (saturated) colour and diluted colour (diluted with white or black). Diluted values appear to gain in vitality and the pure colours to lose some of their brilliance when they are placed together.

Contrast of complementary colours

Two colours that are opposite each other on the colour wheel, placed together, will create maximum vitality and vividness.

Contrast of warm and cool colours

As we have seen, the colour wheel divides into warm and cool hues. But while every colour appears to have a temperature value, this is not constant; for instance, a red will look hotter when it is surrounded by cool colours than when surrounded by more reds or oranges.

Contrast of texture

The quality of any colour can be affected by contrasts in the texture of the pigment used. Imagine a thick impasto next to a thin wash, a pigment textured with sand against a smooth colour, or paint applied with a palette knife against pigment applied with a brush. All produce wonderful contrasting effects.

Contrast of proportion of colour area
Large, simple areas of colour contrast with small, broken-up areas. This important relationship changes chromatically if the proportions are reversed.

Visual and optical phenomena

Besides the contrasts described on the previous pages, there are many other visual phenomena relating to colour that are important to the artist. The eyes can induce colour where none exists, depending on which hues are placed next to each other. A great colourist like Matisse – whose major concern was to use colour for its own sake, subject only to the harmony he created within a work – could so balance two colours that they cancelled each other out, then place a small area of a third colour to take all the attention.

If you look for a long time at a red circle, then turn your eyes to a white wall, you will see green spots, green being red's complement. This phenomenon is known as successive contrast. The painter Bridget Riley exploits this in her work, making colours move and appear to change.

The eye can mix colours together and see a new colour. Small dots of, say, pure blue and yellow placed closely together blend in the eye to read as a green. This was one of the theories of the Pointillists and was most fully developed in the work of Seurat, who may well have been influenced by contemporary improvements in the printing process in which this method of colour mixing was used.

In a broader way the Impressionists did a similar thing, by breaking one pure colour over another so that small areas of the colour underneath showed through to give a scintillating effect. The paint was applied with dots and dashes, using a juxtaposition of complementary colours.

Some helpful hints

While a knowledge of colour theory is useful, intuition and experiment play a great part in giving you the effects you want. It is when things go wrong or a painting doesn't seem to be working or looking 'right' colourwise that these colour theories offer guidance. Looking at the colour wheel can sometimes answer the problem. The following suggestions may give clues or serve as useful tips; they are not intended as rules.

(i) Wholly harmonious colours (those that are adjacent on the colour wheel) tend to produce monotony. If you look at a landscape which is predominantly green everywhere, the eye gets tired of seeing so much green and longs for a little bit of red – which is green's complementary colour on the wheel.

(ii) A painting in which the warm and cool colours are equally balanced tends not to work very satisfactorily. The mood or feeling of a painting usually demands a definite warm or cool predominance to give it conviction.

(iii) In most colour compositions some subtle, neutral greys are needed to unify the painting, and to provide a foil for the stronger hues. If strong, dominant hues are used throughout, the eye becomes tired and the effect can often be garish.

(iv) Consider edge qualities. Strong tonal contrasts and sharp edges come forward, whereas soft, diffused colours lie back. This is used in aerial perspective to give a feeling of space and distance. In some more abstract paintings all the edges are deliberately kept hard in order to flatten the form and create a two-dimensional pattern.

(v) It often helps to unify a painting if the colour is distributed in such a way that the eye moves from one colour to another. This also helps to break up the 'local' colour of objects. Local colour is the colour of an object if you ignore the effects of light and dark on it.

Tonal scale

Colour intensity

Light tonal value

Colour selected from the colour wheel

warm, related colours with lower intensity

neutral grey

cool, related colours with lower intensity

complementary of red

Dark tonal value

Each colour on the scale has a tonal value, from the pale lemon which reads as almost white, to the dark purple, reading dark grey.

By increasing the proportion of green to red the intensity of colour is reduced until equal quantities of the two colours produce a neutral grey.

Project: A tonal study

The purpose of this project is to help you 'see' tone in order to better assess the balance of a subject which is in colour. It is all too easy to see a painting at only one level – in terms of colour, shape and the accuracy with which the subject is rendered. But actually a painting is like an orchestral piece with several different themes going on at the same time, some of them more obvious than others. The term 'tone', or value, describes the lightness or darkness of a colour. People sometimes confuse this with light and shade, the amount of illumination on a subject. A simple way to understand tone is to think of a colour photograph of a scene, and then imagine that scene rendered as a black–and–white photograph.

You will need
- [] paper
- [] charcoal
- [] a putty rubber (kneaded rubber eraser)

By reducing a subject to tone, you can better see the distribution of lights and darks, without being dazzled by the colour itself.

The importance of tone

Surfaces with the same tonal value will appear the same shade of grey in a black–and–white photograph, even though they are not the same colour. It is important to recognize tone and to be able to manipulate it because it will always be there in your composition, as a sort of sub-text. If you feel a composition is unsatisfactory, it may be worth examining the tonal relationships – they may be unbalanced (in fact many artists make a tonal study of their still life before embarking on the final painting and you may find it worthwhile doing the same).

As with the previous colour project, there is no short cut to an understanding of tone. I can share with you all I have learned over the years, but it is only by looking, seeing and understanding for yourself that you will gain a thorough knowledge of the subject which will allow you to use it in your work.

Looking for the tones

For this project I have chosen to use charcoal. It is an ideal medium for this sort of exercise, since it is a tonal rather than a linear medium – and you can erase and lighten it very easily. You could work with pencil, pastel or paint, but try charcoal first, as it is simple to use.

We have black and we have white, and it is the range in between that we're concerned with. For the beginner it can be difficult to see the tones, as the colours confuse the issue. Here, for example, the orange is a very bright colour. So ask yourself – is it brighter than white? Which is the darker of the two? When you are considering colour and tone it is hard to see one or the other on its own. You can only judge a colour by seeing it in relation to another colour. It is much easier if you take a sequence of two or three colours, then you can compare and contrast them. That's white, that's a little bit darker, that's darker still, is this as dark as that? Look at the apple in the photograph – is that darker than the orange? I'm talking about simplifying the tonal value. You must go around the subject comparing, contrasting, checking, analyzing, looking for similarities. No one colour or tone is right or wrong on its own; each works in relation to the other colours or tones present.

A putty rubber (kneaded rubber eraser) is very useful for this exercise, since you can shape it and use it to flick out little highlights. An ordinary India rubber (eraser) is too coarse to use for this: you cannot achieve enough of a point on it.

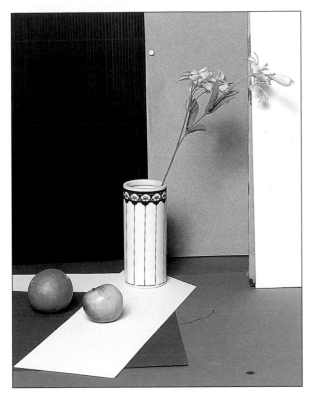

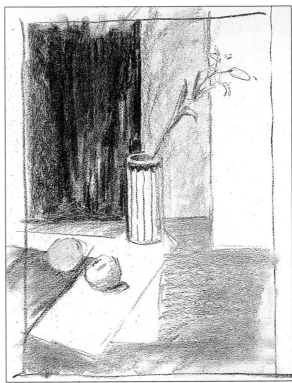

Thinking about tone

The black-and-white reproductions you see in newspapers and magazines are invariably describing something that exists in colour, but they are translated into various tones. Yet in our minds we associate those tones with colour: if there is a light colour in the background, representing the sky, we assume it is blue, to take a simple and obvious example. Black-and-white photography is such a stimulating medium for this reason – it gives the viewer scope to interpret.

You can make this exercise slightly easier for yourself by choosing subjects which are not highly colourful. If you choose a lot of brightly coloured objects which are very nearly the same value of hue, it is very difficult to decide on the exact tonal value. This group here is pretty simple in this respect. In any case, this is not a one-off exercise. You can try it again and again, with different subjects.

One advantage of thinking in tone is that you can consider edge qualities. Here, for example, the apple is the nearest thing to us, so you'll want to paint it with very clear, crisp edges to bring it forward. Objects that are farther back in the plane of the picture should be painted with softer edges. This helps to place the objects in their relative place in space. You will see where the vertical line of the vase fades into the white card, that the sharp edge of the apple picks up against the white and brings the eye forward. If you think purely in terms of white card, green apple and patterned jug, you might be less conscious of these edge qualities.

You can do this tonal exercise by numbering the tones if it helps – so white could be one, and something slightly darker could be two, and so on. At first the process is rather slow, but as you become more experienced you become more adept. Working with tonal values eventually becomes second nature.

Light

All the images we see are composed of reflected light – without light we see nothing. We need light to reveal form, so the direction of light is important. If the light falls on an object from one side, it catches only certain aspects of the form, while the rest remains dark. On the facing page you will see that some of the photographs tell us more about the object than others. The lights and darks we see on an object are one of the means by which we interpret what we are seeing.

In these photographs, light is used primarily as a means of expressing form, but you should also remember that the direction from which light falls produces shadows of different shapes and sizes. Careful choice of lighting position can help to facilitate any problems you may have initially in rendering convincing shadows.

Organizing the light

Still life painting has an advantage over landscape painting in that the light is reasonably constant, but in both subjects light very rarely comes from one source only: reflected light almost always adds another dimension.

The Impressionist painters only worked on the same piece for a short time each day so that they did not get confused with the changing light and colour, as well as changing shadows. So if you are painting near a window, unless of course you are lucky enough to have a studio that faces north, bear in mind that the light during the morning will be very different from that of the afternoon.

In the photographs on the facing page we have taken a simple subject – a white jug, against a white background – and lit it to show just how important the lighting is.

Light and shadow

Light and shadow can create atmosphere and drama in a painting.

Shadows are significant if you are painting objectively: they make shapes that are as important as the objects which cast them (sometimes, in fact, more so); they define the three-dimensional quality of an object and clarify its form; and they add to the overall tonal pattern of the painting.

If you are painting outdoors or by a window, remember that sunlight produces shadows that are more clearly defined than those produced by artificial light. You may, for this reason, find it easier initially to work with shadows cast by artificial light, which you can manipulate to a certain degree.

In arranging the lighting of a still life group, it is always a good idea to experiment with the source of light first.

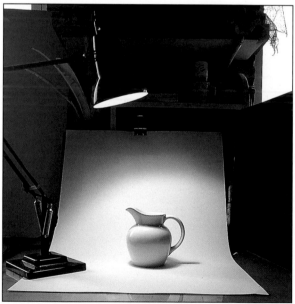

Set up an arrangement as above using a desk lamp with a flexible arm to illuminate a simple object, such as a kitchen jug. Use a reasonably thick white paper as background.

92

General illumination from the front flattens the subject. The complete lack of shadow makes the jug nearly indistinguishable from its background.

Low, directional light from the left creates harsh but dramatic shadows and silhouettes but gives no indication of the object's three-dimensional shape.

Softer light beamed from a lower angle gives a very strong and interesting silhouette but the jug's curved outline has still not become apparent.

Backlighting from a higher angle puts the upper edge in shadow and gives a more dramatic form; the most useful for painting.

A three-quarter horizontal light from the front creates a theatrical effect, with interesting shadows, but doesn't explain the shape.

Overhead lighting creates a strong silhouette, but the shadow thrown is confusing and appears to be part of the object.

Drawing and composition

Drawing is undoubtedly of vital importance to any painter, but sometimes students study drawing skills to the exclusion of 'seeing'. I believe drawing and painting should develop side by side. The practice of drawing involves many different mental activities: seeing and understanding, memory and discipline; it is a very personal form of study. I strongly recommend using a sketchbook, but the word sketchbook itself is misleading: drawing is the most convenient way of exploring the visual world and your own ideas and feelings about it. Perhaps the words study book are more appropriate.

A successful composition is one in which all the various elements, although they may well 'read' individually, are also combined into a unified and satisfying whole. But this too is closely linked to the whole purpose of the painting: the expression of the artist's ideas.

Charles Bartlett 'Blue Wallpaper' 290 × 380mm (11½ × 15in). This simple painting is very striking because of the way the picture area has been broken up: the relatively small still life at the top is balanced by the large, patterned area at the bottom. The painting has some interesting compositional factors: the shelf is approximately two-thirds of the way up the composition, and the red jug, an important focal point, sits about two-thirds of the way along from the left.

The value of drawing

Everyone 'sees' to some extent and in general terms, but the artist 'sees' in a particular way: he develops a personal vision which is directed to some form of visual expression. Good drawing is fundamental to all forms of painting; and since drawing is simply another way of communicating information, it can be learned to a degree, just as writing or speaking can be learned. The idea that the camera can replace drawing is a complete fallacy, since the camera is in no way selective and records only light and dark and colour.

In still life painting, you will probably use drawing to explore your subject and identify in it the elements you might use in the painting. These preliminary drawings do not have to be in pencil; you can use wash, charcoal, pen and ink or any other medium (or combination of media) you feel comfortable with.

These studies will help you to become familiar with the subject and help to clarify in your mind how you are going to tackle the actual painting.

The study of composition

A subject like composition is capable of almost limitless extension and I can give no more than a brief introduction to it here. But still life groups are particularly relevant when studying composition and the understanding of some theory will help you to carry out the study in a practical way.

In the two projects that follow, we think carefully about the organization of the still life group, and the way we can 'make' or 'compose' a painting.

Using the picture area

One of the fundamental elements in composition is the realization that you have four straight edges (two vertical and two horizontal) and four right angles to the rectangular surface area of your picture. Your design must take these into consideration. The moment you draw anything, the dynamics of composition assert themselves. The forces brought into being are the energies which

operate between the mark or line drawn on the paper and the containing sides and corners of the rectangle. Your subject has to be organized so that the various dynamic forces created within the picture rectangle are held in equilibrium and everything looks in balance.

The way in which you divide up the picture area is important because it determines the proportions that make the first impact on the eye. There are some fundamental laws of proportion in nature and these have been used by artists throughout the ages.

You will find it a useful preliminary study to make abstract subdivisions of a given rectangle, noting which proportions work best in terms of balance. It is also interesting to experiment with arranging different shapes within a rectangle. Try producing several balanced designs using different sizes and shapes of contrasting tone, distributed in various ways. To do this, cut up

newspaper photographs or sheets of grey paper and paste them down.

Direction and movement

Line direction plays an important part in composition. Static and dynamic shapes are another factor that the artist needs to understand. Everyone knows that horizontal lines create a static feeling of stillness, tranquility and peace, whereas diagonal lines suggest movement and excitement. Straight lines can create tension or direction, whereas curved lines have a softer effect. A good composition usually combines lines and curves.

Right angles are very important in the composition of a painting; they give it strength and an architectural quality. The interplay between verticals and horizontals is part of the classical tradition in painting.

Three simple exercises
The monochrome drawing (left) explains the concept of visual balance, which has to do with the contrasts of light and dark and tone. If you imagine that the little table was supported on a stick, the bottle on one side would tonally balance the few apples on the other.

This composition with cake stand and fruit (right) experiments with warm and cool colours in an abstract sense. Warm colours tend to pull forward, while cool colours lie back – hence the blue background. The area of orange takes the eye to the back of the painting.

The work of the Masters

You can learn a tremendous amount by putting tracing paper over a reproduction of a good painting and analyzing the linear directions and movements the artist used. A similarly useful exercise is to trace and copy the areas of colour. Simplify the colours into flat areas and analyze their distribution.

Reproductions from the great collections are usually good guides. William Rothenstein used to tell his students at the Royal College of Art, 'If you must steal, steal from the rich.' It is a good piece of advice.

Perspective

I am not proposing to demonstrate the theory of perspective here, although this can be an important part of composition. There are a number of books on the subject and I would recommend that you study one of them. Perspective is a subject that can be learned by

anyone, but it is important to remember that it is not a law; it is up to the individual artist how he or she uses it, or whether you use it at all.

Linear perspective is a mathematically based system, developed by the Renaissance artists, that allows you to establish the scale of objects in space. We all know that the further away from us an object is, the smaller it appears. Linear perspective enables you to decide how small, and render it convincingly in your work.

There is another system, called aerial perspective, which also creates an illusion of space. Aerial perspective is less concerned with the precise shapes of objects and how they are made to appear smaller as they get farther away, than with tonal and colour changes. As objects get farther away, they generally appear bluer and paler, and their edges become less distinct. This is because the atmosphere interferes with our perception of them. J. M. W. Turner's works demonstrate this; in fact, watercolour, in general, lends itself to expressing aerial perspective particularly well.

In this exercise (above) the red predominates but the opposite colour green, though small in area, is made more important because the pears are identifiable objects.

If you are looking with a low viewpoint (left), you emphasize perspective. The objects nearer to you will appear much larger and will have sharper edges. As they recede into the distance, they become softer in outline and their colour gets diffused. If you are looking down (below left), the objects are all the same size – their real size, in relation to one another. Looking down produces a greater sense of pattern, which is almost abstract if you take the shadows away.

Viewpoint

When it comes to choosing a subject for a particular still life group, there is hardly anything which isn't 'paintable'; the choice of a still life subject is unlimited. What is important is to select a subject that really appeals to you so that you enjoy painting it. It can be useful to select objects that have common associations, or objects of a similar colour range, or simply what you see immediately around you. It could be utensils, or food in the kitchen or a corner of the garden, the bedroom or bathroom. Whatever subject you choose try to see it with a fresh eye: examine it, arrange it and enjoy it.

When you have selected your subject, you will have to decide on a viewpoint for the painting. It sometimes helps to cut out a rectangular 'window' in a piece of card approximately 100×150mm (4×6in). This can be used to help you settle on the view of your subject. By holding it in front of the still life group and moving it backwards, forwards and sideways, you can decide whether you want to view the group close to or at a distance. I

suggest that for the first still life you take a fairly flat, straight-on view so that you will avoid complicated problems of perspective.

Having a focal point of interest is often a good idea although not essential. This can take the form of a bright area of colour, a group of small objects against larger ones, or an intersection of a series of lines or shapes. Alternatively, a focal point can be emphasized by using a frame within a frame, such as a window. A good way of establishing your composition is to take the 'focal point' and draw out from it in every direction. When the centre of interest begins to get obscured, you know you have extended the subject too far.

Charles Bartlett 'African Violets' 500 × 600mm (20 × 24in) is worth analyzing in terms of composition, colour and organization.

I decided early on to paint it in a high key with a small area of complementary colour (green) in the plant itself, which is fairly centrally placed. Everything else in the picture is reds, hot ochres and pinks. Red is a difficult colour to handle in painting, since it tends to jump forward in space, distorting any spatial relationships you are trying to set up.

The composition relies partly on a structure of angles to hold the objects together. There is a series of right angles in the painting, and the sloping angle of the brushes is continued in the red drapery on which the plant and pencil jar stand.

Charles Bartlett 'Cyclamen against the Light' 480 × 380mm (19¾ × 15¾in). In this case, I intended the painting to have an overriding warm feeling of light. You usually want a background to be cool, but by using broken paint and superimposing cool colour over the warm, the warmth comes through. The shadows are also warm.

Right: Olwen Jones 'Winter Geraniums' 480 × 580mm (19¾ × 23¾in) is very concerned with reflected images and, because the still life is seen through glass, some parts are clearer than others.

This should help you decide on how much to include in your picture.

Apart from the simple, straight-on view, there are many other possible viewpoints. You can look down on your subject, seeing it almost as an abstract pattern, or use a long, simple foreground shape reducing down to small objects near the upper part of the painting. You can base your composition on geometric shapes, as Cézanne so often did, or treat the still life in a wild rhythmic flurry of colour.

Structure

There are two forms of structure that the student of still life painting will need to know about: the structure of the objects themselves, and the structure of the picture plane.

One of the great advantages of still life painting is that the objects and their relationship with each other can easily be understood. The size of one object against another, the distance between each object and the inter-relationship of the planes are all visible. You should look at them before you start painting.

If you imagine that you are viewing your subject through a sheet of glass, so that the image is on a two-dimensional surface (the picture plane), it is the forms and structure of the shapes that form the basis of the pictorial composition. In the painting above, the fact that the subject is seen through glass immediately gives it a two-dimensional feel and a rather abstract quality, caused by the flattening effect of the glass and the reflections created.

Rather than thinking of the structure of the objects themselves, think of the shapes and angles they make on your flat surface; compare one shape with another and analyze the spaces between them; estimate the varying angles created by the objects and the background. It helps if you estimate the angles in relation to either upright or horizontal lines or draw a horizontal and vertical line to divide the rectangle into four equal parts to help estimate the angles.

Remember, though, that the structure of the picture plane is not only linear, but also depends on tone and colour, and you will have to consider these aspects too.

Project: Still life in watercolour

This project is about composition. If you study any painting by one of the great masters, Cézanne being a particularly appropriate example, you will find certain shapes, angles and directional movements, repeated again and again. The orchestral analogy springs to mind because everything has a counterpoint. Directions are picked up, bounce off the frame and are picked up again. If you analyze his paintings you will see that, compositionally, they are very complex.

Movements within a composition sometimes happen subconsciously, but a painter like Cézanne was very aware of what he was doing. If as an artist you ignore compositional ideas, it will show in your work in time. Without an underlying structure, all paintings eventually start to look 'thin', and do not retain a lasting interest. This is why composition – in other words, the study of the form of the painting itself, and of the forms that it contains – is so important. As with the study of colour, you will find that the study of composition is never finished: it will preoccupy you throughout your life as an artist.

This exploratory tonal study for the still life is done in charcoal, and then reinforced with a monochrome wash.

What is a good composition?

There is no rule that defines what is a good composition and what is a bad one, but if the arrangement creates a lasting satisfaction and sums up the feeling the artist had when he or she saw the objects, then it works.

In this case, the little plant and the various pots in the studio looked interesting, but needed some adjusting to make a balanced and unified composition; for example, I slightly moved the palette knife, pliers and a couple of pencils to lead the eye up to the plant, and placed the white mug on the left to balance the predominance of lights on the right. In this way, the eye is led round the composition and the painting will have a structure that the group of objects itself lacks.

Preliminary studies

I began by making a very simple and direct tonal study in charcoal, looking for the broad structure, and for interesting relationships within the still life group. If you look at the study carefully, you will find certain motifs beginning to emerge – directions, angles, shapes – these will be more fully resolved later. I dusted off some of the charcoal so that it wasn't too dominant, and fixed it with a spray fixative.

Having worked out the broad outlines, I then used a wash of colour to investigate the tonal dynamics within the painting. Basically I have divided the work into light (the white of the paper), dark and mid-tones. I used a colour called neutral tint which is a very useful colour to have in your palette: it is not as dead as black but has a slightly purply quality.

Look carefully at the disposition of the white areas. Now look at the darkest areas – the ink bottle, the jar with the upright brush, the bowl in the background and the handle of the palette knife. All of them represent sub-plots in a composition which will eventually be many-layered. Each of the many layers must work, and eventually they must all be orchestrated in

such a way that they create a successful, single, integrated composition.

To begin the painting itself, I made an outline drawing, using a soft pencil to establish the broad structure of the composition.

I then laid in the first wash of colour. In watercolour, you always work light to dark – and remember that the white of the paper will be your lightest areas. So, leaving the paper to stand for the white pots, the plate and the sheet of white paper, I laid in a pale wash of colour for the palest tone, and left it to dry. It covered all the middle and the darker tones as well.

I pencilled in the main lines of the composition.

Here I have applied the first wash of a pale but warm colour.

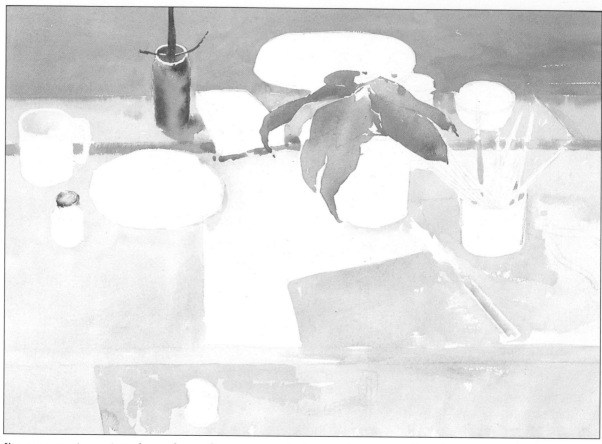

I'm now starting to introduce colour: olive green on the leaves of the plant, Davy's grey on the background, and neutral tint on the black pot with the brush in it. (Davy's grey is another useful colour to have in your palette. Somewhat transparent, it is a slightly green grey.) I have also tentatively tested where I will put my reds.

I am knocking back the background colour by sponging it down lightly. When the colour dried, it had left a rather hard edge; I wanted to soften the edges slightly so that the background would lie back.

Laying in colour

Having applied the first wash, I laid in the background to provide a key to work against. In fact, once it had dried, I found that the background was too dark, so I wet the area using a small sponge and lifted off some of the colour. While watercolour is a demanding medium, it is not entirely unforgiving – it is possible to make changes after the paint has dried, if you have used good quality paper.

Assessing progress

It is important to look at your painting carefully from time to time – to stand back

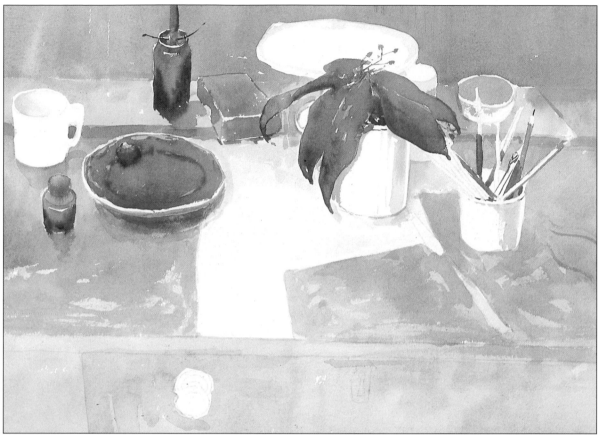

Still feeling for the tonal balance, I have put in the dark plate, the little ink pot and the bright cobalt violet box.

from it to see how it is progressing, and consider whether there are any adjustments to be made. Often, when you are very involved with the subject and with details you can forget to stand back and see the work as a whole. Look for the balance of light and dark, for colour relationships and for the internal logic and structure of the composition. Sometimes studying the painting from a distance and through half-closed eyes will allow you to focus on the broad structure by eliminating the details. I found when I did this that one area of the painting – the olive green plate – was too dark, but I was able to rectify that by wetting the paper and blotting off the excess colour. I then painted over it with olive green mixed with a little viridian.

Analyzing the composition

As we have seen, good compositions do not just happen – they are constructed. For example, I put the palette knife in to counter the strong horizontal movements within the group. I then created another line which meets it at right angles and links it to the edge of the painting, mirroring other right angles within.

In composition you try to contain the eyes of any viewer within the picture by bouncing lines off one another and off the edge. You create interest by repeating angles and shapes. You are depicting real objects, but you are looking for abstract shapes. You will usually want to make slight adjustments towards the end of the painting. For instance, I wanted to pull the front of the table forward, and make it sit

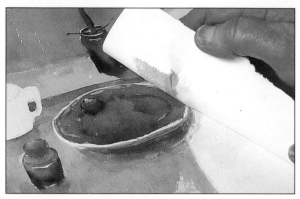

The plate got a little too dark, so I took some of the colour away by loading the brush with clean water, flooding it onto the plate, then blotting it off.

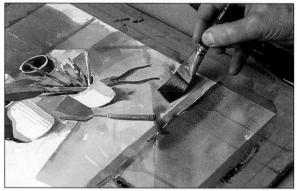

This picture shows how useful a square-ended brush can be, for painting large areas or a straight edge. Sable is the best fibre for wash brushes.

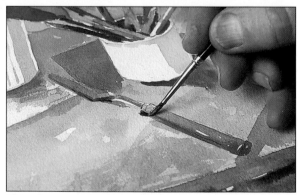

Here I am emphasizing the important compositional direction of the palette knife by strengthening the shadow with a dark colour.

vertically in space – so I darkened that area and added detail, texture and interest. This emphasized the angles and underlying geometry, and in turn made the rest of the painting sit back in space, so that it began to work better spatially.

Using colour

It takes a long time to establish a balanced palette and it is essential to start off with a limited range of colour. Beginners should stick to the primaries – red, yellow and blue – in various intensities. You can have high key or low key colours, so yellow can go down to yellow ochre or raw sienna or come right up to lemon yellow, and so on.

We have talked about the importance of contrast in painting. Here I'm using warmer colours in the foreground and cooler colours in the background – blues and greens at the back are set against pinks in the foreground. This helps create the illusion of space.

The pinky brown is mixed from burnt sienna and Prussian blue. Burnt sienna is a hot colour, while Prussian blue is cold – a useful mixture. I also ran a little bit of Prussian blue into the olive green of the plate while it was still wet to accentuate its form.

Finishing off

Normally in painting you save the little touches of your brightest colour till the end, whether it is your brightest lights in oil painting, your strongest hues in watercolour painting. It is always rather exciting to do these because they bring the painting to life.

It is is sometimes very difficult to see when a painting is finished. It is finished when you've said all you can about your feelings on that subject. I think it makes good sense to keep the painting stretched on the board near to you for a time, so that you can keep looking at it. Your eye gets tired after working on the same painting for a while and it is all too easy to

I've saved the brightest touches of colour to add at the very end – they give a painting that extra bit of zest. I used pure cadmium red (scarlet lake) for one or two of the paintbrushes and the top of the little pot, as well as for the red berries on the plant.

Below: The finished watercolour still life.

overlook an obvious error. But you may come down to the studio bright and early one morning, feeling sharp, and see exactly what is wanted – just a touch here or there – that you haven't seen before.

Still life and composition

In conclusion – when you do a still life you are not trying to copy something, you are creating a parallel to nature by expressing it in your own way. In order to put over your own ideas as forcibly as possible, it might mean adjusting colours and adjusting shapes, strengthening some areas, playing other parts down. Like a composer, you repeat certain notes, certain forms, certain colours, then you orchestrate the whole painting. This creativity is what makes painting exciting – not mere dexterity.

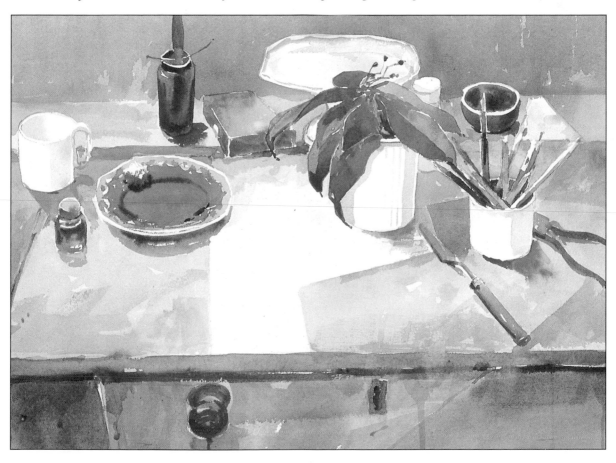

Project: Still life in oils

This is another project about composition, this time executed in oils. It is about 'making a picture' from abstract shapes. Many people recoil at the mention of the word 'abstract' but in truth, all good painting is about abstract forms – even a highly finished portrait, a figure drawing or a detailed flower painting. It is the underlying abstract forms which give the painting structure, substance and interest. It is the formal relationships between shapes which separate the competently rendered picture from the good and the great, the insubstantial from something which will give endless satisfaction.

<div style="border:1px solid">

You will need
- ☐ canvas 50 × 60cm (20 × 24in)
- ☐ oil paints
- ☐ brushes and rags
- ☐ a palette
- ☐ a dipper (palette cup) containing turpentine

</div>

Right: Selecting a viewpoint is of paramount importance, so take time to get it 'right'.

Viewpoints

An important aspect of composition which we have so far touched on only briefly is viewpoint – your position in relation to the subject. This can have a profound influence on the appearance of the finished image, and more importantly its emotional content. Arranging the objects and choosing a viewpoint are essential preliminaries to doing any still life.

Once you have set up your group, study it from different viewpoints – from close-to, from a distance, from one side, then the other. Try standing on a chair or a step ladder to get a bird's-eye-view, then bend down so that you see it at eye-level.

It helps if you frame the image – use a pre-cut mask, or simply make a frame using the thumb and forefinger of both hands. This will help you to isolate your field of vision. An image looks very different when it is seen against a large background, and when you crop right into it. You will be familiar with this idea of framing the image if you take photographs.

You can create fascinating and sometimes ambiguous images by cropping and choosing an unusual viewpoint – if this is taken to extremes, the image eventually becomes unrecognizable.

On the facing page we illustrate this point with pictures of my still life set-up taken from several different viewpoints.

Looking for the composition

In this project I want you to look for the relationships we have discussed before: the interplay of light and dark, the relationships between the shapes and textures of different objects; think about the colours and see if there are any underlying themes you can exploit in your composition.

Eventually each painting takes on a life of its own – this will be a product of the subject matter, and the way the artist responds to it. So if five different artists sat down with exactly the same materials, to paint the same still life arrangement, the result would be five entirely different still life paintings. And the point is that all five might be equally good – but they would be different.

When an artist is presented with a subject he sees fragments, or building blocks, from which he or she can construct a complete unity. He does this by adjusting and rearranging the shapes. The way he interprets what he sees and the sort of colours and shapes he uses are dictated by the feelings the subject evokes. These may be friendly and emotional, or cold and calculating. The finished painting becomes, not a collection of disparate objects, but a single, unified entity, so that if any one element were taken away the whole thing would cease to 'work' and collapse.

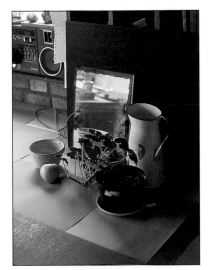

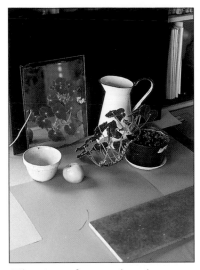

The reflection in the mirror is not so interesting as it could be here because the plant is not reflected in it. The shadows tend to halve the shapes of the objects, but without actually adding any definition to them.

The piece of orange board was dropped on later because the pink and the ochre paper looked a little too 'sweet'. This stronger colour seemed to stabilize them, partly I think because it's a colour that appears again in the plant form.

This overhead viewpoint and landscape format makes it difficult to understand the shapes of the objects and their spatial relationships to one another. The mirror confuses the composition rather than adding interest to it.

This is very close to the viewpoint I eventually selected. I like the movement of the foliage in the red plant, the reflection in the mirror and the shape made by the curved handle of the jug.

Here the group of objects is viewed from too far away. From a distance, all the objects become flattened, so that the composition lacks intrinsic interest and definition.

Again, we are looking down on the objects, but this format is more satisfactory than the landscape format above. However, it loses some of the curved shapes that interested me.

By moving the objects around and arranging the background, you can see how one colour will affect another, and how the overall balance works.

Left: I've done a lot of landscape painting, so tend to see things in that format, but when I tried this still life in that way it seemed rather dull. It divided into two parts, which I didn't want.

Below left and below: When I tried an upright format, the foreground pushed the eye up to the focal point in the middle of the painting. I also saw that it needed a geometric grid playing off against the curving shapes of the jug handle and the plant, so I decided on a frontal perspective with strong horizontal and vertical elements.

Exploration

I started by making an exploratory drawing in which I tried to find the key themes around which I could construct my painting. This will be a 'hot' composition – predominantly warm colours balanced by the cool background colour. The colours were an obvious and exciting theme: singing pinks, reds and ochres set against the dark pot, the white of the jug and the cool, black block of background.

The mirror underlined another theme – the notion of shapes and forms being balanced by reflected shapes and forms.

Negative shapes

Another common and useful compositional motif is that of negative shapes – the shapes formed by spaces between the objects, rather than by the objects themselves. Composition is actually about abstractions, or abstracting what is there before you, and the objects themselves can be an impediment to seeing the underlying abstract shapes, forms and themes. Your brain, which is used to 'making sense' of what you see, keeps on telling you that here is a jug and that is a plant in a pot. Somehow you have to unlearn what you know and see everyday objects afresh. Looking for these 'negative shapes' is just one way of doing that. It is rather exciting to look

There are pots of odd shapes and sizes lying around the studio. How you decide what to include is a question of colour, size and relationships.

at an ordinary and very familiar arrangement of everyday objects and to see it in an entirely different way.

Counterchange

Counterchange is another compositional concept which helps you see things in a new way. It is used to describe the contrasts of light and dark shapes which are present in every subject and which the artist can exploit to give a painting more impact. In my arrangement, there is a series of curved shapes; sometimes they are seen against a dark background, for example the handle of the white jug against the black paper, and at other times against a light ground, as in the shape repeated where the black plant pot is delineated against the bright pink paper.

The format

I have already mentioned the importance of the four straight edges and the corners in any composition. The format itself is also significant and should not be an arbitrary decision. In this case I started off by working to a landscape or horizontal format. This produced a composition which was satisfactory but lacked drama. It created a rather static image and didn't give enough emphasis to the vibrant colour relationships in the foreground. The more I studied the arrangement, the more I focused on those colours and on the stark, underlying geometry of the blocks of background colour.

I then did a quick sketch of the same arrangement in an upright format, and immediately the whole emphasis changed. The new shape forced the eye into the middle of the arrangement of objects accentuating that area. It also gave me longer straight lines, which contrasted with the series of short, curving shapes in the centre of the drawing. I decided that the band of the orangey-red colour across the bottom should also be included, to pick up on the colour of the leaves.

Preliminary drawing

My preliminary drawing was really an investigative drawing, to analyze the elements of the arrangement. This enabled me to see what was there and what its potential was – what I could make of it. Various themes, rhythms and energies became immediately apparent and more would be revealed as the painting progressed. Apart from the hot/cool colour contrast and the counterchange themes, a strong geometric division of the picture area also became apparent – a sort of underlying grid, created by the rectangular shapes of coloured paper on the table and in the background, as well as in the shape of the mirror. This striking cross shape quartered the picture area and created a focal point just above the centre.

I work very quickly in pencil in a sketchbook. While these drawings are sketchy and unfinished, they represent an important part of my thought processes. I had to work through these stages in order to reach the compositional solution. Do not underestimate the importance of this process: the more time you put in at this conceptual stage, the more likely it is that the finished painting will work because it will be underpinned by a rigorous structure. Make as many of these drawings as you need and don't worry if they are a little scrappy – they are only working documents.

Laying in the underdrawing

Having resolved my approach to the composition, the next thing to do is transfer this to a canvas. I used a ready-stretched canvas, size 50 × 60cm (20 × 24in). It had a fairly rough texture and was already primed. This is an expensive way of working – you can stretch your own canvas or even use primed hardboard (Masonite) for oil paintings.

I used charcoal to lay in the drawing. It is an ideal medium, lively and easily erased and corrected. Even at this stage I am still

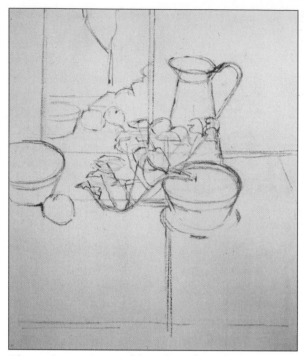

Charcoal is a very useful medium for indicating the main directional lines of your composition. If you use soft pencil on canvas, the paint may not adhere to the graphite, but charcoal is a medium to which paint adapts itself very readily. It can also be very easily erased and changed.

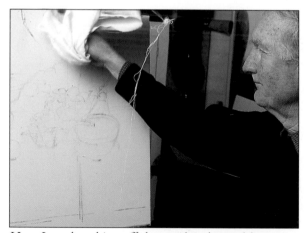

Here I am knocking off the surplus charcoal by flicking it with a duster. Then I will fix the charcoal, otherwise it will disappear once I start painting over it.

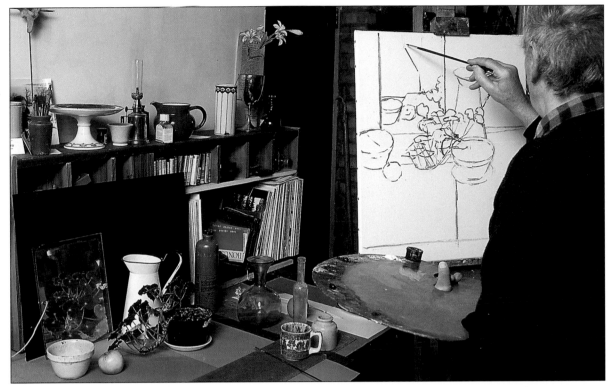

I decided to establish the drawing in burnt sienna, using thin paint and a small, thin brush.

developing the composition, looking for repeated shapes and forms, making adjustments here and there.

When the underdrawing is complete and I have enough information to work with, I knock back the charcoal by flicking it with a duster. Charcoal is a powdery medium, and if you didn't remove the dust particles they would contaminate your colours. Even when most of the charcoal has been removed it leaves a faint trace, sufficiently strong for you to see the outlines of your drawing.

Fixing the drawing

The next stage is to establish the drawing with thin paint, using a small, pointed brush. I want to establish the composition in paint so that I can paint over it when it is dry, but still see the drawing through very thin paint. I am continually making adjustments to the

composition – emphasizing certain features, subtly changing angles and accentuating the internal dynamics. The process never really stops until the painting is completed.

I am still drawing by shape, rather than by what I know the object is – I am drawing what I see rather than what I know to be there. I draw the background shape at the same time as the object rather than completing one object and then moving on to the next. The drawing builds up, a line here, another line there; I am always looking for relationships, trying to integrate everything in order to create a coherent and harmonious whole.

I am going to paint the composition in a warm key, so I used a brown and a red in the warm areas of the painting and a blue in the cool areas. Cézanne always outlined his drawings in blue because he wanted the edges to recede.

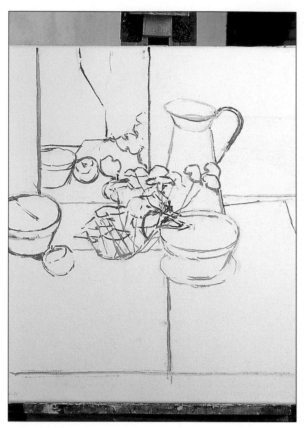

The painting is now half-established in paint, but some of the charcoal is still showing through.

Here I've started with golden ochre and the violet colour, which is magenta mixed with white.

Different artists, different concerns

Different artists have different concerns. The Cubists, for example, wanted the viewer to be very conscious of the fact that they were looking at a two-dimensional plane. They rarely painted landscapes because of the distances involved. For them still life, with its limited depth of field, was the ideal subject. If you look at a Cubist painting you will find that it takes you back a little way and then takes you forward, but never very far. The Cubists usually worked with a very limited palette, often a single pair of complementary colours, a blue and a hot brown, for example. They manipulated space by playing off the warm and cool aspects of the painting.

My main concern, however, is composition. What interests me most about this grouping of objects are the repeated shapes.

The themes

The main thematic shape in this painting is that of the jug handle, which is repeated throughout the composition. There is also a recurrent oval – seen in the mouth of the jug, seen from above, and the leaves of the plant. The strong horizontal and vertical lines within the painting give architectural stability to the composition.

Blocking in colour

I worked alla prima, that is, I went straight for the tone and colour I wanted rather than doing a tonal underpainting.

There are a few points to remember about the sequence of working in oils. You always work from lean to fat – in other words, you start by mixing your paint with turpentine and then, in the later stages, add undiluted oil paint. You paint in oils from dark to light, which is the opposite to the approach in watercolour.

Using oils

The theory about painting in oils is that the more applications of paint you put on, the

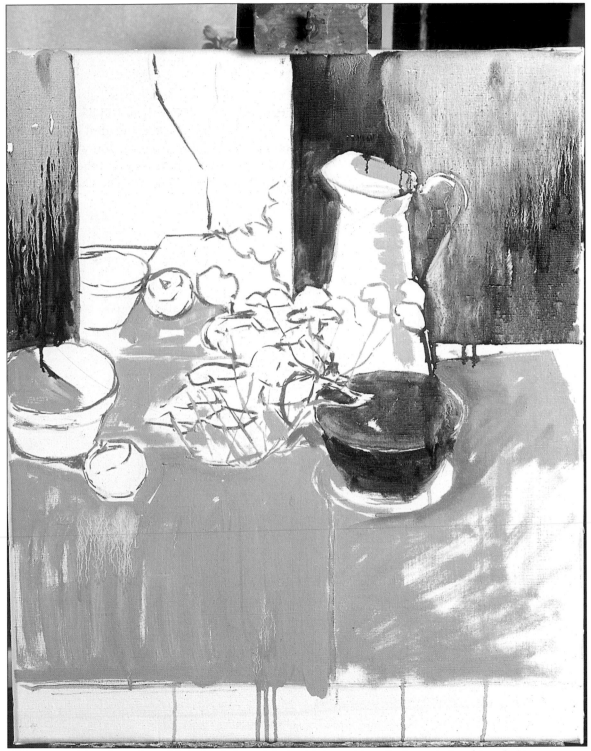

Using very thin colour, I establish the feel, and deal with intensities of colour, dark against light.

Here I am putting in the red of the plant, a pure cadmium red. The plant is a key element in the painting, since it is a focal point and, being a strong colour, it could actually throw everything off-balance. You need to colour it in at this stage to be able to assess the way that colour in the whole painting is going to work.

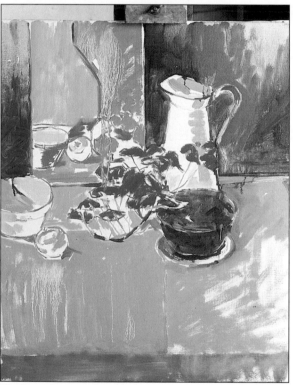

Until you've got the whole canvas more or less covered, you can't really begin to see the painting as a whole and assess whether it is working, because you are still dealing with individual areas of colour. As the painting progresses, you begin to get all the relationships of colour and tone among the objects and their background right.

richer the surface becomes. Not only does the paint get thicker and more textural, but in each successive layer a certain amount of the underlying layer shows through so that the colour becomes complex: it is as though you were looking through layers of colour.

Where several colours meet each other, or intersect, they need to be balanced quite accurately and can then be extended out. If you tackle an area where several colours intersect, this can give you the key to the whole painting.

At a later stage you can crisp up the edges, which gives a lot of depth to the painting. You can establish the dark edges by painting up to them with impasto in a light colour, filling in the 'negatives shapes' in this way.

The final stages

Oil is a very flexible and forgiving medium. You can work on a painting, leave it for several days or even months and then come back to it. You can achieve a lot in a single session, but if the paint surface is beginning to get too wet, it is best to leave it for a few days to dry off; otherwise, you risk the paint beginning to get overworked and muddy and the painting losing its freshness and sparkle. I tend to develop my paintings over several sessions with gaps in between to allow for drying.

I have now done more work on the image in the mirror, but I have also picked up the drawing, and the rhythm of the plant stems; the jug and the dark pot have also been established.

More work is still needed on the foreground.

Adding yellow ochre over the pink for unity.

The final touches are all-important.

More work on the plant.

The finished painting

In the final stages I have done a lot of work on the foreground of the painting. The leg of the table has been put in and the slight feeling of a diagonal on the table top has been emphasized to give more directional movement. The yellow and pink areas were previously too separate but I have now carried the yellow ochre over into the pink to unify the two areas. The painting in the mirror has been completed. You will see that the mirror image sits back with, for example, the edges of the reflected apple much softer than those of the apple in the foreground. I have also done more work on the pot in the left of the picture and filled in the areas of white canvas on the left to give a truer impression of the painting.

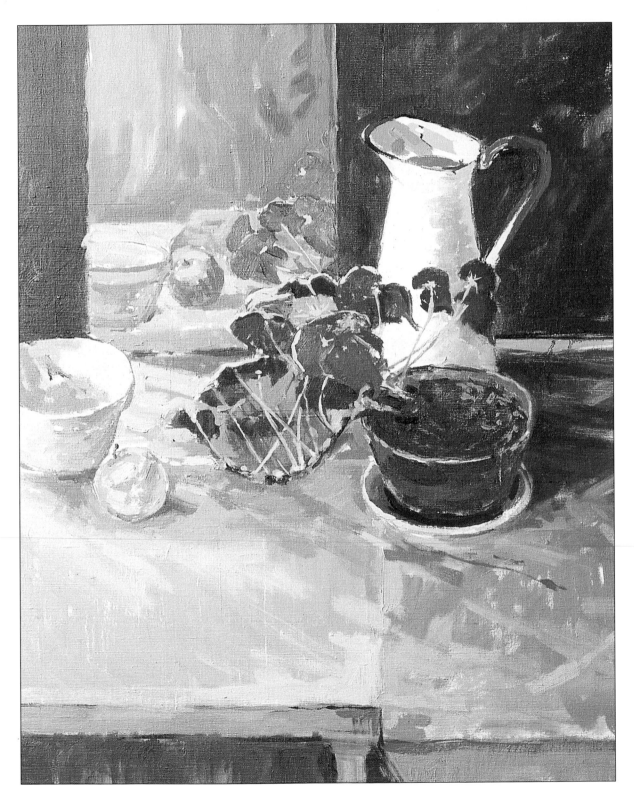

Imagination and experiment

So far we have looked at still life as a means of investigating colour, composition and perspective. In this section we take a broader look at the subject, and see the exciting directions in which less literal interpretations of the subject can take us. Still life can be a most expressive and stimulating vehicle for the artist and can be used as a jumping-off point for all sorts of explorations. Unfortunately, many people are far too restricted in what they believe still life to be and in seeing what can be done with it. The subject doesn't have to be the eternal bottle and lemon – almost any object can be included in a still life painting, including, as we shall see, plants, flowers, animals and parts of a room.

Olwen Jones 'Whatnot'
350 × 440mm (14 × 17½in). This
exciting collage is made from
shapes cut out of newspaper,
prints and pieces of wallpaper,
together with some drawing, laid
one over the other to give a
surprising feeling of depth.

Looking for inspiration

Some people find it extremely difficult to paint in an abstract, expressive or imaginative way. This is especially so if they have spent a great deal of time studying from life and are unduly concerned with subjects such as perspective and form. Even if these are your primary concerns, it is a good idea to try a different approach from time to time, for it will make you look at life, and at your work, with fresh eyes. There are many ways in which you can force yourself to look at a subject in an original way, and although you can apply these techniques to almost any subject, still life offers a particularly varied and stimulating starting point. You could, for example, collect unusual objects, such as stones, driftwood, even bits of broken machinery, or alternatively try assembling groups of objects which have no obvious connection with each other. Mixed media is an excellent way of introducing a strong textural element into your work. By all these means you can arrive at a form of abstraction in which the areas of colour read only as colour and not as a description of the object.

Many artists arrive at abstraction by the application of a theoretical concept – by experimenting with geometric shapes, for example, so that the composition and structure become the main purpose of the painting.

Collage

Collage is just one of many ways in which you can experiment with new ways of seeing things. It has several advantages and is ideal for beginners because it is very direct. Cutting paper and sticking bits down isn't quite as terrifying as making the first pencil mark on a pristine sheet of paper or the first spot of paint on a blank canvas with a brush. All of us are inclined to be a bit tentative sometimes, but collage won't allow you to fiddle. In addition, you can often get purer and more intense colours from cut paper than paint. The disadvantage, however, is that you cannot be sure that the colours won't fade.

You can study composition in the abstract by simply arranging bits of coloured paper. You don't even have to try to represent anything, but simply look for interesting balances of tone, colour and texture within a rectangle. The possibilities are unlimited: some of the greatest paintings of this century are Matisse's cut-paper works, done when he could no longer paint.

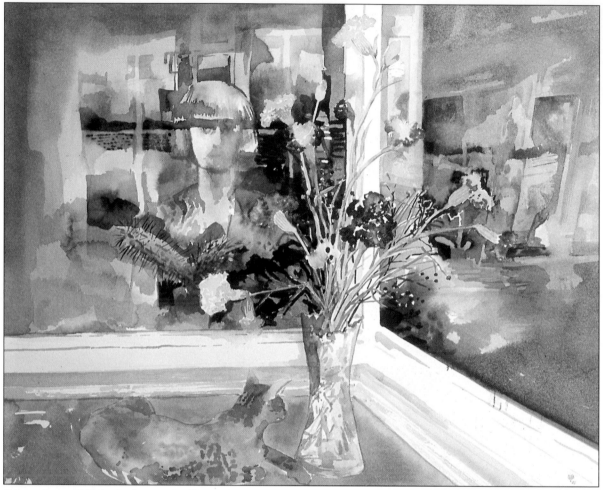

Olwen Jones 'Night Reflections' 400 × 460mm (16 × 18¼in). In this painting, the artist has added interest by distorting various elements and by showing herself reflected in the window.

The value of a sketchbook

Sketchbooks are an invaluable tool to the artist: they serve as a diary and a notebook – a place to record ideas, and to try them out. For example, you might be visiting a friend's house and see something you are very keen to paint. You probably haven't got your painting gear with you and anyway it might not be convenient to work there. However, you can use a sketchbook to make notes from which you can paint in a studio. A sketchbook liberates you from always working directly from the subject.

A sketchbook also forces you to be more selective and therefore more imaginative. When you make a drawing, your eye is selecting what is important to you at the time, so a lot of irrelevant detail is eliminated. When you come to do your painting you have already discarded a lot of useless material, so the process of selection is done in two stages. If you had taken a photograph, there would still be a lot of peripheral elements there to distract you.

The first thing that strikes me about the painting above is that you would be very fortunate indeed if the cat sat still for long

Olwen Jones' first ideas for 'Night Reflections' as they appeared in her sketchbook.

enough to allow you to do a painting – but it *would* probably stay long enough to do a couple of quick drawings.

Paintings often have to be worked up from drawings, sometimes from more than one drawing. A sketchbook allows you to collect all the information, which you may or may not use later. In the sketchbook drawings above, the information on the cat and the flowers is there – but not the background, which is a reflected image of the artist. This painting has obviously been assembled from more than one source.

In this painting we see an example of the way artists can deliberately distort images to create a particular effect. Here the base of the vertical plane behind the flowers is horizontal. If it was indeed horizontal, the line on the right would

have been vertical and there wouldn't have been a sloping perspective on it. It was made to slope like that in order to lead the viewer up into the painting. If it had been straight, the right-hand side of the picture would not have belonged – it would have been cut off. This is an excellent example of an occasion where an artist feels the need to adjust reality, even the rules of perspective, deliberately.

Notice the way different parts of the painting are treated – the flowers are painted in a very detailed way, with outlines used in some areas to give them strength, while the background has been washed down to make it recede. The cat has not been over-emphasized, which suggests that the cat, being ginger, was only half-seen against the orange foreground.

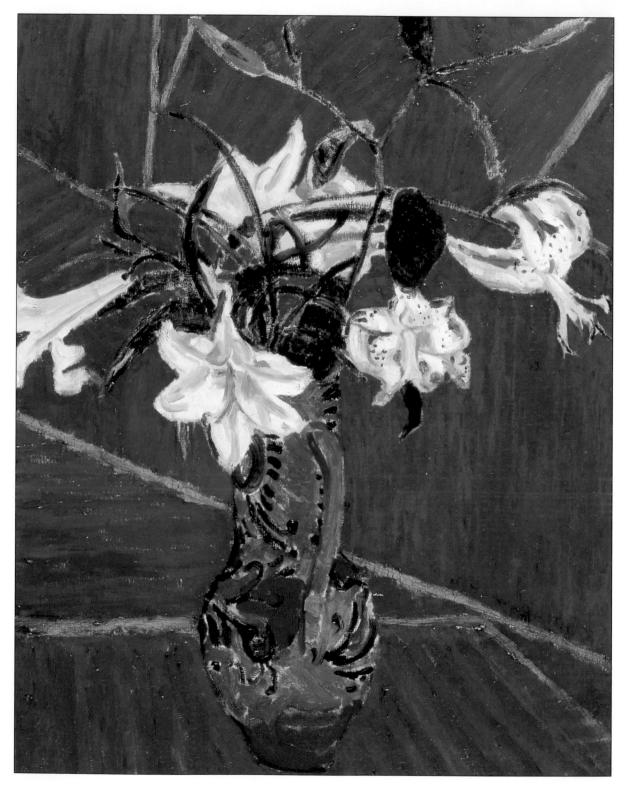

Opposite: Matthew Smith 'Lilies' 760 × 510mm (30 × 20in) (left). Many artists who paint flowers work in a rather stereotyped way, but this painting is extremely imaginative in its approach. The shapes of the stems repeat those of the flowers, both of which are played off against the geometric straight lines of the background.

Victor Pasmore 'Lamplight' 762 × 635mm (30 × 25in). This romantic painting is not a study of the structure of objects but a painting about the special quality of subdued light – it is poetry in paint.

In Matthew Smith's painting of lilies opposite, the moving shapes of the stems repeat the shapes of the flowers and all these movements are played off against the geometric straight lines in the background. The whole effect seems to explode and radiate out from the centre. The use of the red is striking: there is red on the lilies, red on the lines of the background and red on the vase. The colour of the pot itself is a light purply grey which has red in it, so it carries the red up into the flowers. Look also at the pattern of light and dark: the whole painting is dark overall, emphasizing the lightness of the lilies. The blue is very strong, and the artist has not differentiated between the horizontal plane and the vertical plane behind – this is done deliberately, in order to flatten the picture and emphasize the abstract qualities of the subject. It is a picture that relies on two-dimensional pattern rather than three-dimensional form. The perspective of the ellipsis at the base of the vase, for example, is flattened, which is another device by which the artist distorts form to create pattern. From this distance, the base of the vase would in reality look much rounder.

Note the way the flowers are cropped off at the edges. This again draws attention to the shapes and away from the identity of the objects. The patterns in the background become shapes with the plant stems, so that background and subject are seen as one and the spatial arrangements are visually contradicted.

In conclusion

In this chapter I have suggested possible directions and ideas to explore through a study of still life. I have shown you still life paintings that are refreshing and inspirational in their approach. If I have opened your eyes to the enormous possibilities of still life painting I shall feel rewarded. It is an exciting, stimulating and rewarding subject which has produced great works of art in the past – and will continue to do so in the future. So enjoy it!

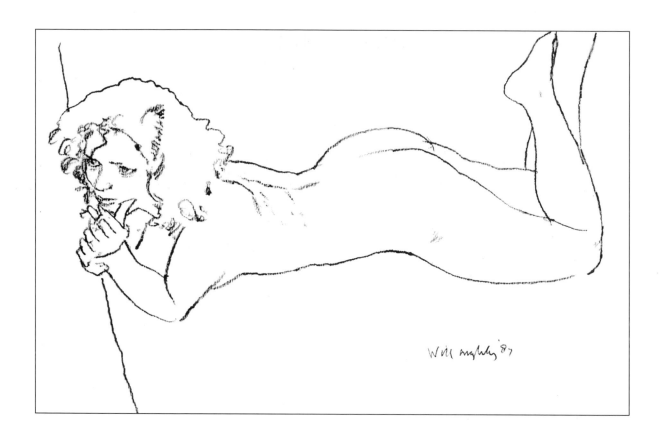

PART THREE

Figure Drawing

Introduction

A lot has been lost in the last twenty years, when most art schools discarded 'life drawing' as a subject for study. What I would like to do is attempt to restore some of the values that might have been forgotten in the process. The figure drawing exercises that follow are not new – I make no claim for inventing them. They are primarily designed to help you to find out, to discover!

The most important thing, as you will see throughout, is to make your pencil respond to what you are seeing – and the key to this is total concentration. By projecting your mind and empathizing with the figure before you, you will eventually be able to convince yourself that your pencil is actually touching the part of the form you are seeing.

Once you've experienced this, you will understand and appreciate the qualities of the great draughtsmen of the past: Degas, Toulouse-Lautrec, Ingres, Rubens, Rembrandt and Michelangelo, to name but a few. Copy their drawings; it will give you an insight into their minds; how they looked at, responded to, and drew the figure. Do it creatively, not caring about the results; don't forget you are drawing to find out, not to show how skilfully you can copy.

The Degas drawing opposite is obviously a working drawing: it is a study. Seemingly rough and ready, and without thought for the finish, it is nevertheless full of subtleties. All the gesture is there: note around the neck – although very little of it is showing – the amount of tension expressed. Look at the movement contained in the towel, twisting and suggesting the form underneath, of the forearm, wrist and hand. Note also the way the muscles of the upper arm and shoulder bulge with energy. The 'bulging' movement is repeated by the towel pulling against the head – there is a sort of reference between the two. Against the flow and shape of the towel, the right arm has a tautness about it, but nevertheless it repeats, mirror-like, the same movement in reverse. This is the basis of the design.

The body, supporting the design, has a strength, a fullness, expressed by the amount of modelling showing the secondary movements: the cause (drying the hair) and the effect (bringing into play opposing muscles); these can be seen in the bumps and indentations through her back.

Note how the charcoal seems to touch the flesh and bone, the emphasis on the contours strengthening the design, and

Edgar Degas 'La Toilette',
720 × 900mm (28 × 35in).

ending up in a flurry of lines about her haunches as though coming to the end of a symphony with the banging of drums!

Everything stems from the initial gesture — the drying of hair. How little it takes to make a picture — the marvellous movements a woman makes at her *toilette*!

Materials and equipment

You can get away with surprisingly little in the way of materials and equipment for figure drawing. Essentially all you need is a drawing board, a pencil and some paper, but later on we will be using a variety of materials, which you can buy when the time arises. Most drawing equipment in any case is fairly inexpensive, with the exception of a sable brush.

The drawing board

Get a good-quality wooden drawing board measuring about 58 × 40cm (24 × 18in) and as light as possible. It should take drawing pins (thumb tacks) since this saves time and is more workmanlike than securing your paper to the board with strips of masking tape. A good drawing board should last a lifetime, if looked after. Mine is nearly 40 years old!

Selecting the right paper

Paper comes in varying qualities and you will find it best to use different kinds and grades for different purposes. Most of the exercises in this book will be done on cartridge (drawing) paper, but some of these papers are smooth and thin, while others have a slightly rougher texture. It is good to work on paper that has a bit of 'tooth', since this drags on the pencil, breaking up your lines and marks somewhat. Experiment with different grades of paper; buy yourself one or two sheets of expensive paper and discover the different responses you get.

Many of our exercises are fast moving, and it is important to work quickly. When time is an element, each exercise may last only one or two minutes, so you should use cheap paper for these – sugar paper (newsprint) or even layout paper will do.

Reserve your good quality cartridge paper, which is more sympathetic to work on as well as being more durable, for the longer exercises. However, cartridge paper will cockle (wrinkle) if you are using a wash and it needs to be

stretched. If you have some spare pieces of hardboard (Masonite) the same size as your drawing board, it's a good idea to stretch paper in advance. The more expensive, heavier papers will take quite a lot of wear and tear without you needing to stretch them first.

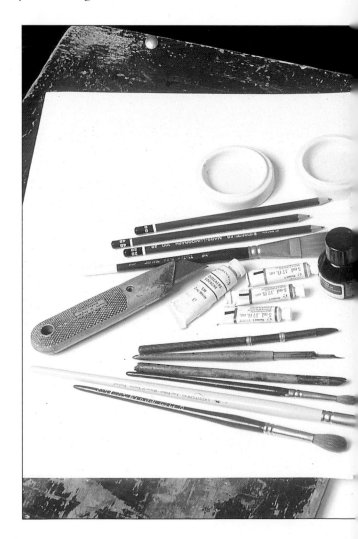

Pencils and charcoal

Experiment with different hardnesses of pencil but do not be tempted to use one that is too soft. Start off with a 2B and see how it feels. For many exercises, especially the contour and gesture exercises, you will need more instant response from a softer pencil. A 4B will give good flexibility of tone within the line.

Various grades of charcoal are available. Soft charcoal will smooth out the line, making it blunter and less 'edgy'. Start off using a medium grade charcoal, and break off the point if you want to get a sharper line.

Brushes

Do not make your exercises more difficult by buying cheap brushes: they do not hold their shape or point and therefore cannot respond. Sable is by far the best fibre, having lots of 'spring'; sable brushes hold to a point and are more responsive in use: the weight of your touch changes the denseness of the line.

A sable brush above no. 8 will hold a good brushstroke of wash, yet keep a good point. It is important to test brushes for this when you buy them. Wet the bristles: if they do not hold together, reject the brush. You will also need a soft nylon wash brush for larger areas of tone.

Recommended materials

You should be able to find the items listed below in a local art materials store; otherwise, most art schools have retail outlets selling good-quality drawing materials.

White cartridge paper
Tinted (grey) Ingres paper
Hardback sketchbook 32 × 24cm (12 × 9in)
Pocket-size hardback sketchbook
Pencils: 2B, 4B
Box of charcoal sticks
Drawing pen with nibs
Reed pen
Sable brushes: nos. 8 and 5
Large nylon brush for laying washes
Plastic (kneaded) eraser
Indian (India) ink
Sepia ink
Tube of ivory-black watercolour
Tube of white gouache
Ceramic stacking palette (cabinet nest) or dishes
Bottle of fixative, with spray
Drawing pins
Adhesive paper tape
Craft (utility) knife

Drawing the figure

When faced with a figure, the possibilities of where to start, what to go for, can seem overwhelming: it is all too easy to end up blindly copying. I remember a man called Booth, the new Head of Painting at Hull Regional College of Art where I was a part-time student in the late 1940s. I was producing drawing after drawing, assiduously copying what was in front of me, but really getting nowhere. His advice was the most important lesson of my life. He said to me, 'Keep your eyes on the edges of the form when you're drawing. Look at what is happening around the contour – make your pencil describe and respond to that!' That was the key that opened a door for me. By projecting your mind and concentrating totally on the part of the figure you are looking at, by convincing yourself that your pencil is touching that part, you will experience the form in a way you wouldn't have thought possible.

Approaching life classes

So often in a life class students have to sit on a bench, or stand at an easel, wherever you can find room, which is seldom the spot you would choose. You are confronted with a model, set up in a certain pose over which you have no control. Very often the pose is rather dull, but students put their time in, doggedly drawing something that does not interest them. The result, hardly surprisingly, is invariably boring.

Over my years of teaching, I have found that the best way of overcoming this rigid approach is to break up the life-class session into a number of exercises, each directed to a particular aspect of drawing. I find that this motivates students and makes them aware of all the possibilities in drawing the figure. In time, the exercises meld together, and it is up to students to emphasize what is important for them.

Now I realize that in a life class, you have to take whatever the teacher gives you, but you could perhaps suggest that you would like some quick poses as well as the longer, more static one. Use the static pose for the more measured, disciplined drawing, the quick pose for contour and gesture exercises. The realization that the model might move at any second motivates you to work quickly in order to get the gesture down fast.

It is a good idea to ask a friend to model for you. Choose one who has similar interests, and take turns to model for each other. Alternatively, draw yourself, using a big mirror; secure your drawing board to an easel first.

Sitting and standing to draw

Sit facing the model so that you can see both your drawing and the model at the same time. By simply raising your head, you can make comparisons. Rest the top of your drawing board on the back of a chair positioned far enough away to make a comfortable angle; rest the bottom of the board on your knees.

Sit well back, drawing with your arm extended; this enables you to see the whole of your drawing, and you will have complete freedom of movement, permitting your shoulder, arm and wrist to come into play.

If you are using an easel, stand well back and draw with your arm outstretched. Make sure the easel does not obscure your view of the model. Try to keep your head fairly still, to maintain a constant viewpoint.

Get up from time to time, and stand away from your drawing, taking a dispassionate view of its progress. This will help you to check proportions and relationships, as well as simply refreshing your eye.

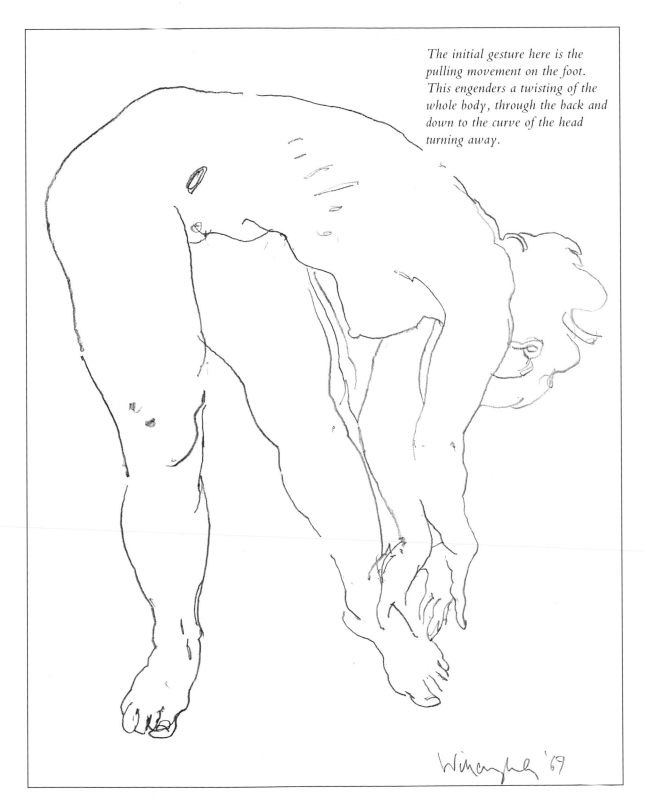

The initial gesture here is the pulling movement on the foot. This engenders a twisting of the whole body, through the back and down to the curve of the head turning away.

Basic anatomy

I cannot stress too strongly the importance of understanding the structure and workings of the human body. A *working* knowledge is what is required: Latin names of the body's many parts are not important to the artist. But an understanding of anatomy will help you to make sense of what you are looking at, and the more knowledge you have the better your drawing will be. I'm not advocating putting every bit of anatomy you know into your drawing, or drawing in an anatomical style. Use your knowledge only when the drawing needs it.

Understanding the body

There are entire books devoted to the subject of anatomy and it would be worth studying one of them. Look for a book that's written for artists, with good illustrations. Examine how the muscles move the bones by means of the tendons attached to them, how they twist about the bone to turn it. Notice how every muscle has its opposing muscle, so that when one is contracted, the other is relaxed.

An understanding of anatomy certainly makes gesture drawing more exciting. Once you know the tensions involved, you will understand why certain muscles are bunching up, and others are slack. You will know which sinews are attached to which muscle when they show on the surface in certain gestures.

If you can get hold of a skeleton at some time, draw it in the same way as you would during an exercise in life drawing – that is, to find out. Look at it as an engineer would – scrutinize the different joints: the ball and socket, the hinge, and the swivel joint. To understand their different functions, work the joints physically, to the extremities of their orbit of movement. See how the radius works with the ulna, for example, how they swivel on each other to operate the hands, as do the fibula and tibia to turn the foot.

Explore the skeletal structure and relate it to your own body. One of the very best ways of understanding the human body and the way it works is to get to know your own body. After all you are available without fee, are prepared to work unsocial hours, and will not consider requests to take up a particular pose unreasonable. Most importantly you can study your own body from 'inside' – you can really 'feel' every movement.

The artist as model

Hold your left arm in front of you and explore it with your right hand. Find the places where the bone is close to the surface and compare these with the fleshy parts where the bone is well-covered. Then flex your arm and feel the bunching of the muscles. Notice the way moving your arm has a ripple effect, causing muscles in your shoulder and back to expand and contract. Let your arm flop and see the way it looks in repose, but more importantly, 'feel' the muscles in repose. Clench your fist and bring it up to your shoulder so that your biceps are flexed. Compare this state of tension with the look and feel of the muscles in repsose.

If you are working from sketches and not sure of how a particular gesture or pose works, always go back to the primary source rather than guessing. Get a friend to pose for you, even a few seconds can be enough to resolve the problem. If there is no-one available, use yourself as a model – a full-length mirror is an extremely useful tool for an artist. It is only by going back to basics each time, that you will really begin to understand the complexity of the human figure.

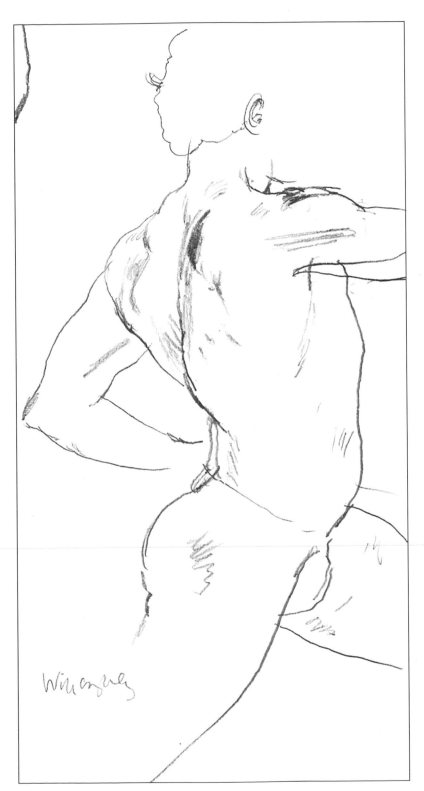

When teaching students about anatomy, I set the model up in gestural attitudes that bring the muscles prominently to the surface. This model had a pleasing, well-developed body but would be unable to keep the muscles taut for longer than 30–40 seconds. Therefore it was important to work quickly and to capture the muscular tension of the body. The pencil line responds to the tautness of the muscles. The incompleteness of the drawing is unimportant and reflects the fact that all extraneous information has been discarded.

The contour drawing

The contour drawing is one of the most important exercises you can attempt, as it forces attention on to the edge of the form, and it gives you a focus for your total concentration. This isn't easy; the temptation to watch yourself draw, to see if you are going wrong, is almost overwhelming! One way to overcome this until you have had a little more practice is by getting a friend to hold a card below your eyes above your drawing board, while your pencil is moving, calling out for it to be removed when you come to a new contour. Once you have found the new contour, it should be replaced.

Ten-minute exercise

Pose the model in a position which sets up a lot of foreshortening.

Start drawing at any point, keeping your eyes firmly fixed on that point, and your pencil on the paper, 'touching' the part of the body you are looking at: project your mind to convince yourself that it is touching, and concentrate hard. Now, slowly move your eyes along the contour and keep your pencil moving correspondingly along the same contour.

Continue until you lose the contour you are following behind a fresh one, and then stop.

You can now look down at what you've drawn. Having looked, place the point of the pencil in position to start the contour that has taken over, convincing yourself, once again, that it's touching. Return your eyes to the model, taking in the direction the contour is moving, what the form is doing in space – coming forward, backward or sideways. Try to feel the surface of the form: is it rounded, sharp, soft or hard? Your pencil should be responding

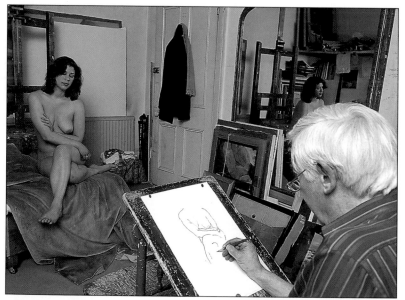

Pose the model, bearing in mind that it is easier to find changes in contours when there is a lot of foreshortening, then position yourself a comfortable distance from the model, with your drawing board resting on your knees and propped up against the back of a chair.

This close-up of the model's pose demonstrates the foreshortening and the many different contour lines that it offered.

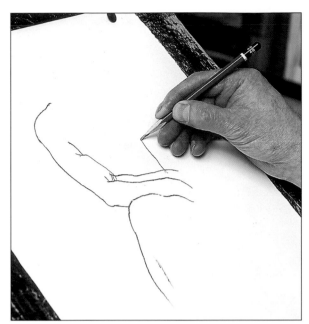

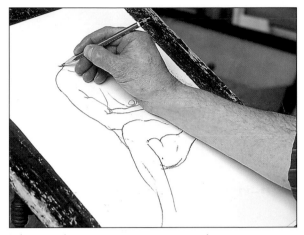

The pencil jumps to a new countour here.

You can start anywhere at all in this exercise. It is simply a matter of latching onto a contour, and drawing until you see it disappear behind a fresh contour.

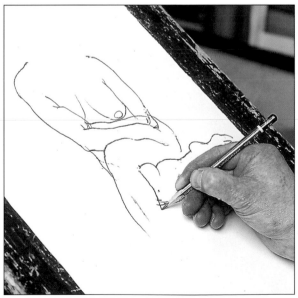

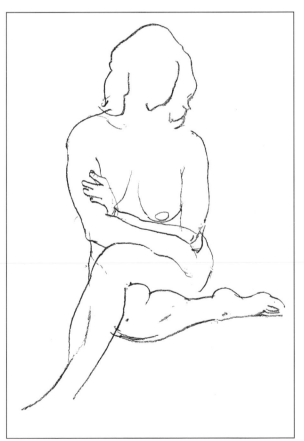

Drawing the contour of the knee coming in front, I jump from one limb to another. I am conscious of the muscle flattening out here and although it isn't a contour I'm going to express that.

The direction the pencil line takes each time reflects what is happening to the form and the space around it. Stop at the end of ten minutes, whether your drawing is finished or not.

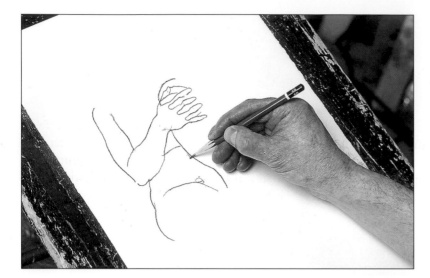

In this contour drawing, I started off with the arms and hands, which contained the primary gesture of the figure. The lines made by the interlocking fingers are simply a tighter series of contour lines.

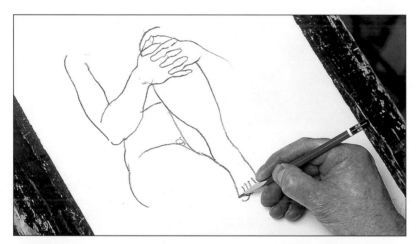

Many people are worried about drawing hands and feet, regarding them as very complicated. But if you simply take it as it comes, the same spirit prevails as with a larger piece of form.

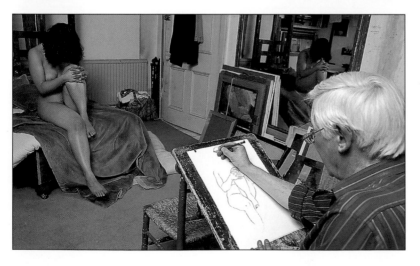

There are many contours involved with the model's hair and one could get bogged down with individual curls and details. I'm just looking for the overall shape it makes.

to your thoughts all the time. Once the contour is lost again, you can look down – but only to find the spot on your drawing to begin the next contour. Do not look for discrepancies between one contour and the next.

Continue drawing like this until the ten minutes are up, or the drawing is complete. Do not worry about completing the drawing. Keep to the same slow but steady speed; this is important, because it lets you gauge the approximate length of each line (in relation to

the others) by how long it took you to draw it. Later, when you have a fair amount of experience, the speed can vary according to your reactions, but at this stage, keep it steady!

You will probably end up with a drawing that is 'all over the place' but do not worry. It's the experience you gain from doing the exercise that matters! Think of it as going on a journey, on which it is the travelling to your destination, rather than the destination itself, that counts.

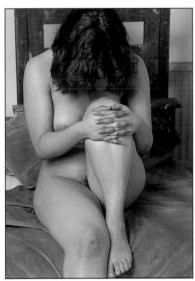

It doesn't matter in the least that the finished drawing does not reflect every detail of the pose and, to some extent, is out of measurement with it. It has captured the essence of the pose and that is all that's important.

I have deliberately set up a draped figure to introduce the contour to drapery. It is important that your pencil responds to the feeling of material in the draped figure. A towel or, as here, a piece of silky fabric, feels completely different from flesh.

This whole drawing took rather longer than the previous contour drawings – about 15 minutes. I spent the majority of this time responding to the head, and particularly liked the unusual shape occurring within the style of hair.

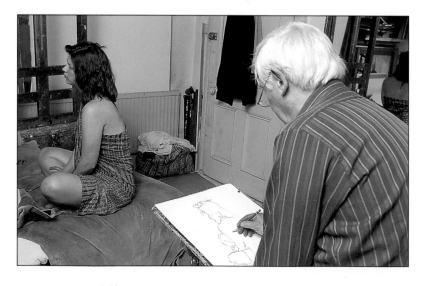

The tilted head produces unexpected contours. The folds of fabric, and the draped curve of the back, are all drawn as contours, the pencil responding to what the eye is seeing in the pose.

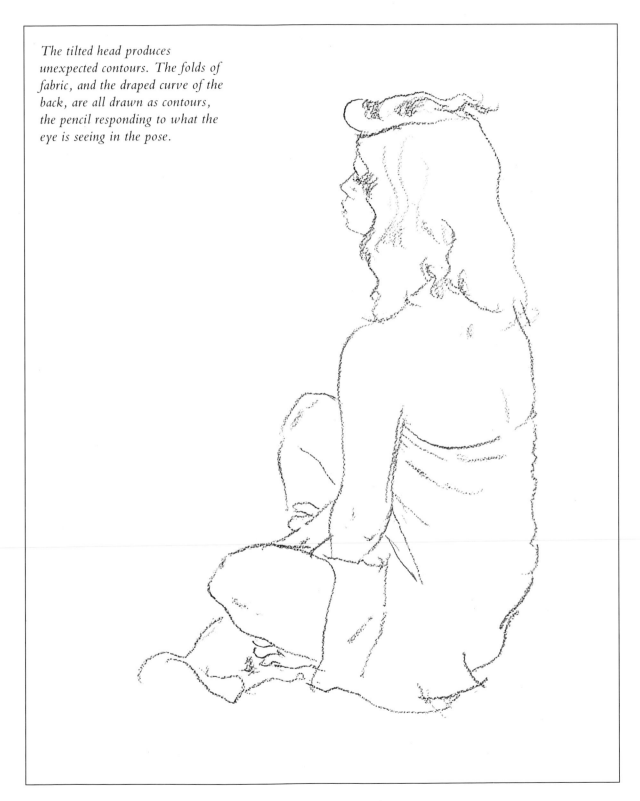

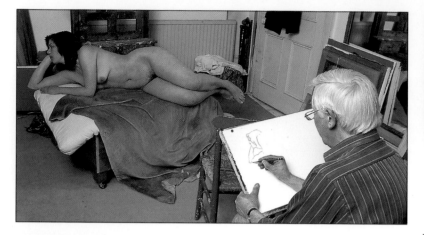

I set up the model in a reclining pose because the problems of drawing contours are greater when there is no obvious foreshortening. It is less easy to find changes of contour, because they are all relatively on a parallel plane.

I worked from the head backwards because I found it easier to draw the figure coming towards me in space. Working from left to right if you are right-handed also reduces the risk of smudging the pencil line.

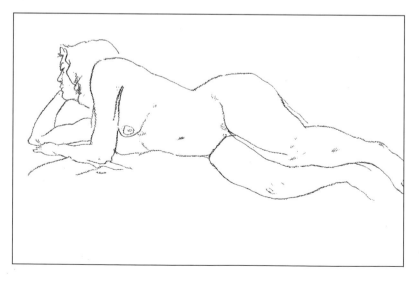

Along the back, for example, there appeared to be few lost and found contours, which gave the exercise a more sustained pace.

When drawing a head, it is often necessary to make imaginary contour lines. The eyes, for example, are not connected and you have to make an imagined contour across the head to relate the drawn eye to the other eye.

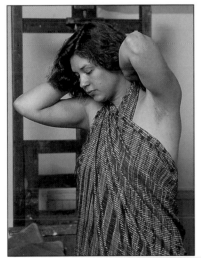

Facial features such as eyes, nose and jaw need to be placed so that they are seen on a tilted plane with, as it were, the imagined contours running at right angles to it. I have selected contours in the hair to give its rhythm, clearly visible, for example, in the movement of the hair on the far side of the face.

143

Drawing shape

The point of this exercise is to recognize the overall shape of a form, taking no account of its solidity, or any internal projections. You are simply going around the outside edge, and ignoring what is going on internally.

You should always be aware how important an element shape is. It is particularly relevant when you are thinking about composition, when you want to extract the best-looking shapes, and choose certain shapes to balance others in the overall scheme.

One-minute exercise

This is similar to the contour exercise, except that you do not look down at the drawing at all during the course of this exercise!

Fix your eye on the edge of the form, your pencil touching the same spot. Let your pencil move around the form quickly, ignoring new contours. Don't worry about a section of the form coming in front of another, even if it's another part of the anatomy.

You can try this exercise with furniture, or indeed any object: just forget what the object is doing, spatially, and go around the outside of it.

The positions have been chosen to make the recognition of overall shape as obvious as possible. Once you see shape for its own worth, you can latch onto it in your drawing.

Drawing the overall shape immediately makes the form more abstract. Here the folds of the fabric, as well as the model's toes, and details of her hair have all been obliterated.

An exercise like this in drawing shape is to a great extent an exercise in selection.

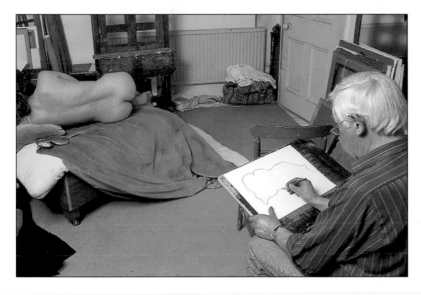

I have had to throw away what is the most obvious thing about this pose, which is the curve of the model's buttocks, and the line of her back.

The resulting shape is almost completely abstract. There is a lesson to be learned here that is very valuable when it comes to composition, and shapes need to be chosen for their intrinsic worth.

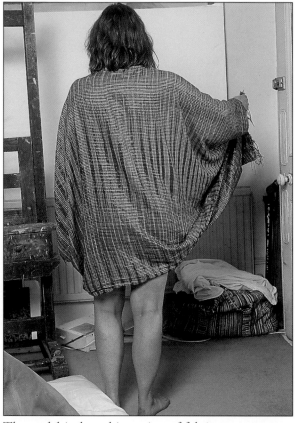

The model is draped in a piece of fabric to create an entirely new abstract shape.

I have simply gone around the outside edge of the form, taking no account of its internal details.

In drawing the form's shape, I am ignoring totally the model's gesture, her hair and the drape and feel of the material in which she is clothed.

146

Drawing the shapes 'in between'

The spaces left by the figure or objects – generally referred to as the negative shapes – have their value too. They are often ignored by beginners but can be just as important as the solid forms, sometimes in fact more so. When it comes to composition, every shape, every space, has to be considered. This needs practice; it isn't easy to disassociate the object or figure from the spaces but with concentration, it can be done! Try the following exercise.

A simple exercise

Assemble a small still life composition – it could be a collection of related objects, such as the tools in the drawing below, or plant forms, or anything that you have to hand. The idea is that you are going to draw them purely as a series of related shapes. Use any medium you feel comfortable with, as long as it is simple to use.

It often makes the negative shapes easier to sort out if you set up the objects against a pale background, as I have done, so that you can pick out areas of light and dark. Squinting also helps by reducing the definition of the forms.

Still life pencil and wash drawings trying to concentrate on the negative shapes. The important thing is not to draw a plant, or a collection of tools, but merely record the shapes of the objects in relation to one another, in a fairly abstract way.

147

The gesture drawing

In the mildest of movements – even in repose – the body has gesture, and this gesture means something. The gesture is the genesis, the primal expression of an idea, and this becomes the *raison d'être* of the picture. The expression of movement engendered by a particular action is seen in terms of the action and reaction of one part of the form against another.

The exercises below should take no more than two minutes because it is essential to draw quickly in order to get to the point, or the inner meaning, of what the person is doing. And in order to capture that, you have to feel it within yourself. Empathize with the gesture. Go through the action yourself physically, to find out what it feels like. Experience what your muscles, your sinews, are doing.

Two-minute exercise

The object of this exercise is to get to the basic movements of the figure in action, to force you to think about the absolute essentials. In other words, what is this movement about? To begin with, set up the model doing something rather vigorous, so that her movement is obvious.

Your drawing should be a 'scribble', searching freely from the inside of the form, and reflecting the directions the form is taking, the action involved. Don't worry about contours, or drawing around the outside of the figure. The drawing should be fast and excited. Go for the primary action, such as a stretch, or a bend, then respond to what happens because of that action. Every action has a reaction.

You should be responding to such aspects as the hardness or softness of the form as it appears on the surface – the tensions set up by the very action of doing something, for example a twist of the head bringing the mastoid muscle in the neck bulging to the surface. Be positive in your drawing and don't worry about 'mistakes': the resulting scribble can be thrown away. It's the experience of doing the exercise that matters.

Setting up the action

Listed here are several examples of positive or vigorous actions or 'gestures' that your model could adopt. All sorts of 'everyday' things we do without thinking could equally come into this category: the act of shaving, brushing one's hair, cracking the shell of a boiled egg for breakfast. All these actions have a gesture about them. Watch the way a man leans against the bar, holding a glass, while talking to friends, and you'll see immediately what I mean.

Some of the suggestions below could be captured in three stages, for example the action of throwing a ball could be caught at the beginning (winding up), in the middle (mid-throw), and at the end (release).

Getting into a chair at a table
Getting into bed
Stepping into a bath
Climbing steps
Pulling on a rope
Pushing against a wall
Lifting a heavy object (feel the weight)
Yawning and stretching
Stretching one's body
Drying one's back with a towel
Drying one's foot with a towel
'Starting' position for a race
Throwing a ball
A boxing stance – throwing a punch
And so on . . .

You might throw in a few poses where the body is in repose, to remind yourself that there is gesture there too – and it will give your model a break.

Repose

Figure lying on back, with loins and legs propped on pillows to be higher than rest of body – arms flung out
Figure lying prone in an indolent position
Figure lying on side, with head on elbow
Figure lying on back, head propped on pillows

You will find that your hand responds through itself when doing a gesture drawing. You are not simply drawing what you are looking at, but what you feel. Empathize with the gesture and capture its essence: do not allow yourself to be led astray by considerations such as contour, or measurement.

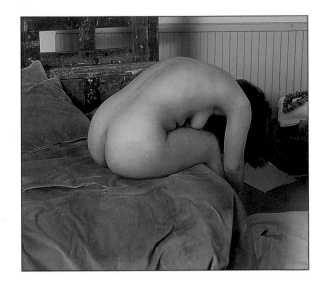

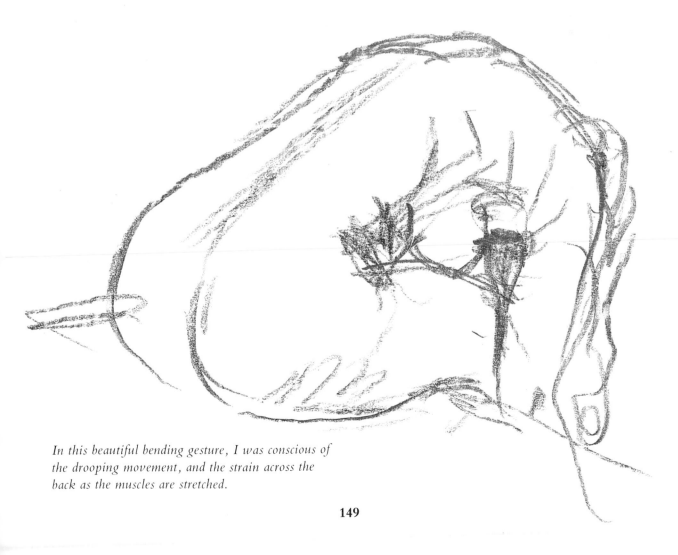

In this beautiful bending gesture, I was conscious of the drooping movement, and the strain across the back as the muscles are stretched.

149

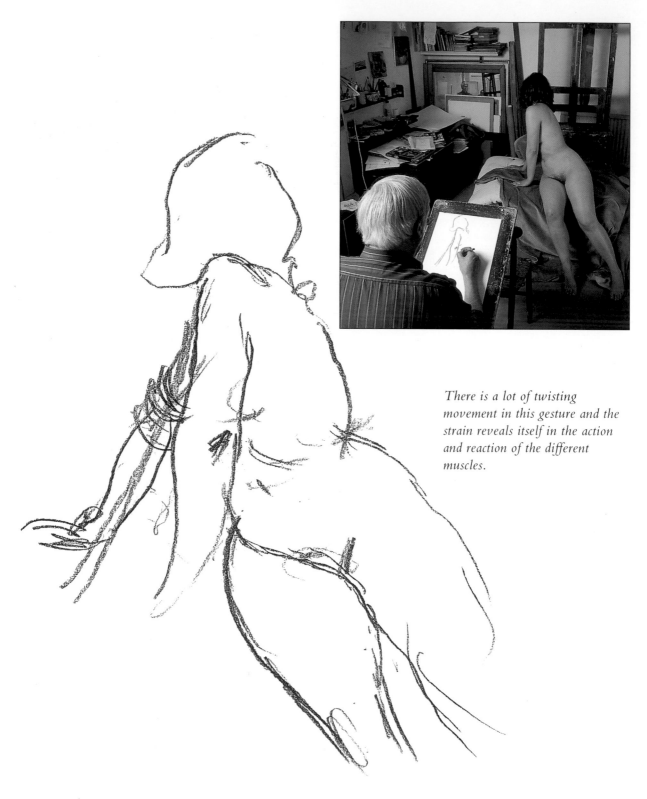

There is a lot of twisting movement in this gesture and the strain reveals itself in the action and reaction of the different muscles.

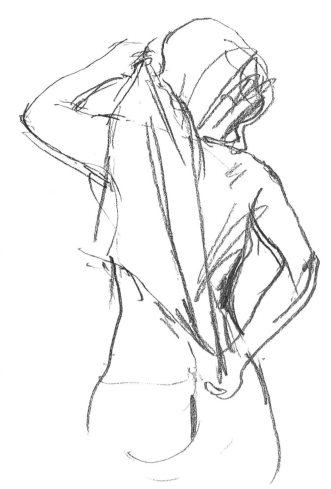

In this pose the towel itself is part of the gesture, not just a piece of material. I had to feel the towel being pulled between the two hands, and bearing against the back. I started my drawing with the towel and the bent upper arm. This arm has a distinctly different feel to the lower arm, because of the different muscles employed to create the tension and the pull between them.

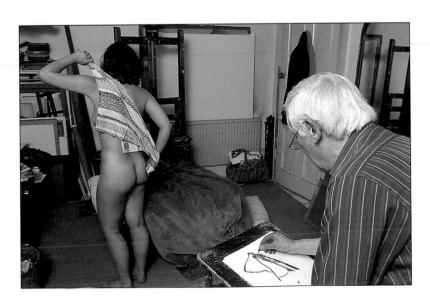

The gesture in this pose is less vigorous but it is still there. The nearer leg has a gentle pulling-up feel, while the far leg has a bit of tension, a certain thrust to it.

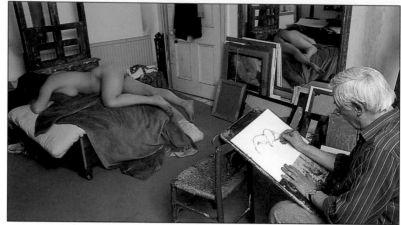

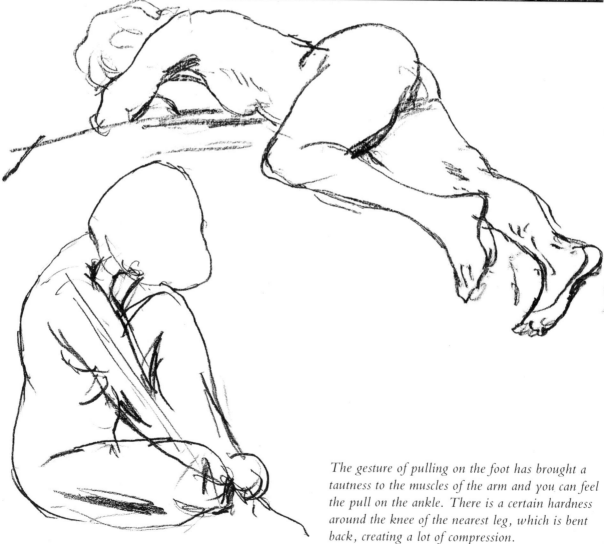

The gesture of pulling on the foot has brought a tautness to the muscles of the arm and you can feel the pull on the ankle. There is a certain hardness around the knee of the nearest leg, which is bent back, creating a lot of compression.

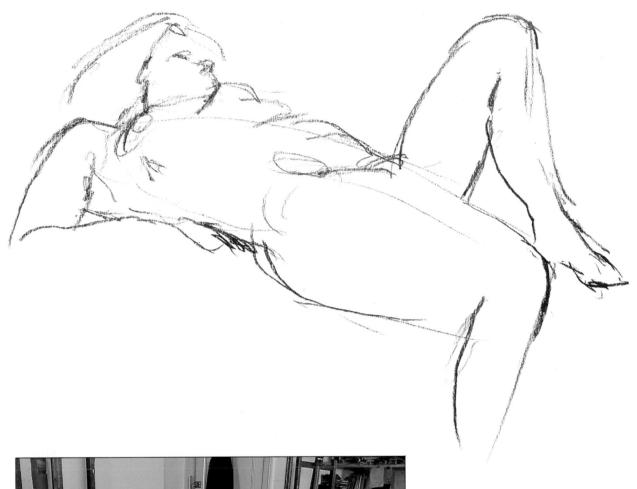

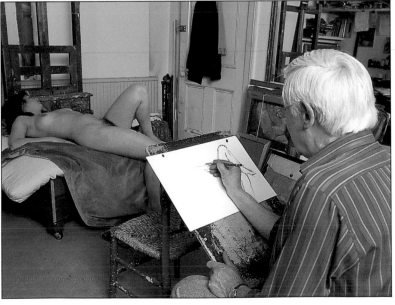

Here, the model is lying down but supporting her raised shoulders on her elbows. This gesture of half-sitting up creates a degree of tension between the shoulder and the arm, which moves right across the ribcage.

Drawing the cross-section

In order to make the figure work spatially in your drawing, you should understand the cross-sections of the form. If, for example, you saw through a tree trunk horizontally, this would be its cross-section. Similarly, if you could simplify the form of the body, you would get the same cross-sections, running along the length of the form.

On the clothed figure these cross-contours are very evident at the cuff of a sleeve, for example, or a belt around a waist. On a life model, this can only be imagined. One way to get a hold on this, is to try drawing cross-sections on your arm or leg with charcoal. Draw them in different positions and, with a mirror before you, notice how the ellipse changes as you move your limbs. Models will also sometimes allow you to draw on them in this fashion.

Another way to aid one's understanding of the human body in terms of cross-sections, is to imagine a caterpillar crawling across the body on a journey from one side to the other. It is moving at right angles to the direction the figure is taking and follows its contours.

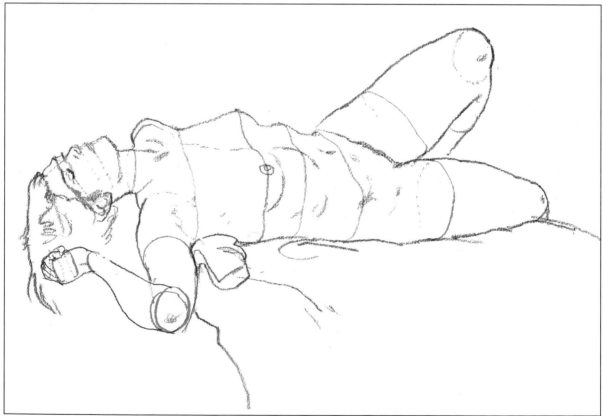

A sheet of tracing paper has been placed over the figure drawing as an overlay. 'Cross-contour' lines have been drawn in to show the imaginary cross-section of different parts of the form. It is as though you are building up the form in terms of cylinders. It is important to be able to envisage these cross-contours, as a way of understanding and completing the human form.

Drawing to sight-size

This is the natural size at which you see objects or figures. Drawing sight-size means that you can mechanically check your accuracy in getting parts of the form in proportion to one another, by the simple means of holding your pencil up at arm's length against the object or figure. The pencil should be held vertically, with the tip of the pencil at one end, and your thumb measuring the other end. Close one eye when doing this. Now place your pencil against your drawing, and check how true you have been, by eye alone.

You are training your eye, so always draw freely first, then use the pencil as a check, or if you feel you are going wrong. Do *not* use this as a crutch.

I hold up my pencil and measure off the length of the model's head as I see it from where I am sitting. This will not, of course, be the head's actual length but its 'sight-size'.

I measure this against the drawn head, with the tip of my pencil on one point of the measurement and my finger and thumb against the other point of the measurement, to see how accurate I have been.

I then use this measure to compare the size of the head with the length of the upper arm, to check that I have drawn the parts of the form in the right proportions to one another.

155

Tonal wash drawings

It is important not to be a slave to the model when using tone. Never try to 'copy' every little nuance, every small detail. You are not trying to get near to the accuracy of a photograph; on the contrary, you are going to be as economical as possible. To this end, for these two drawings I propose to limit the number of tones to three (or four, if we include the white of the paper). This limited choice will force you to make decisions as to which tone would be appropriate to the part you are studying, relative to the rest of the drawing. Sickert's work shows us fine examples of the use of simplifying tones.

It is important to have the right lighting; use one source only, as the shadows become confused if light comes from all over the place. Set the model up near a window, if possible, or, if there is no natural light, rig up a spotlight.

Mix three tones in separate palettes: light, medium and dark. At the top of your drawing board, pin a scrap piece of paper and lay out a brushful of each tone, making sure you wash your brush out and dry it from the previous tone each time. When it is dry, this will give you a useful guide for future decisions.

Mix up your three tones in separate palettes: light, dark and a pleasing mid-tone. I have a limp wash brush for the broad areas of tone and a sable brush for drawing finer lines of wash.

A 30-minute exercise

Quickly and loosely, sketch in the main lines of the figure, in order to give a base for your tones. Absolute accuracy is not important, so don't spend too much time on this.

We have to have a key, or scale, by which to judge relative tones. If you take the highest tone – it might be the highlight on the face, or the sun shining on a white wall – keep the white of the paper for that part. Then put a wash of the lightest tone over the rest, and let it dry.

You now have to decide where your half-tones lie, judging against your tone chart on the scrap of paper. It's a choice between your strongest tone and the middle one. Your choice has to be arbitrary, to a certain extent, but you should be brave and bold about it. Go for drama, and save your dark tone for the most pleasing shapes. Wait for the medium tone to dry, then finally apply for the dark tone.

As an alternative to white paper, try using a grey. This immediately establishes the light tone and you can get into the middle and dark tones

Having posed the model, I first did a very loose line drawing to establish the gesture, the form and the principal lines. I then applied my lightest wash over most of the body, leaving the breasts and stomach to stand as white highlighted areas.

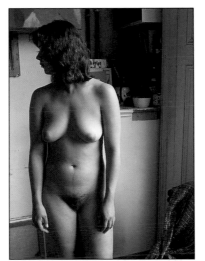

I am using a large, nylon wash brush for the broad areas of wash.

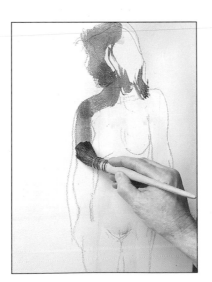

In the end I left out the middle tone, moving straight to my darkest tone for the areas of the model's body in shadow.

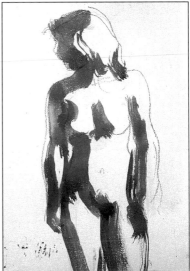

I found the stronger tone described the form more interestingly.

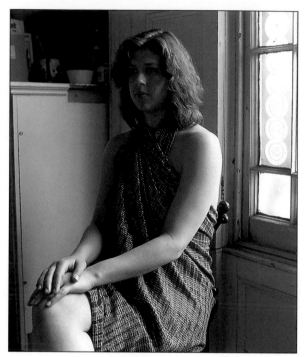

Areas of the flesh are obvious highlights.

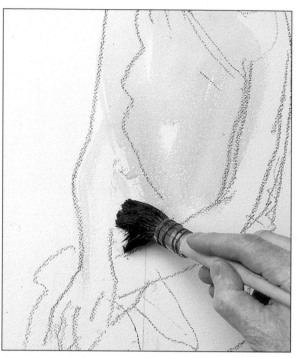

I lay in the lightest tone of wash.

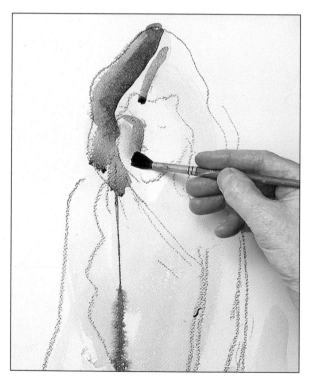

I am using a finer sable brush for the head.

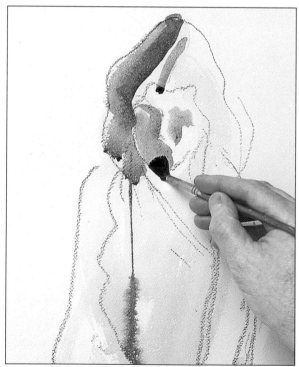

I am choosing to bring out certain facial features.

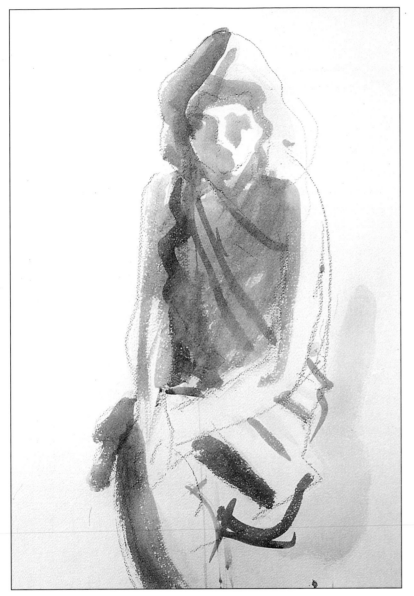

The mid-tone has proved much more useful in this second exercise than it did in the previous one. It plays a descriptive role, in the same way as the stronger tone did in the first exercise, while the dark tone is reserved for picking out the gesture of folds within the draped body.

straight away. I find that it is then rather satisfying to put in the highlights with white for the finishing touches.

Tone is a concept which is sometimes difficult for novices to understand and to 'see'. Black-and-white photographs are really tonal studies in that shadows, tones and local colours are translated into light and dark shades of a single colour. A simple way of making the

tones in a subject easier to see is to stand back and study it through half-closed eyes. This makes everything look darker, so the dark areas really stand out and the light areas become more obvious by contrast. You'll often see artists screwing up their eyes and squinting at a subject. They may be looking for the tones, or they may be concentrating on some other problem such as composition.

Drawing the clothed figure

I find drawing the clothed figure rather easier than drawing the nude. The sections and points of change are more discernible, and so are the measurements. The contours, too, are more defined – and are therefore easier to see.

Perhaps the most difficult thing for the beginner, when drawing the clothed figure, is to find the form hidden beneath. This tends to become more difficult as the weight of the fabric increases: it is easier to find the form beneath silk than tweed, for example. If you remember that all folds in the fabric radiate from the points of the body that are in articulation, or stretched by a movement, it becomes easier to find the form underneath.

Preliminary studies

These exercises will entail studying the qualities of various types of material: their weight, their texture, how they absorb and reflect light. You will find that different materials 'hang' in different ways. You will also notice that the tailor (custom) made suit looks and feels different from one bought off the peg (rack). When they wear *haute couture* clothes, women generally respond to the fit, style and richness of the material and therefore feel more gracious; as a result, you will find they stand and move in a more elegant way.

Try drawing a model draped in a series of different materials, repeating exactly the same movements. Use fabrics of varying weight, such as silk, wool, heavy flannel, brocade, lace, cotton, satin, cashmere – and any others you may think of. In this way you will be able to see that all fabrics have different properties in respect of the quality of their folds, how they hang and to what degree they take on and reflect back the light.

It is above all the quality of the folds that explains the type of material – several light folds in sheer fabrics, fewer, larger ones in heavier weights – and your line should react to that. Again the important thing is to draw what you see, rather than what you know to be there.

A lined jacket has a certain stiffness around the lapels and the shoulders.

Whereas the lined jacket sits somewhat stiffly over the body, the lightweight brushed cotton blouse drapes the figure more softly, its folds gently billowing and dropping away from the form. The pencil line should reflect this contrast, indicating the properties inherent in different materials.

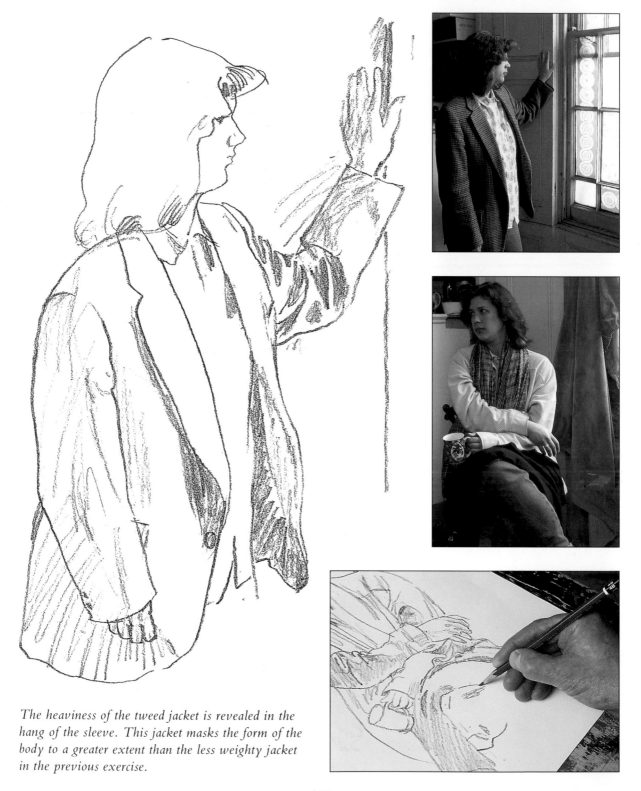

The heaviness of the tweed jacket is revealed in the hang of the sleeve. This jacket masks the form of the body to a greater extent than the less weighty jacket in the previous exercise.

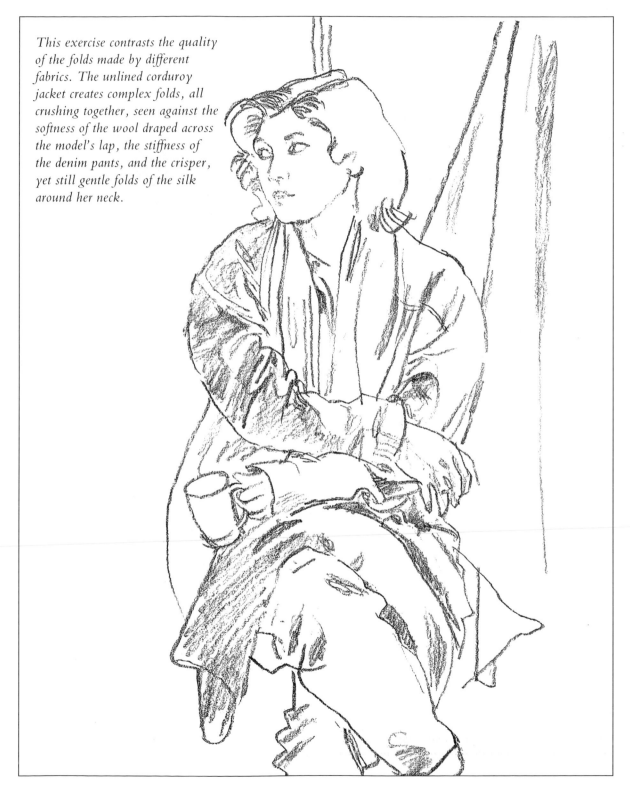

This exercise contrasts the quality of the folds made by different fabrics. The unlined corduroy jacket creates complex folds, all crushing together, seen against the softness of the wool draped across the model's lap, the stiffness of the denim pants, and the crisper, yet still gentle folds of the silk around her neck.

Project: The extended drawing

You will need
- ☐ board with cartridge (drawing) paper
- ☐ 2B, 4B pencils
- ☐ kneaded eraser

Here we are attempting to bring together all the knowledge gained so far from the previous exercises, with the addition of composition. The extended drawing has to be considered in a fairly abstract way; the final drawing might look rather mechanical but that doesn't matter. You have to consider the placing of shapes within the rectangle, and the rhythms within the whole composition. Concentrate on getting it right in these abstract terms.

Edgar Degas 'The Cotton Market, New Orleans' 730 × 920mm (29$\frac{1}{4}$ × 36$\frac{3}{4}$in).

Composition

Before starting your definitive composition, do a few sketches of the set-up before you. Analyze what the composition should be, not forgetting that shapes left between objects and the figure can be equally important, and that areas left empty on your drawing have their place. By doing this you will be able to start the composition with a sense of purpose, placing lines and areas by enlarging those you have selected as the best on your sketches.

Be bold when drawing the main lines of the composition; draw them in quickly and lightly. Be as abstract as possible at this stage because once you start to involve yourself in the figurative element, you will not be able to push the composition about. Absolute accuracy in terms of measurement and proportion is not important, although you should have some general relationship between them. Speed is important as it will keep your mind on the essence of the task. Use your eraser if you really feel something is wrong, but keep the lines you think are most interesting, and don't get fiddly: a clean drawing is not possible or desirable using this method.

Once the composition is fairly resolved, you can allow yourself to get involved in whatever interests or excites you, bringing to the drawing some sense of measurement, delineating shapes, using contour and cross-sections to define the spatial aspect – and not forgetting, for a minute, the gesture. Tone can now be introduced too – try to keep a balance of weight within the whole area. All this should be done with some sense of speed and a feeling of creativity, otherwise it will go dead.

Try to be as positive as possible in your composition. There are moments when you will feel tentative, quite rightly; there is an awful lot to keep juggling and to keep in control, but the important thing is to explore, to find out. Don't worry too much about the result. Most artists do not work from life when they paint a complex composition, especially if several figures are involved. They usually find individual studies much more useful. Degas and Sickert certainly advocated this method.

Stand back from time to time and you will be able to make a fresher assessment of your drawing by getting farther away from it. All you have done so far has been pretty abstract – but you mustn't forget what it was that inspired you to make a record of the situation. Return again and again to the initial impulse you had.

How composition works

Analyzing a well-known painting in terms of composition can be very helpful. Degas' 'The Cotton Market, New Orleans' is a fine example of a composition that would have been put

together from individual studies. Watch how the people in the picture behave, and their gestures as they interact: the older gentleman in the foreground, obviously the senior partner, examining and tugging, testing the cotton; the rather raffish-looking younger man reading a newspaper, his son-in-law possibly, not too interested in the business, I suspect; he may be looking up cotton prices but on the other hand is probably looking at the racing pages. The cashier at the right-hand side of the picture, doing the account books, with the waste paper basket at his feet, brilliantly brings the composition round to the middle group of figures, dealing with a parcel of cotton covering the table, ending with another casual-looking figure leaning on a window sill.

Notice the number of verticals repeating through the composition, the strong black shapes of their business suits running into each other, creating an abstract pattern; although there is no interior modelling, each figure seems to 'read' perfectly.

Notice, too, how the black hat on the man in the foreground cuts into the white cotton lying on the table, making a more interesting shape of the white area. Indeed, the composition is brilliant in the way it uses little dashes of white here and there – on shirt cuffs, collars (always perfectly describing the form by its section) – leading the eye around and sending the composition spinning onwards.

By these means, Degas makes the painting lively, conveying a sense of bustling business.

Composing within the shape of the paper, I started by establishing the big vertical of the easel.

A two-hour exercise

This exercise is intended to build up discipline in terms of accurate measurement, of direction the forms take, of cross-sections and the relationships between them, and in the ability to jump from figures to background and to surrounding objects.

As this will be a fairly long pose for the model to sustain, make sure that she is comfortable, either sitting or reclining: very few models will stand for any length of time. It is also preferable to have the model doing something, in a natural kind of situation – it makes a point to go for. Obviously the model is the focus, but try to make the set-up as

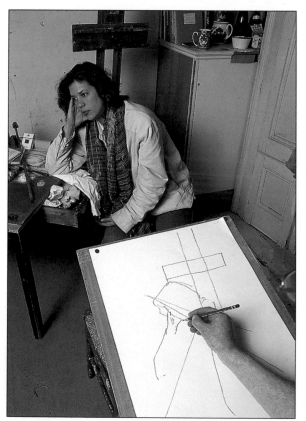

Establishing a relationship between the head and the easel has given me a degree of measurement in relation to which I can look at other elements.

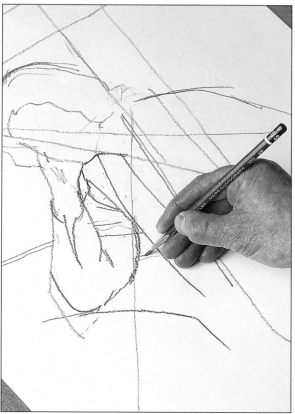

Judged against the vertical line of the easel in the background, there's a strong diagonal line running through the body.

interesting as possible by using props, such as drapery, cushions, maybe a plant. They should of course be related to the figure.

Develop the drawing by measurements, directions, shapes within and about the figure and surroundings. The whole drawing should be developed at the same time. Do not draw the figure in isolation, tacking on the surroundings later: every line has a bearing on the rest.

Measurement

Draw sight-size. Drawing larger than you see naturally is giving yourself an extra problem. From the very beginning you will be establishing marks of measurement which you can relate to throughout the exercise. With this

in mind, it is as well to find a small unit, such as the head. (Of course, with some poses you might not be able to see the head, in which case any small unit will do.) One reason for choosing the head to start the drawing is that it is easier to establish the shoulders on the head and neck, than the other way around. It is also always easier to draw from the top downwards.

Having decided on your unit of measurement, you can now see how many units, or fractions of a unit, go into a larger measurement with some degree of accuracy. Try to do this by eye; you can check with your pencil held at arm's length vertically, with the tip of your pencil at the top part of the unit, your thumb marking the bottom part.

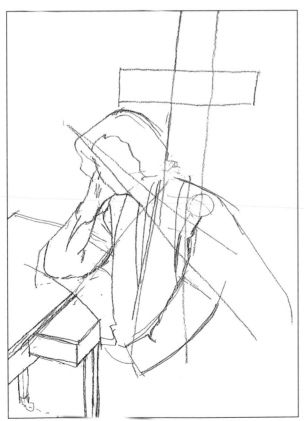

The piece of drapery has given me another measurement and a clue as to where to draw the side of the drawer, which I see as a pure shape.

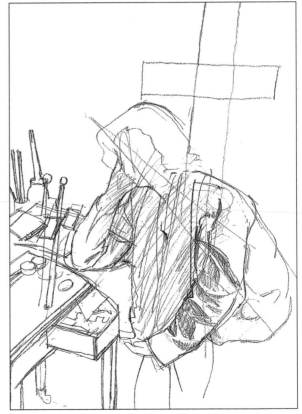

I am now making a lateral development and drawing various objects alongside the body. These verticals, or near verticals, are now coming together.

I am now getting a bit further into the head, developing it from the blank stage. It is important to find the contours of the eyes, the mouth, the nose and the chin; since the head is bent forward, they are on a tilted plane.

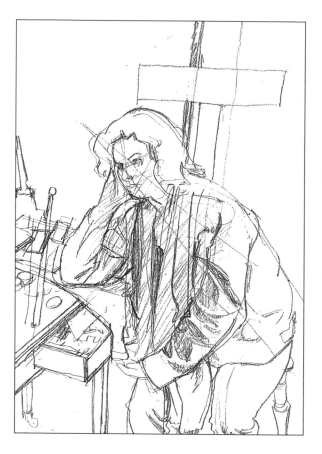

I'm still looking for directions and rhythms, trying to see it in a fairly abstract way.

Left: I decide I need to readjust the composition because all the weight seems to be at the bottom. To get a better balance, I take a bit off the empty space at the top and draw in feet.

Right: This makes for a happier composition, proving that nothing is so final that it can't be adjusted. I am now satisfied that the directional lines are strong enough, that the proportions work, and that I have filled in enough detail in the drawing.

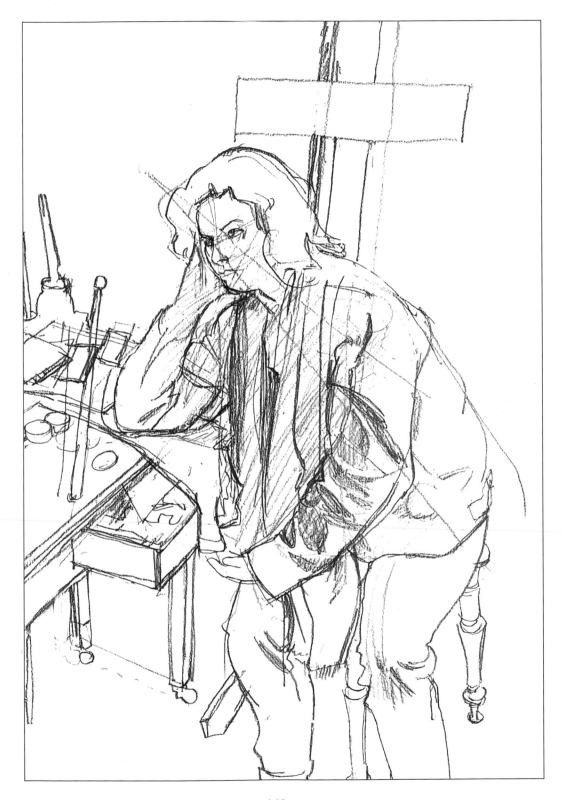

Using a sketchbook

It is a good idea to carry a pocket-size sketchbook about with you all the time. You will benefit by keeping your pencil active and, by constant use, you are training your eye and powers of observation, as well as stretching your drawing ability. Don't worry about the results or about whether you get everything you would like to down; even the merest scribble is useful.

A studio can be a very lonely place and I enjoy the stimulation that one gets from sketching outside. By being always on the lookout for material, I find that almost anything that presents itself is worthy of note. Sketching new subjects is a source of renewal, even if the material is not used. And if you are by yourself and bored, sketching is a means of usefully passing the time.

I sometimes take a larger sketchbook out, with the intention of spending a few hours at a specific place, where I know I'll find something interesting to draw. Workplaces very often fit the bill, since each job seems to have its own gesture, its own rhythm. Not only do you have people doing exciting gestures, but very often there are interesting backgrounds too. The atmosphere can also be exhilarating, especially if it's busy. Most people engrossed in their work pay little attention to you while you are sketching, which is of course an advantage.

I am sketching the gestures seen in faces, captured here in a bar in south-west France.

What to look for

It is always worth sketching the gestures people make when carrying out certain activities. This could be people at work, on holiday, people involved in sport – as well as relaxing. I have found that some of the most interesting gestures are made in bars, cafés and clubs. Their gestures, and the way people interact in groups, reveal a lot about the sort of people they are, their different characters, different modes.

I find it particularly interesting to watch how figures overlap. Scribble the shapes they make, and the main lines of movement.

I enjoy collecting these examples, almost caricatures, of stagey Frenchmen.

An interesting composition is made by these overlapping heads, turned in different directions. The patronne *behind the bar gives it a sense of occasion.*

These sketches were all made quickly in public places, in cafés, at the races (below) and in a park. In each case something caught my attention and I made a note for possible future reference. In the drawing (below, right) the initials represent colours – this is a quick and easy way of recording colour in a sketchbook.

I liked the repeated gesture in the foreground.

The sense of outside and inside is interesting.

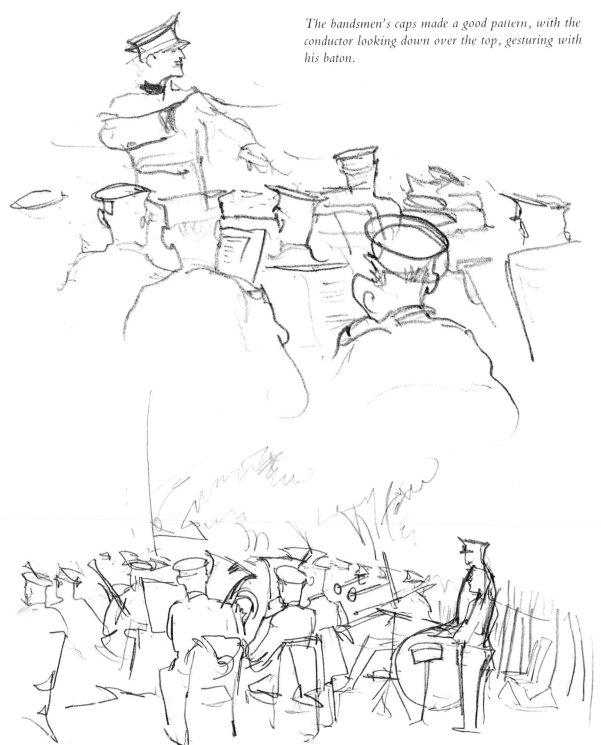

The bandsmen's caps made a good pattern, with the conductor looking down over the top, gesturing with his baton.

The layered composition of backs, caps, and the big drum captured the feel of the moment on a summer afternoon in Chelsea.

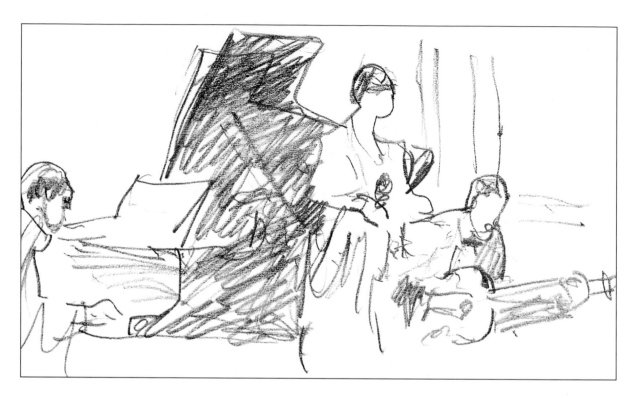

Left: *A musical evening at*
Chelsea Arts Club. I tried to
capture the marvellous shape of
the grand piano with its lid, and
the horizontal movement of the
guitar in these sketches.

Dinner at Chelsea Arts Club:
little gestures reveal different
personalities.

Above: *I sketched this group*
conversing when the concert was
over to show the different
attitudes people take when
listening or talking.

The composition of overlapping
heads interests me. The half-head
on the left can still convey a lot
about a personality.

I did a series of sketches while sitting in the auditorium watching the All-American All Stars band, featuring the late Slim Gaillard, famous jazz pianist and composer. I drew as fast as I could to capture the excitement of the moment.

These two sketches were done within seconds of each other, the musicians rearranging themselves as they played. I particularly liked the gesture and the grouping of the trumpeters.

Musical instruments make strong and interesting shapes in themselves, but I also tried to capture the exhilarating feeling of music being played.

I liked the faces of these two Spanish guitarists, playing in a coffee bar in the late 1950s.

177

Frenchmen enjoying aperitifs outside a café.

These chairs and tables created a rhythmic pattern.

Sitting outside a country pub on a summer's day.

A young boy holding a rugby ball.

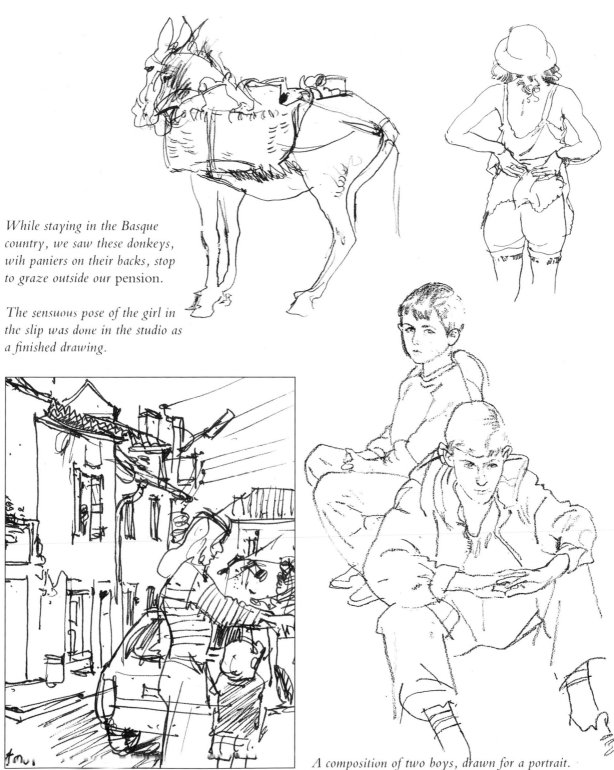

While staying in the Basque country, we saw these donkeys, wih paniers on their backs, stop to graze outside our pension.

The sensuous pose of the girl in the slip was done in the studio as a finished drawing.

A street scene in a village in south-west France.

A composition of two boys, drawn for a portrait. Character is expressed through their bodily gestures.

In conclusion

These three finished drawings bring us full circle to the subject of life drawing. The beauty of using a model is the freshness it brings, enabling you to discover every inch of the human form, as though you had never seen it before in your life.

In their day, Klimt and Rodin had access to models so cheaply that they kept a small group permanently on hand in their studios. It is significantly more expensive to hire a model these days, but I hire one for two hours whenever I can. I draw very quickly and might get nine or ten drawings out of it, a couple of which will really work. I don't direct models, on the whole, but let them be spontaneous, finding the pose as they move. I like only natural poses, not anything too 'posed' as is all too often offered in art school.

The free relationship between artist and model is all-important. There needs to be a certain chemistry between you; you need to feel excited by the model, or the drawing won't convey any excitement.

It is always important to surprise yourself when drawing. Never allow yourself to get stale by repetition.

You can read books on anatomy, drawing or painting, you can study the works of the great Masters, but there is no substitute for sitting down in front of the model and looking and drawing. No matter how many times you have done it before, no matter how many years you have been drawing from life, you will always make new discoveries. By approaching the subject with fresh eyes every time you will continue to learn more about the human form, and will also learn to handle drawing materials with greater confidence and skill.

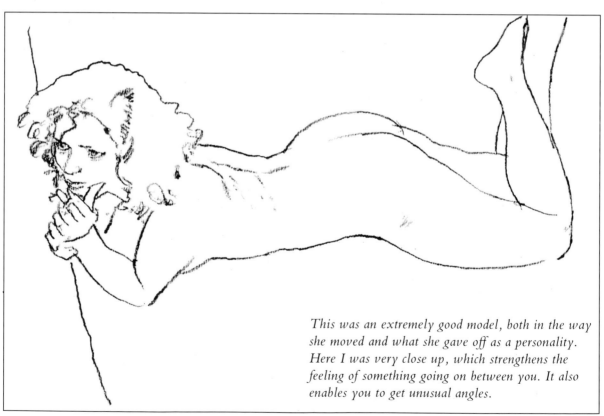

This was an extremely good model, both in the way she moved and what she gave off as a personality. Here I was very close up, which strengthens the feeling of something going on between you. It also enables you to get unusual angles.

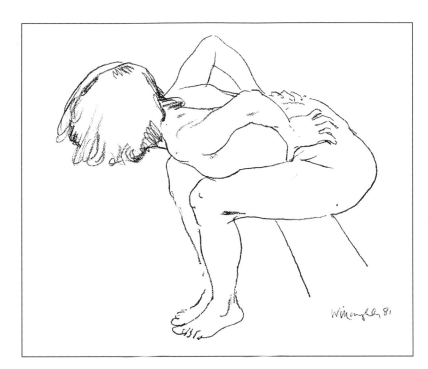

I liked the strong movements contained within this pose, running through the model's arms and legs. There is a pleasing follow-through within the contained strength of her body, right down to the head.

When you do portraits of babies and children you have to empathize with them and to respond to their characters. You have to love doing it, even tiresome young children! The main thing with babies is to respond to the quality of babyhood in them and to capture it.

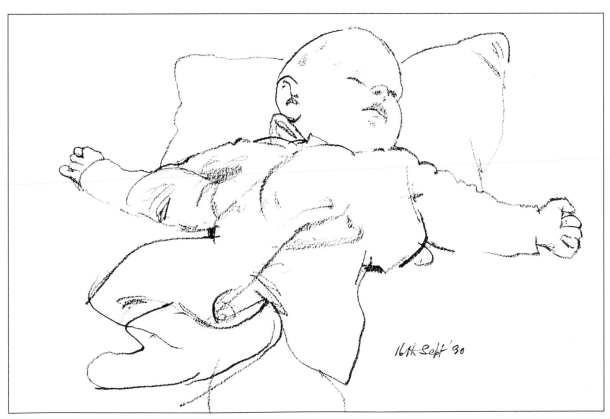

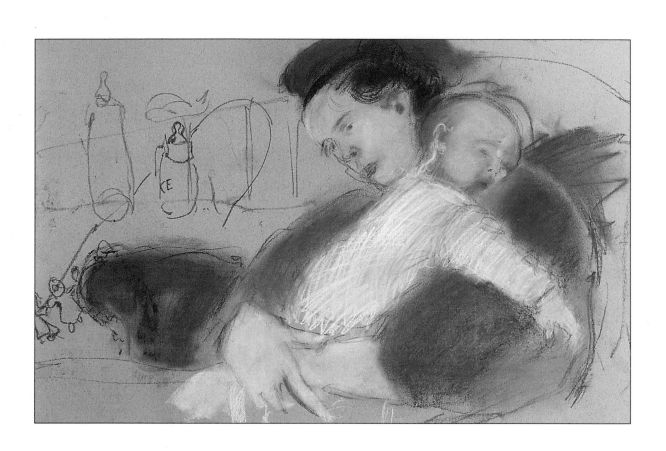

PART FOUR

Portraits

Introduction

In art, there is no bigger source of fascination, nothing that raises the emotions more, than the representation of the human form. But how many times have you visited a town hall or art gallery, and marched swiftly past rows of skilfully done, yet rather remote and uninspiring portrait paintings?

The portrait that really makes us stop and look is one that is a good picture as well as a successful portrait. It is also one that speaks to us across the ages. Rembrandt is perhaps the greatest exponent of this: his portraits draw you from across the room. They are not grand or complicated, but show people as real, sensitive human beings who may be vulnerable, despairing, innocent or lonely – and the faces he paints stay clearly in your mind. Rembrandt scrutinized the human face in such a way that his portraits almost look into the soul.

Few of us are ever likely to reach the standard of Rembrandt but I use him as an example because his portraits are simple and direct, and because many of his subjects were friends and family, as yours will probably be. Their purpose, surprisingly, was not primarily to create a likeness.

This preoccupation with achieving a good likeness is probably the biggest single thing that holds people back (some very accomplished artists, among them) from making portraits. My aim is to show that this should be way down on your list of considerations. First, and most importantly, I will show you how to construct a solid, believable shape that resembles a human being; secondly, how to compose a satisfying picture with this knowledge; and, thirdly, to ask yourself what you want to say about this person. The likeness will often arise as a result of all these considerations.

The pose, the expression, the clothes, the use of colour, the setting, and the composition as a whole – all these are elements that make a portrait really come to life.

I am not a professional portrait painter. Most of the portraits I do are non-commissioned pieces or have arisen as the result of bigger commissions in my capacity as artist-in-residence. I do not work to any set formula, and I believe that there are no shortcuts or magic recipes to portrait painting. In a sense, this makes things a good deal easier for the beginner, who need not be confounded with lists of rules and technicalities. But do practise as much as you can, look hard and learn from your mistakes.

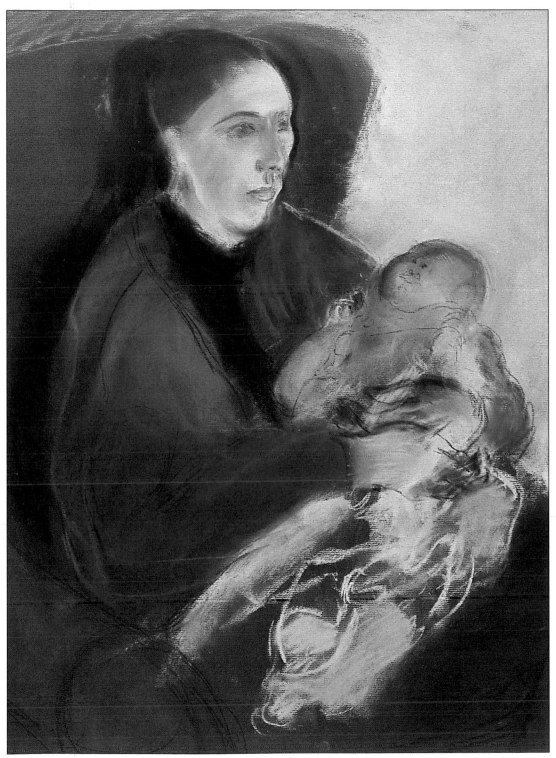

Jane Stanton 'Sam Sleeping II' 750 × 550mm (29½ × 21¾in), pastel.

The structure of the head

As with figure drawing, it is useful to understand some anatomy in order to make a good portrait, but obviously it is not essential to know the names of every muscle and bone in the body, or even of the head and shoulders, which are the most important for portraiture. It is enough to know that what goes on underneath the surface of the skin alters the features and, therefore, the appearance of the face you are trying to draw. The important thing to remember is that, as with most things concerned with the human body, there really are no hard and fast rules. Every head you draw or paint is different and theoretical knowledge is no substitute for looking and studying hard while you are working. You may find it useful to refer to the theory if a portrait appears not to be working, for example, but above all concentrate on what you see in the face before you, rather than what your knowledge of anatomy tells you should be there.

In this chapter, I have described only the elements of human anatomy directly relating to portraiture, that is, largely concentrating on the head.

The skull forms the basic shape of the head; the muscles and flesh are only secondary to this. The contours of the skull shape are the points from which you will measure off the location of the various facial features.

The skull

The basic structure of the head is determined by the skull: if you feel your own head you will realize that beneath the skin the bones of the skull are very close to the surface. While you are drawing, it often helps if you think of the head as basically an egg shape containing and protecting some of the most precious organs of the human body – the brain, the eyes, the mouth, the nose and the ears.

Each skull has its own individual shape and characteristics; indeed, it is interesting to note that nowadays forensic scientists can build up a good likeness of a person's face just from the shape of the skull.

Your own skull provides you with your best and most easily accessible study material – so get to know it. If you feel your own head all over, you will appreciate that the jaw, the cheekbones and the forehead have only the

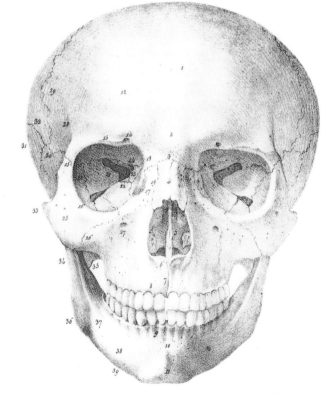

thinnest covering of skin very close to the bone. The top of the head, called the cranium, protects the brain. Feel around the orbital cavities, which protect the eyes, and realize how big they are in comparison with the rest of the skull. The cheekbones to a large extent determine the shape and character of the face. Feel how wide the jawbone is in relation to the mouth: this is the only moving joint in the skull. The cavities in the skull create the recessed, and therefore shadowed areas of the face, such as the cheeks.

Study the diagrams below and below right and mentally superimpose them on to each face that you draw.

The muscles of the face

The muscles form an extremely complex network of forms within the face. The muscles of the face and of the neck and shoulders are illustrated on the following pages to give you an idea of the endless permutations the muscles can make. You then start to get some sense of the complex network under the skin, the muscles working together to create the many facial expressions and actions, such as smiling, winking, frowning, expressing surprise, and so on. Try out the different actions as I list the major muscles and their functions, working from the top down.

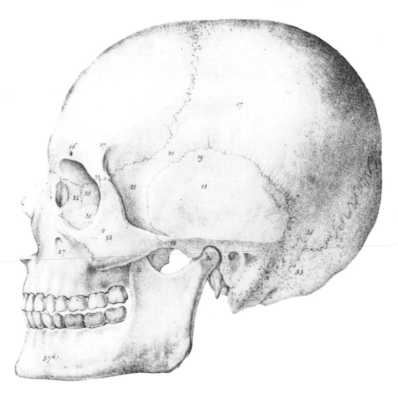

From a side view, you will notice how large the cranial part of the skull is in comparison with the 'mask' area (the eyes, nose and mouth). Try to think of this basic skull shape underneath your subject's face and describe it as you draw.

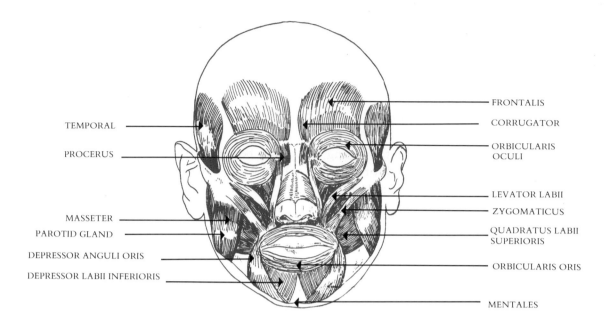

TEMPORAL

PROCERUS

MASSETER
PAROTID GLAND
DEPRESSOR ANGULI ORIS
DEPRESSOR LABII INFERIORIS

FRONTALIS
CORRUGATOR
ORBICULARIS OCULI

LEVATOR LABII
ZYGOMATICUS
QUADRATUS LABII SUPERIORIS

ORBICULARIS ORIS

MENTALES

The *Temporal*, the large muscle that moves the scalp, is not of great significance in portrait painting. The *Frontalis* is a flat area of muscle which causes the forehead to wrinkle. The *Corrugator* pulls the eyebrows down towards the nose. The two *Orbicularis oculi* encircle the eyes, opening and closing the eyes and helping you to squint or narrow your eyes. The *Procerus* is a small muscle which causes wrinkling at the top of the nose.

The *Orbicularis oris*, around the mouth, gives rise to some of the most expressive actions of the face. It is a sphincter muscle very much like the *Orbicularis oculi*, and capable of a great variety of movement. Many of the other facial muscles run into the *Orbicularis oris* and act against it. The *Levator labii* and the *Levator labii alaeque nasi* both lift the upper lip. The *Zygomaticus* muscles and the *Quadratus labii superioris* also lift the mouth, and help in smiling and grinning.

The *Depressor anguli oris* and the *Depressor labii inferioris* mark the beginning of the forms around the chin and work together to pull down the lower lip and the corners of the

mouth. The *Mentales*, which is often more noticeable in the male face, is made up of two cones which cause a cleft in the chin in between them; they work together to cause expressions of doubt and also to form small dimples on the chin.

The *Buccinator* is used for sucking and blowing, while the *Masseter* creates the chewing motion and holds the bottom jaw against the top jaw. Its form varies in size from one person to another. Finally, the *Parotid gland*, which produces saliva, is a significant part of the facial form and causes the fullness of the jaw, particularly in the male face.

The muscles of the neck and shoulders

The head is a very large and heavy form in comparison to the rest of the body's extremities and it is supported by the neck and shoulders. I often start my portraits with the shoulders, thinking of them as the ground from which the neck grows; the neck is the column supporting the head.

This basic structure of shoulders, neck and head has to be right in order to make a head look convincing. If you plan where the neck and shoulders will be before you begin to work on the facial features, you will achieve a more solid and lifelike structure than if you add the neck as an afterthought.

The neck and shoulders contain fascinating forms which should not be ignored for portrait painting. They are composed of muscle and bone, with the exception of the epiglottis, or Adam's apple, which is made of cartilage. You will also notice as you draw and paint more people, that the epiglottis is more pronounced in males. Explore the muscles of your own neck and shoulders with your fingertips, and identify the main points show here.

The Clavicle, commonly called the collar bone, is often very prominent and can be a very interesting form to draw, especially in people who are thin.

The Sternomastoid or *Sternocleidomastoid* is a large and prominent muscle of the neck. It winds gently round from the ear and down to the suprasternal notch at the front.

The *Hyoid* muscles, which run from the hyoid bone to the clavicle, are strap muscles which help you to raise and lower your head. They become stretched when you throw your head back. The *Digastric* lets you open and close your jaw.

The Suprasternal notch is a very good constant reference point, located in a direct line down from the chin at the top of the ribcage.

The Trapezius is the large muscle which lets you raise and lower your shoulders. It goes from the back of the neck across the shoulders and down to the back proper. The *Platysma*, just below the skin, is a covering muscle.

The trapezius and sternomastoid are very well developed in sportspeople, particularly if those sports involve throwing and lifting.

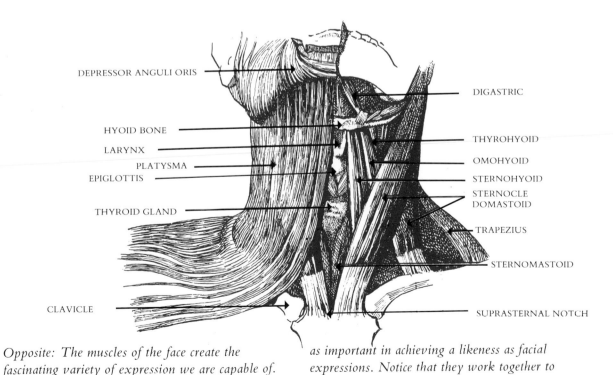

DEPRESSOR ANGULI ORIS

HYOID BONE

LARYNX

PLATYSMA

EPIGLOTTIS

THYROID GLAND

CLAVICLE

DIGASTRIC

THYROHYOID

OMOHYOID

STERNOHYOID

STERNOCLE DOMASTOID

TRAPEZIUS

STERNOMASTOID

SUPRASTERNAL NOTCH

Opposite: The muscles of the face create the fascinating variety of expression we are capable of. The muscles of the neck and shoulders (above) can be as important in achieving a likeness as facial expressions. Notice that they work together to support the head.

Facial features

Before you tackle a whole head it is a good idea to practise drawing the individual features of the face in your sketchbook as frequently as possible. Study your own face in a mirror, or try drawing a friend reading, sleeping or watching television.

You can learn a great deal by drawing from paintings in art galleries or from reproductions in books. Go through the features in turn and make several small studies in a sketchbook, filling a page with drawings of each.

On the following pages I have made some studies of separate features – some are drawn from my own face, others from the faces of friends, and several are from the works of the Old Masters. Take some of these drawings as examples to copy, then make up your own different expressions and viewpoints.

The eyes

I have started with the eyes because they show us the real character of a person. Because of this, they are the most difficult feature to capture. They become less so if you think of the eye as being a sphere, and realize that what is revealed is only a small part of it. Remember that the eyelids have a thickness of their own and cast a shadow over the iris. The only way to gain confidence in drawing the eye is to practise again and again from life and to copy.

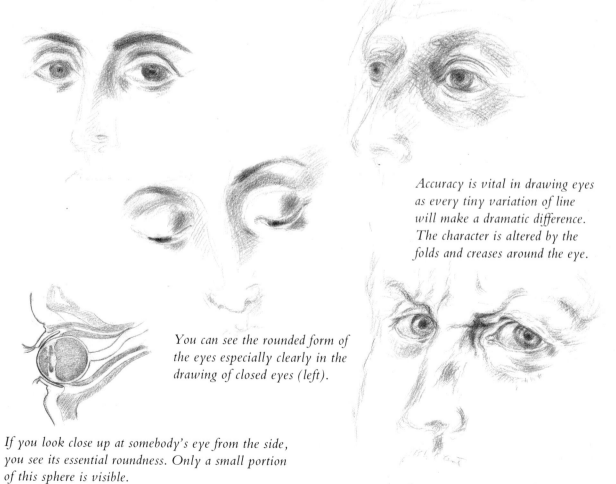

Accuracy is vital in drawing eyes as every tiny variation of line will make a dramatic difference. The character is altered by the folds and creases around the eye.

You can see the rounded form of the eyes especially clearly in the drawing of closed eyes (left).

If you look close up at somebody's eye from the side, you see its essential roundness. Only a small portion of this sphere is visible.

The nose

The shape of the nose varies tremendously from one person to another. The diagrams below will help you to understand the basic structure and begin to give you an indication of the endless varieties of shape found in the nose. The nose is made of bone, cartilage and fat which forms the nostrils. It is good practice to make quick sketches of noses from faces on television; repeated practice gives you confidence in your drawing ability.

The nose is not capable of a great range of expression, as the eyes are, but it nevertheless forms the basic character and individuality of the head. Draw some noses from people of varying ages and from different viewpoints as I have done here.

It is interesting to note that the nasal cavities are rarely symmetrical: this is because the partition of cartilage between the two is normally deflected to one side. The nasal bone ends at the top of the nose, forming the often distinctive bridge.

The mouth

It is important to get the mouth right so it is often a good idea to leave it until the last moment, to define all its forms.

Sit yourself in front of a mirror with your sketchbook and draw your own mouth in a variety of expressions. Note that the teeth are not usually revealed, and that if the mouth is open the teeth are shaded. Try to let the forms develop in a subtle way out of the face; don't think too much about the colour of the lips.

The ear

The ear is often considered a minor detail but the ears are in fact of great importance. They are made of cartilage and fat and, like noses, vary tremendously in shape from one person to another. Fill several pages of your sketchbook with ears. They are beautiful, elegant forms.

The most important point to note about ears (and one that many beginners fail to appreciate) is that they 'grow' out of the head and are not tacked on like appendages.

Like the eye, the mouth has an orbicular muscle around it which makes it capable of a wide range of expressions.

One of the commonest mistakes in drawing the mouth is to imagine that there is a line all around it. The only real change is in the colour and texture of the skin. The most important shadow and line to be emphasized is between the lips. The upper lip usually overhangs the lower, and casts a shadow on it. But the lower lip usually catches more light.

The diagram above shows the main underlying forms within the lips: three at the top and two at the bottom.

Hands and arms

After the face, hands are the most significant part of the body. The human eye will always look to see what the subject is holding or where their fingers are pointing. In the paintings of Van Eyck or Goya, for example, the hands were often an opportunity to draw attention to a particular document or piece of jewellery.

If you feature hands and arms in your work you will find that they become a secondary focus of attention, after the eyes. What the sitter does with his or her hands may signify their innermost feelings, or an important facet of their personality.

Many people get into difficulties drawing hands. If you bear in mind that the thumb operates independently from the rest of the fingers, and draw it separately, this will help. You will get into trouble if you tackle each finger individually, one after the other – you may end up having to count them to see if you've got them all in! Remember that a hand can span the face from chin to forehead, so don't underestimate the size.

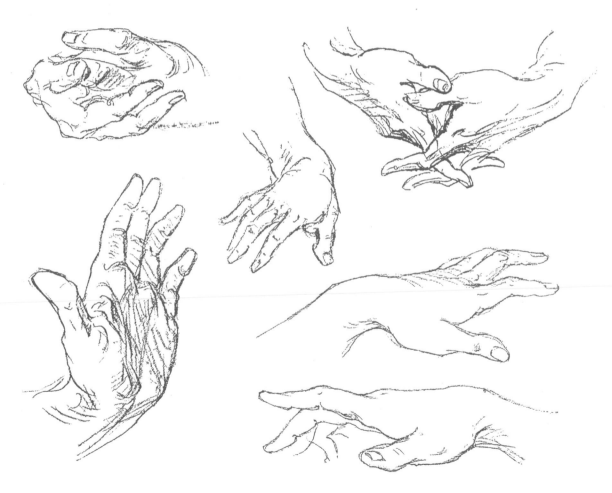

A selection of hands. The wrist is one of the most highly articulated joints in the body, giving rise to the infinite variety of hand positions.

Proportion and perspective

Getting the proportions and relationships correct in a portrait is vital if you wish to achieve a likeness. The head should be in proportion to the neck and shoulders, and the forehead in proportion to the cheeks, the chin and the jaw. Perspective does not usually present too many problems in portraiture, although viewpoint can be significant.

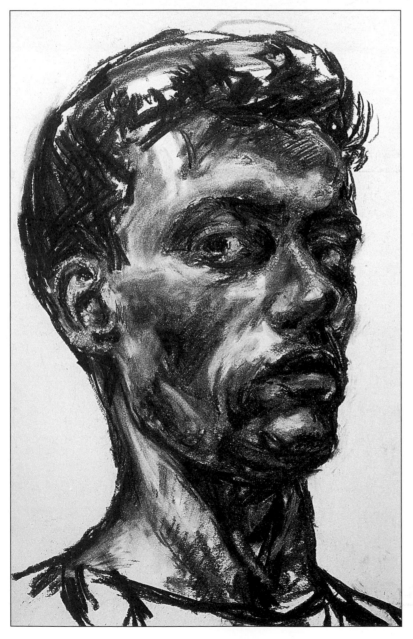

Left: Peter Evans 'Self portrait' 500 × 400mm (19½ × 15½in), pastel. The moody, superior tone of this portrait is heightened by the angle from which the picture is drawn, that is, from slightly below the head, with the subject seeming to look down on us. The neck is emphasized and has to be drawn well as our eye runs along it up to the central focus of the head. The three-quarter view gives a very solid, sculptural quality to the head.

Right: Jane Stanton 'Frank, Writing' 530 × 460mm (21 × 18in), charcoal. This portrait, depicting the writer immersed in his books, was drawn from a standing position, looking down on the subject, which emphasizes his absorption. The top of the head is fully on view, with the features appearing to be crowded into one small area. This is also a three-quarter view but slightly inclined at an angle. With a complicated viewpoint such as this, careful observation and measuring are required in constructing the features.

194

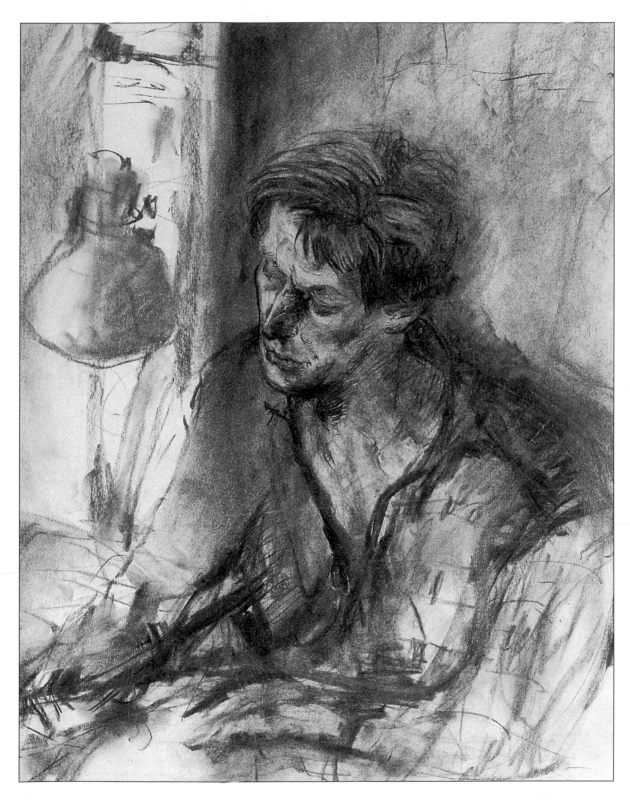

Measuring the head

The starting point for measuring the head is the 'tilt line' or central axis. This is an imaginary line which bisects the face vertically between the chin and the eyes and suggests the inclination of the head. All other measurements can be made using the tilt line as a basis.

To establish the tilt line, hold your pencil up at arm's length and parallel to your own face, inclining it at the angle of the observed tilt line. Bring your pencil smartly back to the page at the same angle and mark it in faintly. Roughly suggest the oval of the head with a pencil line. Repeat the tilt line process again, horizontally, to give you the direction of the eyes, and for the nose and chin. All other measurements can be taken from this reference point. For example, the bottom of the ear lobes always begins at the top of the lips and they finish, at the top, on a line going through the middle of the eyes.

With practice this should become an instinctive process and you will dispense with the need for drawing axis lines and measuring dots. Don't get too involved with measuring because if it is taken too far your work will look mechanical, and it will kill the feeling and spirit of your picture.

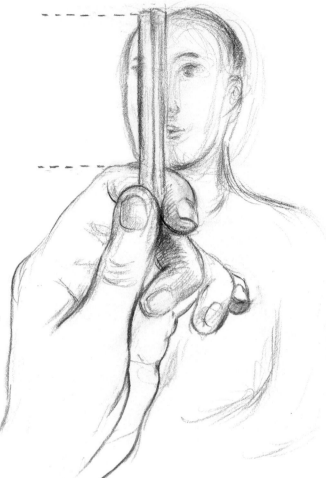

Use your pencil to 'bisect' the model's face.

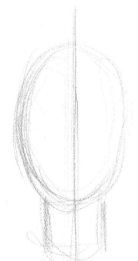

Tilt line in oval-shaped face.

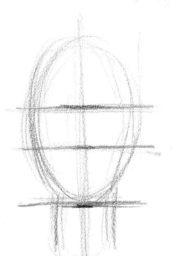

Tilt lines for eyes, nose, chin.

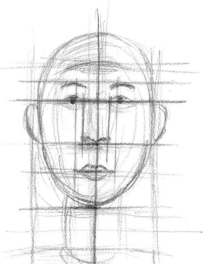

Measure from these lines.

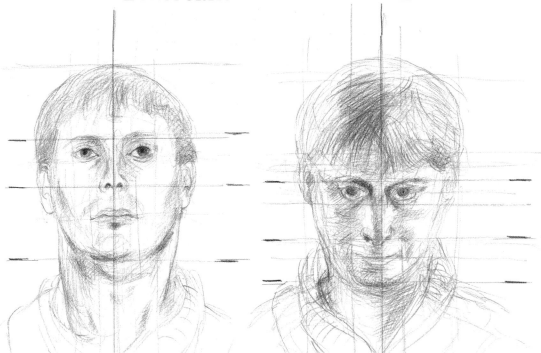

These four exercises of the head drawn in different positions show what happens to the position of facial features as the head moves.

The central axis remains the main reference point. Even with the head tilted forwards, the corners of the lips are still in line with the mid-point of the eyes.

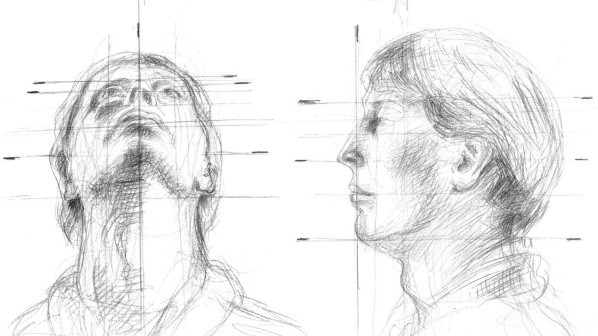

With the head thrown back, the features appear closer together.

In profile, the measurements and proportions become more straightforward again.

Light and tone

As you gain confidence in your ability to accurately represent the human face, you will inevitably want to bring more of a three-dimensional sense into your work. You can achieve this through the use of light and tone, which together with shadows will also impart a feeling of drama and atmosphere and a certain solidity to your portraits.

Light, tone and shadow

The two words light and tone are often confused when they are used in the artistic sense. Basically, light causes the different tones and the tones range from very light to very dark. If you look at the diagram below right, you will see that light hits the cube and causes an almost white upper surface, while the other sides of the cube take on varying degrees of darkness, or tones. Likewise, light makes the part of the sphere nearest the light source appear almost white. You will doubtless have observed artists squinting at their subjects as they work. This often helps to sort out the relative tones by heightening the contrast between them.

It is equally important not to get confused between tone and shadow. Shadow is the shape of the object as projected on to another surface (see both diagrams below). The rules of perspective can help you to understand how shadows 'work' in relation to the object that casts them, and the light source, and it is worth looking at a book on the subject for the basics. Theoretical knowledge, however, is no substitute for observation of your subject.

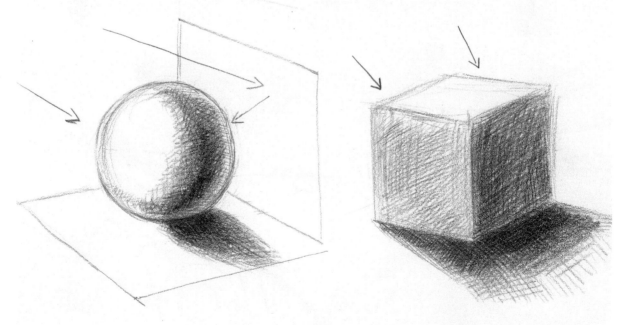

The directly lit area of the ball is on the left, but reflected light creates an additional or secondary light source, which gives form to the sphere on the right-hand side.

The upper surface of the cube is brightly lit, throwing the darker surface into complete shade and the other into semi-shade. Both surfaces, however, throw shadows.

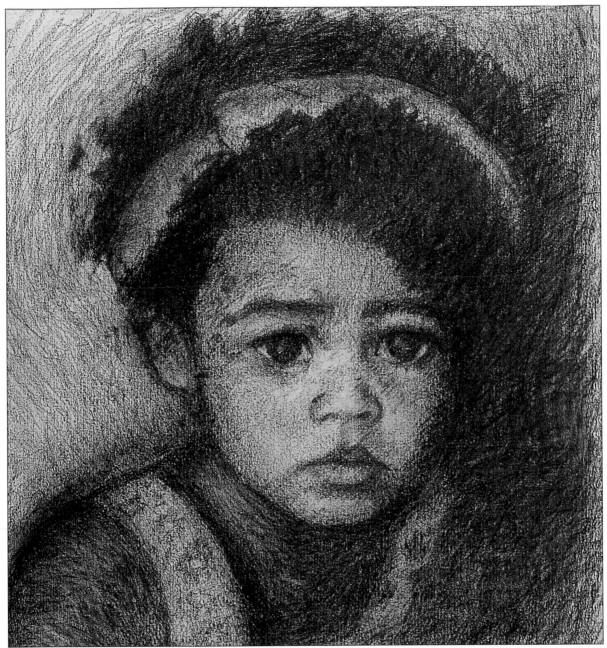

Bernadette Coxon 'Daisy' Drawing in black Conté crayon 280 × 250mm (11 × 10in). This portrait is interesting for several reasons. Notice how the lighter and darker areas are organized and resolved; then how they are determined by the little girl's face. The modelling on the outline of the cheeks, for example, throws them forward so that they appear as chubby young cheeks. The modelling underneath the bottom lip makes the lip project too, giving a slight pout to her expression. Considered work on the eyes gives the child her intense, almost staring, expression. Note also how skilfully the right-hand side of the head and of her neck and right shoulder dissolve into shadow.

199

Modelling the form

If we want to make our portraits seem more three-dimensional, or more solid, we can do this by 'modelling' with the brush or pencil. In painting we can also make the colours darker or more intense at relevant points. I have often heard this mistakenly referred to as 'shading in', and this you must strictly avoid. Remember that a shaded area is not an isolated, flat area, but part of the whole, and that the darker surfaces should still be describing the solid form you are depicting.

In your portrait you must go after a feeling of 'wholeness', and by this I mean a wholeness of form as well as the complete portrait itself. Where the form is concerned, you might make good progress by approaching it as though you were modelling your sitter in clay. Follow the form around with your pencil or your brush. The contours of the face undulate and alter in subtle ways, and this affects where the shadows are cast and where the tones appear darker.

Look at portraits to see how other artists have approached modelling, and try to learn from them, too.

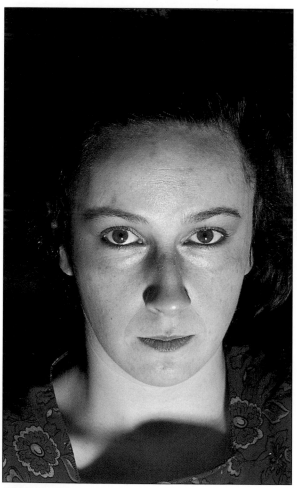

Photography always shows up the effect of light more dramatically than drawing.

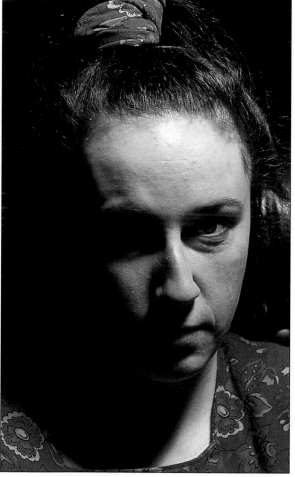

The face disappears completely into darkness on the unlit areas.

The effect of light on the face

It is important to discover for yourself how light affects a face. To do this, find a model (your own face will do) then take a desk lamp or a flashlight and sit the model in a darkened room. Try lighting the face from different angles and draw what you see. Concentrate on studying how the face is affected by different light sources, but still 'feel the form' at the same time. You will notice how the hollows in the basic underlying structure of the skull are revealed by the light.

The photographs on these pages show the results of different lighting angles. The advantage of setting up a pose using artificial light is that light and shadows remain constant.

In natural light the effect can be just as dramatic, but you must always be aware of where your main light source is. If you are painting or drawing by a window in natural light (unless the room is north facing) bear in mind that as the day wears on your light source will change both in direction and in intensity. For this reason, you might wish to limit the sittings to either mornings or afternoons.

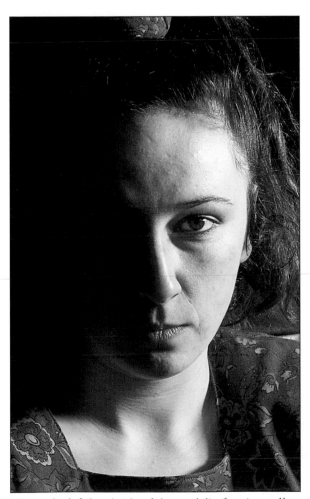

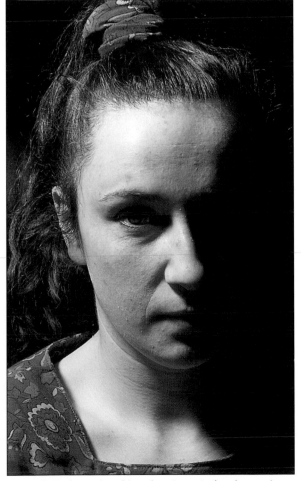

The unlit left-hand side of the model's face is totally obliterated in this shot.

Here the other side of her face is entirely obscured. Drawing can be more subtle than this.

The self portrait

The self portrait is an ideal practice ground for the novice portrait painter: you are available at all times, you will not get bored as you wait for the image to be finished, and you will not require a result that flatters you. Painting yourself is a very personal and private activity: nobody but you need see the results and it can easily be discarded if the attempt is unsuccessful. For these reasons the self portrait has often become the artist's most personal and direct expression of themselves.

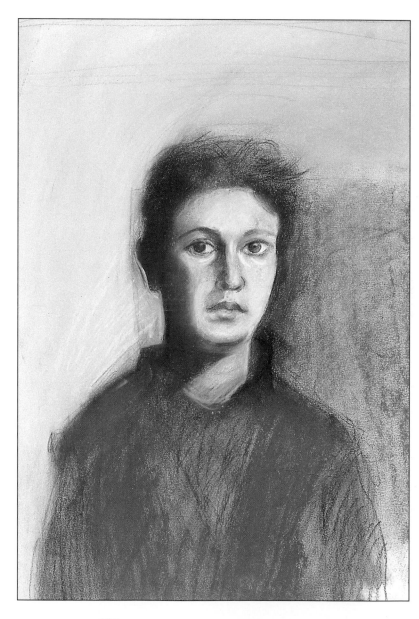

Jane Stanton 'Self portrait I'
660 × 490mm (26 × 19½in),
pastel. Like the other self
portraits on these pages, this one
was done quite simply for
practice; all are straightforward
and unpretentious but I learned a
great deal from doing them.

202

Throughout the ages, many artists have drawn or painted themselves, sometimes for practice in a sketchbook, sometimes as major paintings. Rembrandt's self portraits are well-known but Matisse, Picasso and Stanley Spencer regularly drew images of themselves.

The self portrait has always been important in my work. It gives me a chance to observe and explore a face over and over again, without having to get someone to sit for me. Interestingly, the biggest concentration of self portraits is usually done during the artist's early years. This may be partly because he or she has more time at that stage, with no family commitments and a lack of commissions. But it is also when the artist's work is at a formative stage and this is a very good way of learning, experimenting and establishing confidence.

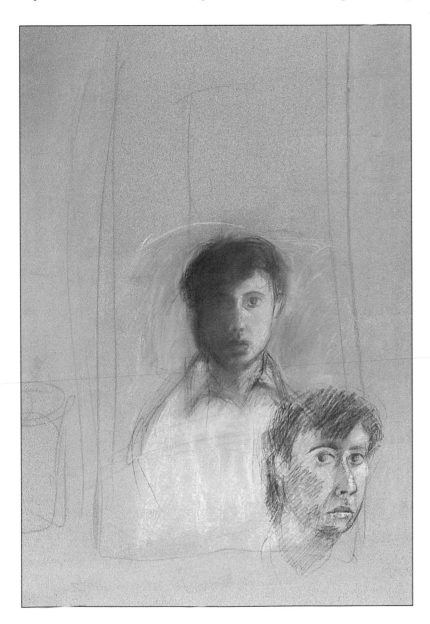

Jane Stanton 'Self portrait and Drawing II' 660 × 490mm (26 × 19½in), pastel and Conté crayon. In this rough study containing two heads, I wanted to experiment with a view of my head from two different angles and was too impatient to find another sheet of paper.

203

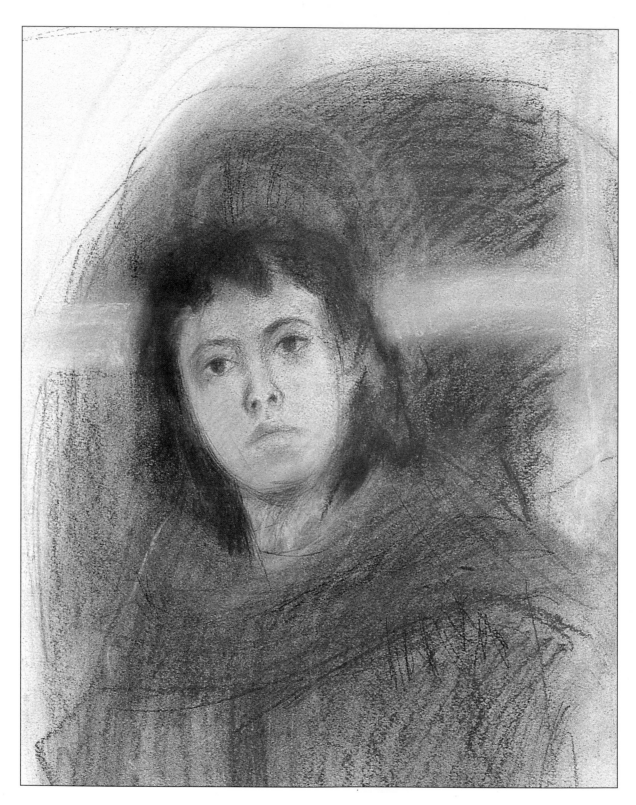

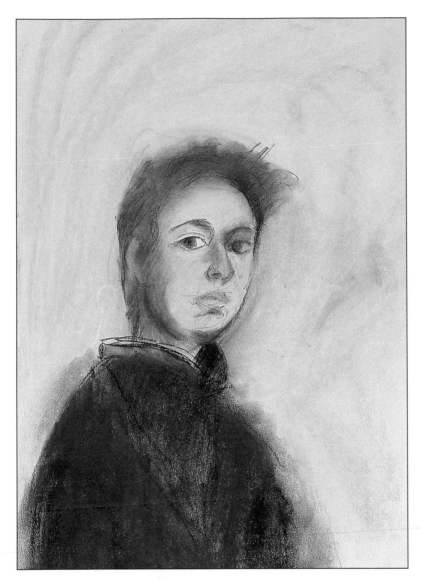

Opposite: Jane Stanton 'Self portrait III' 660 × 490mm (26 × 19½in), pastel and Conté crayon. In this self portrait I tried the mirror at a different angle so that I could see myself from below. I was also trying to see what effect the dramatic red scarf would produce.

Jane Stanton 'Self portrait IV' 660 × 490mm (26 × 19½in), pastel. Here, I wanted to take a slightly more oblique view, so stood with my body sideways on to the mirror, and turned my head to enable me to draw myself.

The composition of a self portrait can depend on what type of mirror you choose and where it is situated. I made the pastel studies on these pages in a large but portable mirror which reflected the view of the window in my studio. Many interesting self portraits have also been done in tiny mirrors, however, and convex mirrors, in polished silver and even from the back of a shiny spoon!

The reflection that one draws is never a true image of oneself, because the mirror reverses your face from left to right. Since nobody's face is exactly symmetrical, this factor will distort your appearance in any self portrait that you do. There are notable examples of self portraits done using two mirrors to achieve a profile, but most are made looking directly ahead.

Bear in mind before you begin that the subject of a self portrait will rarely look happy, because the intense concentration and the constant glancing up and down cause a naturally serious expression.

Project: Self portrait

The cheapest, the most amenable and therefore the easiest model for you to practise on is yourself and this you can do, whenever suits you, in the form of a self portrait.

During this project, try to think of the practice you have gained by drawing individual features and their basic shapes, but remember that they should now be treated as parts of a whole, since they all have a relationship to one another. Above all, keep looking at yourself, and believe what you see, not what you think you know about your face and features.

Suitable materials

For this project I have used a clutch pencil (lead holder) containing a 'pierre noire' lead, but you could use compressed charcoal, Conté crayon, or a soft pencil: don't worry about the medium, choose anything that is easy to correct or remove. Keep your pencil as sharp as you can, as a sharp pencil is easier to control.

It is best to concentrate on the head at first, without worrying about compositional aspects, your pose, the background, and so on. Also, at this stage, don't concern yourself too much with likeness either: just try to achieve a drawing that looks like a believable human being! If this is your first attempt at putting all the features together, don't expect perfection.

Initial stages

Lay down some initial faint guidelines at the outset that can be altered if they prove to be incorrect. Make sure that you glance up and down from your reflection to your drawing as frequently as you can, especially in these all-important initial stages.

Start to sketch in the positions of the features, making your marks as lightly as you can. I have already indicated where the hairline is; the fringe and the headscarf are essential components of the finished drawing.

Choose a position that makes it easy for you to glance often from reflection to sketchbook.

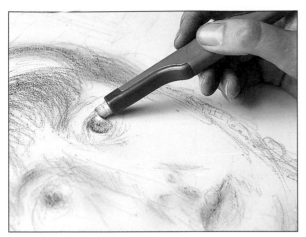

I am working on the eyes with a pencil eraser to get a rounded, shiny look to the pupils. Notice how broad and vigorous all my crayon marks have been.

I constructed a rough oval shape first, to represent the shape of the head, then sketched in the neck and, even at this early stage, showed the outline of the hair and my headscarf. The hair contributes to the general shape of the head and should not be added on as an afterthought. The hairline in particular is a great help in defining the general shape, character and construction of the head.

I find that it's a good idea to narrow your eyes and squint at yourself when you are trying to find the basic shapes; this abstracts the picture that you see and helps you sort out the essential from the unimportant details.

Once the main features were sketched in, I added some shading under the eyebrows, nose, chin and on the sides of the face. I later took away from some of the shaded areas with a pencil eraser, particularly when I was doing more work on the eyes. I had two light sources, which slightly complicated the issue, but this didn't worry me too much because I tried to show just what I saw.

The eyes

Try to work on both eyes simultaneously. Don't complete one and then move on to the other, otherwise they will never look as if they

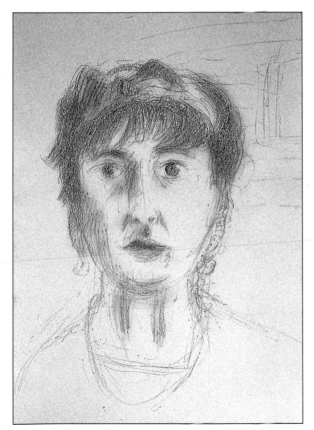

Here I have worked into the right eye in more detail. The shading to the left-hand side of the nose gives a more solid, three-dimensional feel to the image.

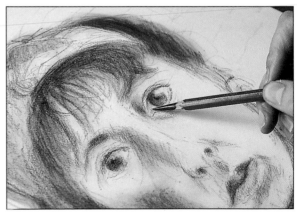

The eyes beg for more detail than other parts of the face. I worked into them with this EE pencil, sharpened to a fine point.

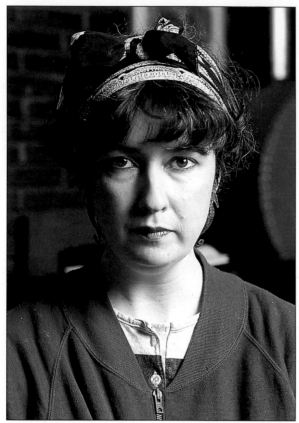

belong to the same person. My advice is to work on a drawing like this as if you were developing a photographic print, where vague impressions slowly resolve themselves and get clearer as time goes on. This way of working becomes obvious from the photographs of the different stages of my self portrait. My shading gets more and more intense as the portrait nears completion. I often achieve this effect by rubbing the surface with a piece of cloth, a paper tissue, or a sponge.

You will probably find, towards the end, that the features of your face are not symmetrical. This is true of all faces to a greater or lesser extent and is particularly noticeable in a mirror, since your reflection is in any case reversed left to right. If you do notice this, it means that your drawing has probably been going very well: you have obviously been looking and concentrating hard on what you see.

The image I was seeing in the mirror was different from this photograph, reversed left to right.

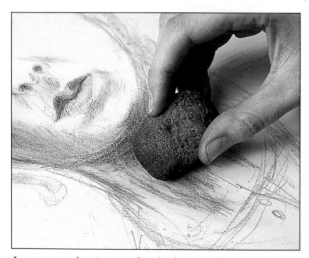

I am strengthening up the shadows under the chin, by smudging the pencil lines with a damp piece of sponge.

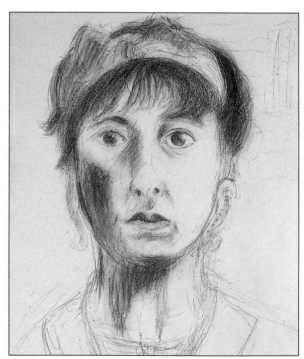

I have darkened certain areas to add to the tonal quality, and defined the hair more clearly. I held the picture at arm's length to gain a fresh view.

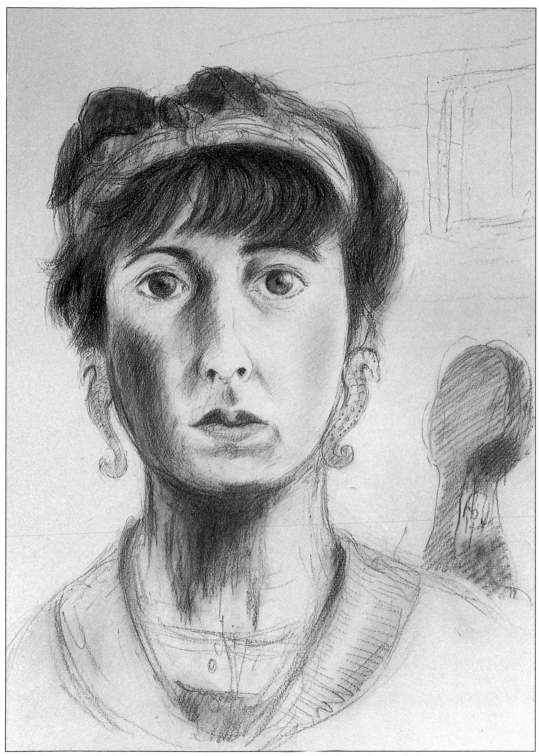

I decided to put the 'cello case in the background as it reflected the shape of the earrings.

An infinite variety

The human face is almost infinite in its variations – young or old, male or female, black or white – presenting the artist with a fascinating subject and an absorbing challenge. Remarkable changes take place in our physical features between babyhood and old age. The skull grows rapidly throughout childhood: most noticeably, the jaw gets larger and the teeth grow, altering the whole shape of the lower part of the face. The ageing process is reflected most clearly in our faces. These changes pose particular challenges for the portraitist.

The drawings on these pages are of my own son, Alfred, as a baby and a toddler. At first I became frustrated when the results were not as wonderful as I wanted. Given practice, I became less worried about producing a 'finished' piece, and had to be satisfied with the sketchy results.

Painting or drawing babies

Babies are notoriously difficult to portray, but it will help the beginner to bear a few points in mind. Babies' heads are enormous compared to the rest of their bodies; their lower jaws are undeveloped, they have small noses and full lips to make it easier for them to suckle, and their eyes are really large. The brain grows quickly in the early years and the skull has to be large enough to accommodate this. Babies also have hardly any visible neck: the head appears to sit right on top of the shoulders.

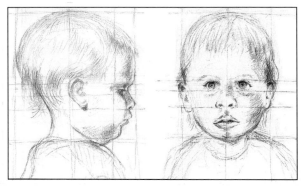

These pencil drawings show the proportions of the head of a two-year-old child. Note that from the eyes to the top of the head represents almost half the total.

When the baby is asleep is obviously an ideal time to make a drawing. You can really get to grips with the seemingly immense size of the head and the fullness of the lips and mouth.

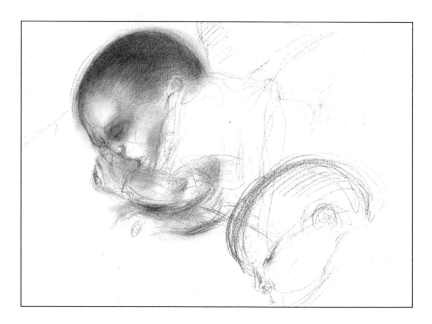

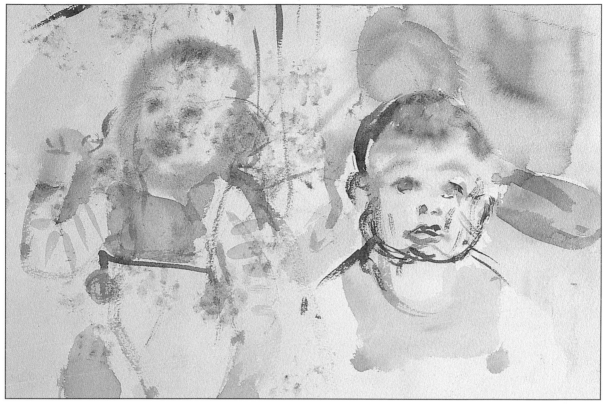

These watercolour sketches of my son were done while he was in a baby bouncer and in his high chair. Once babies start to be able to move around, it is important to limit the degree of movement you can allow them to a certain extent, as I did, in order to make a portrait.

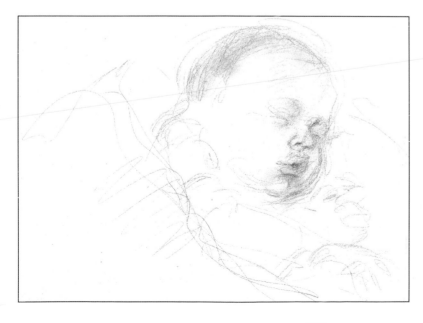

This portrait of Alfred asleep brings out his full cheeks and lips, which I found intriguing to draw.

These two heads were painted very rapidly in watercolour. I put down a basic pink oval shape first and then worked into it. Keeping two heads in progress on the same page is a good idea if the subject moves around a lot — which a child of this age is bound to do. You can then move from one picture to another with ease. I used a small brush on watercolour paper that was not stretched (there was no time), as you can see from the cockling that has occurred.

This changes as babies grow older. The neck gets longer and becomes more significant and the eyes, which in a baby are about halfway down the head seem to get progressively higher in the face.

Even when you are aware of these special factors, babies still present an incredibly difficult subject. One reason for this is that we tend to think in terms of the normal adult faces with which we are so familiar. My advice is to draw what you see, while keeping the anatomical rules in the back of your mind all the time. You could carry out an exercise to demonstrate how different the measurements and proportions of a baby's head are from those of an adult. Copy an image from a photograph of a baby and draw on it a pencil grid, then compare this with the grid lines of the head measuring exercise on page 196. Remember that the perspective will of course alter with any change in the position of the head.

Don't be surprised to find how much individual character there is in a baby's face, even a very young baby. The 'pretty pretty' baby portraits one often sees are simply stereotypes, which make clichés of the characteristics mentioned above.

Here, I started off painting a head straight on, and then went on to draw various profiles with the brush.

Colouring is very important in baby portraiture, and my little boy provided quite a challenge with his straw-blond hair, which is actually a lighter tone than his skin, and his blue eyes. To help you appreciate tones of colour, try to half-close your eyes as you paint, and see the overall mass of colour rather than copying each individual area. Blue eyes should never be over-exaggerated as the irises have a lot of shadow cast on them and in fact will appear quite dark.

I made many sketches and full portraits of my son Alfred during his early years. It is difficult to distance yourself when painting your own child. We all tend to think that our own offspring are beautiful and extremely appealing, so it is sometimes hard to be objective and paint their faces in a truthful way. To get a degree of accuracy, you must look at the head in abstract terms – in terms of overall colour and the relationship of the features to one another.

With a toddler or young child around the house, it is important to keep your art materials handy all the time so that you can sketch or paint whenever an opportunity occurs. You can, of course, use all the little sketches and paintings you produce to make more considered portraits in which you can try to bring out any aspects of their personality that you feel your quick sketches have missed. My son, for example, has a very direct stare which I have tried to capture in more formal portraits. The disadvantage of working in this way is that the results can look 'stiffer'. In many ways the informal approach is more satisfying.

Children

When making portraits of children you have to be able to work quickly because their patience soon runs out. You should cast caution to the winds and draw confidently, since it will be very difficult to have a second go.

The picture below of the group of children was made in a London school. The children were inquisitive and flocked around me, so I decided to draw them just as they were. It took some cajoling to persuade them to stand still for about 15 minutes, which was the length of time it took me to make this very quick sketch in Conté crayon.

The pastel drawing on the opposite page is of a small boy aged five. We discussed making the picture beforehand; I agreed that he could sit in front of his favourite video and that we would

have a rest every ten minutes. It was important to him that he could have a look every now and again to see how the portrait was progressing – it's no good even trying to be secretive when you are drawing children!

It was interesting to see how the face I drew was still reminiscent of a baby but was slowly transforming itself into the face of an adult. The cheeks have become less pronounced than those of a baby and the nose has started to form what will eventually become one of the most characteristic parts of the face. The whole face has also, in fact, started to lengthen.

I worked very quickly in pastel and, when I got to the face, I had to ask Sam to be especially still while I worked in the finer detail. I was expecting to be thwarted at any minute but this did not in fact happen and I think in the end I achieved a reasonable likeness.

Jane Stanton 'Bangladeshi Children, Spitalfields' 200 × 300mm (8 × 12in), Conté crayon.

Jane Stanton 'Sam Glossop' 750 × 550mm (30 × 21¾in), pastel.

Mother and child

It is perhaps a logical extension of painting and drawing babies and children to want to try and include the mother in your portraits – after all, images of mother and child have a long history in art.

The pictures on this page are three of several made when I spent two intensive weeks observing and drawing my sister after she had had her first baby. I wanted to capture the exhilaration and exhaustion, the calmness and the tension of life with a newborn baby. There were occasions when my sister did not really want me there at all, but so determined was I to get my pictures that I stuck it out!

I observed the pattern of their day and worked out when certain events, and therefore certain poses, would recur. Obviously, I had to work very quickly, so I chose pastel as a medium as you can cover large areas with colour fairly quickly. The portrayal of movement is in any case one of the things that interests me most in my work. I often moved very quickly from one drawing to another, referring back when I needed to.

I always limited myself to a few colours: in the case of the portrait below, these were red, blue, magenta and white. You can always mix the colours on the page. Also, experiment on different coloured papers – the coloured paper I used provided my extra 'mood' colour.

Jane Stanton 'Baby Asleep' 550 × 750mm (21¾ × 29½in), pastel.

*Jane Stanton 'Baby Feeding'
550 × 750mm (21¾ × 29½in),
pastel. In this case the mother,
absorbed in feeding the baby,
forms a complete entity with him.*

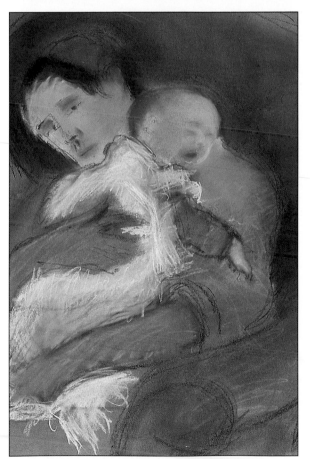

'Baby Crying' 750 × 550mm (29½ × 21¾in), pastel.

I found that it was necessary to think of the mother and child as one whole, connected shape. It was no good drawing the mother in detail and then hoping to add in the child later – it would have been too late! I sometimes tried to get my sister to delay and to try to hold a position but it was often very difficult for her to do so. But this challenged me to look harder and harder, and to try to remember the way things looked. Sleeping and feeding, obviously, were relatively easy poses to portray, but any gesture of movement by the baby was much more difficult as the actions were so fleeting and transient.

First and foremost, I looked hard. I had no time to think about anatomical rules and details, I just drew what I could see in front of me, mixing the colours on the paper as fast as I could. Of course this is a hit and miss affair to some extent, but over a period of two weeks, I produced about 35 drawings, half of which were thrown away because they were too skimpy or just unsuccessful.

I later exhibited about 15 of these pictures; together, I think they told an intimate, everyday story of the early days and weeks of motherhood.

British Rail

These portraits formed part of a commission for British Rail Engineering Works at Swindon. The works were about to close down after a long and illustrious history and I, along with several other artists, was asked to record my impressions. The most striking impressions left on me were of the men who actually worked there, so I decided to show them in their workplaces.

I persuaded each person to stand for me for about 30 minutes, and I drew in the backgrounds later so the men didn't get too restless or impatient. All the work was done outside on location, so I had to use quite economical and easily portable materials, usually graphite or pencil.

The drawing below, of two carpenters who had 99 years of service between them, was an ink sketch that I made before doing a more detailed pencil drawing. The two portraits on the right were pencil drawings which I smudged a little (with a piece of tissue kept in my pocket for the purpose) to give the tonal areas.

This commission was ideal for showing that portraits can actually tell a story and not just be pictures of rather remote personages in their best suits. It was a chance to show people true to life, in the clothes they were normally seen in, and with real backgrounds of machinery and trains and tools.

The portraits form part of a now-historical record of the engineering works. They are probably hanging in a boardroom just as they are – I did no further 'polishing' on them.

Ernest Halliday and Frederick Rawlins, Carpenters

Above: Jane Stanton 'Peter Ovens, Charge Hand'
550 × 750mm (21¾ × 29½in), Conté crayon.

Left: Jane Stanton 'Toolmaker'
550 × 750mm (21¾ × 29½in), graphite.

Opposite: Jane Stanton 'Ernest Halliday and Frederick Rawlins, carpenters' 300 × 500mm (12 × 19¾in), pen and ink.

The ageing process

As the adult face grows older, it becomes complicated with folds, creases and wrinkles. All sorts of shapes and forms emerge, caused by the development and use of muscles, especially around the mouth and eyes. Skin tissue becomes softer and begins to drop down. The eyes seem quite far up on the head, and the hands and ears always appear larger in old people than they do in younger ones. The hands are a more expressive force the older a person gets: they seem to tell a story in themselves.

Aged or weatherbeaten faces are a gift for the artist. But again, be wary: like babies' faces, they can become clichéd. Try to think of the wrinkles and folds as definite forms and avoid representing them as arbitrary lines on the surface of the skin. On an extremely aged face you will find that some areas, particularly the bridge of the nose and around the cheekbones, appear shiny because the skin is stretched.

One problem tackled in all the portraits on this page is that of spectacles. Glasses always make the eyes look bigger. The secret of drawing them to look right is to think of them as part of the head and, as they are in real life, as an element of the person's character. Do not add them on later when you have drawn the face, or it will not look convincing.

Rembrandt did many wonderful self portraits, painting himself from when he was a very young man right through to old age. This inspiring series of self portraits depicts very movingly the passage of time and its effect on the human face and spirit.

Peter Evans, Pencil drawing 590 × 420mm (23¼ × 16½in). This portrait shows up the deeply etched creases on either side of the nose which become more exaggerated in later life. They are structurally more important than the incidental wrinkles which give the skin a new texture overall.

Jane Stanton 'Mervyn, Caretaker at British Rail Engineering Works' 420 × 590mm (16½ × 23¼in), pencil. This British Rail employee, who had retired and gone back to work again as a cleaner, looked terribly sad and world-weary. I drew him against a background of the factory where he had worked for 40 years.

Different racial types

It is easy to generalize about different racial features, but you must never forget that every face is the face of an individual. It is worth repeating that the portrait artist should always paint what he or she sees and not what they think they see. The basic laws of anatomy described earlier on are the foundation of good portraiture the world over.

We sometimes find it difficult to paint faces racially different from our own simply because we are so used to seeing our own faces that our perception of how to portray other types is limited. Once you have progressed as a portraitist and trained your powers of observation and your ability to analyze, this will become easier.

My grandmother was not pleased with this pencil portrait of her watching television. Although I had drawn her many times before, this was too near the truth for her liking. A profile view can be very unflattering, but I felt that this particular view of her was very characterful.

'My Grandmother' 290 × 210mm (11½ × 8¼in).

Composing the picture

Portraits are generally fairly simple compositions, but there are, nevertheless, a great many compositional decisions to be made. The impact of the portrait will depend on many factors – the size of the painting, the way the sitter fills the space, and what the sitter is wearing, for example. You will also have to decide how much of the sitter you are going to include in the picture – it could be simply the head, the head and shoulders, or the full figure. The sitter could be standing or seated, full face, three-quarter view or profile, and set against a plain background or within a carefully rendered interior; think too about what the sitter wears and holds – both can give a great sense of their personality.

The portrait's 'message'

Before you start a portrait, consider what message you want to convey – what you want to say about the sitter – because your composition will be governed by that. For instance, if your subject is to be portrayed as a lonely figure, leave space enough around the subject so that you can control the drama. Look at the pastel self portrait opposite, for example. I composed this in such a way as to give the figure a sense of rather bleak isolation, by leaving a large amount of space around my image. This I then heightened by making the only other element in the portrait the paper lampshade in the background (this is also incidentally the light source). I also stood, and used a mirror on my desk to draw, so that I was looking down on myself. All of these contribute to the figure's isolation.

If you wish to project an imperious attitude portray your subject looking down upon the viewer (as in the portrait on page 194). If you want to say something about the subject's life and interests the painting should show the subject within a context – a room in their home, a garden, or at his or her workplace, for example.

All this may seem quite obvious, but only by working through the general will you arrive at the particular and decide exactly what you want to say in your portrait, and how to say it.

Placing the figure

Whether you are painting head and shoulders only, or a full figure, it is a good idea to avoid putting your figure or your head exactly in the middle of the paper or canvas as this makes the picture too symmetrical and predictable. Another trap to avoid is placing your horizon line halfway down the support – that tends to split the picture plane in two halves. A lot of strong vertical lines can add authority to a portrait, but they must be balanced by some horizontals to make the whole work. Remember the 'wholeness' of the portrait I mentioned earlier: a good composition keeps the eye lingering around the picture for as long as possible. If the picture is in two halves, the viewer will find it confusing and distracting.

Compositional sketches

Before you start your portrait, explore possible arrangements in a series of thumbnail sketches. It can be helpful to make yourself a viewfinder out of card to the same proportions of your picture. Move it around your subject and the background to decide how much you want to include in the finished work. Whatever you finally decide to include – whether it is just the head without neck and shoulders, or the complete figure with a generous space around it – work out your composition very faintly before you start to make definitive marks.

Jane Stanton, 'Self portrait' 840 × 594mm (36 × 24in), pastel.

Learning from the Masters

It will help if you start by thinking of the head or the figure as just a shape, or a series of shapes, with the background and any 'props' as more shapes, all of which must work together to create a satisfying composition. An excellent way of improving your ability to make a composition that works is to study the work of the Masters. Do this by making a series of simple sketches from their finished portraits. Your studies need only be small, rough sketches like the brush and ink studies shown on this page. Look at where they placed their subject in relation to the shape and size of the canvas (and notice that not all portraits are executed on upright, or portrait-format, canvases), what they used in the background, what their subjects were wearing and holding, and so on. Consider too what devices, if any, they used to lead the eye round the composition, and how they used light, tone and shadow.

This direct and marvellous way of learning how the Masters handled and organized their space will help you to plan your compositions effectively.

The background

Your model's possessions, dress, living space, even his or her work space, all tell you something about the subject and all could be incorporated into your portrait. Don't wait until you go to start work on the portrait to think about location and background: consider them when you are planning the sitting (unless of course you have decided to have your subject posed against a plain background).

A lot will of course depend on whether your work is commissioned or is a self-motivated project. If it is commissioned you will often find that the patron has decided exactly how he should like himself or the subject depicted beforehand. Try to avoid this situation at all costs. The patron must be able to accept your views and responses as an artist before he engages you. Disagreements can be avoided provided ideas are discussed and understood first. Above all, I feel that the subject himself should be made as comfortable as possible and should be set in a scene that is suitable and natural for him.

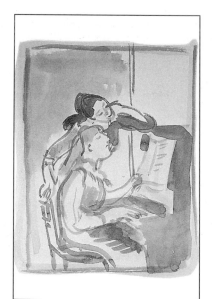
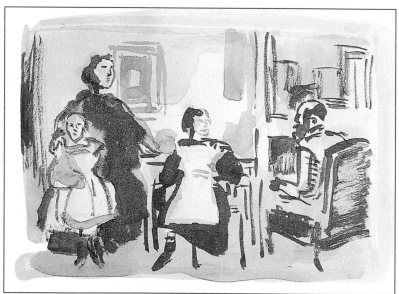

Jane Stanton Brush and ink drawings copied from the works of the Masters.

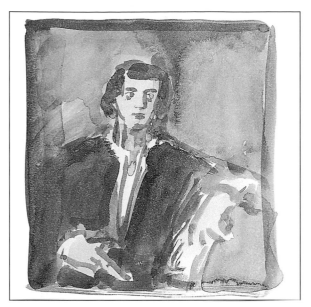

Jane Stanton Brush and ink drawings copied from the works of the Masters.

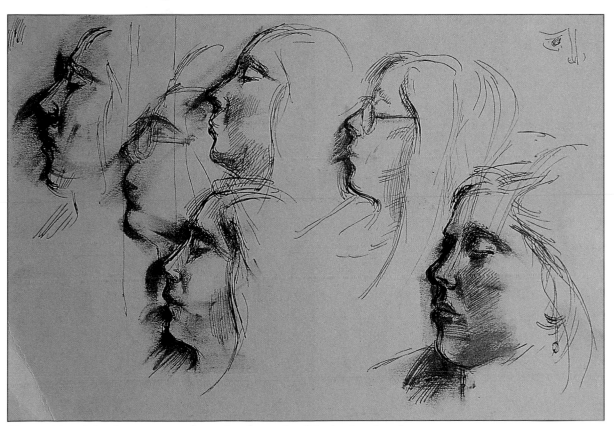

Compositional sketches, to try to determine the angle of the head and neck.

225

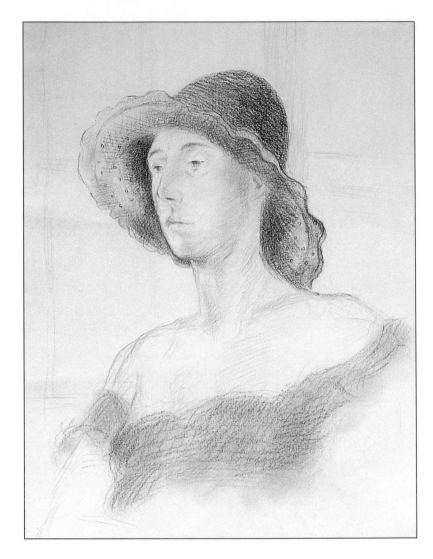

Jane Stanton 'Woman in a Hat'
220 × 150mm (8½ × 6in), pencil.
You can have great fun with
costume and invent more
imaginative and characteristic
portraits through the use of hats,
jewellery and exotic clothes.
Here, both the hat and the
décolleté dress contribute to our
perception of the subject's
personality.

Even if you decide that you want a simple background without any important objects in it, you must still take great care – in this situation, a single shadow could take on great significance. Equally, make sure your background is not so complicated that your subject gets lost in it (unless of course that is your intention). Bear in mind that complicated backgrounds require lots of extra work so you should avoid having your model pose for hours and then get annoyed when he realizes that all the time you have been painting the piano or the curtains, rather than his features.

An interesting background can add considerably to the success of a painting. Consider devices such as an open door with a view onto fields or a garden, a window looking over rooftops, or shelves holding a display of treasured possessions. Any of these will give the painting a sense of place, time and scale.

Finally, you can portray your subject on location – at work or at play: in a factory, shop or office; in a sports context; playing the piano. The possibilities are endless and can provide a more interesting slant on the subject than the traditional head and shoulders portrait.

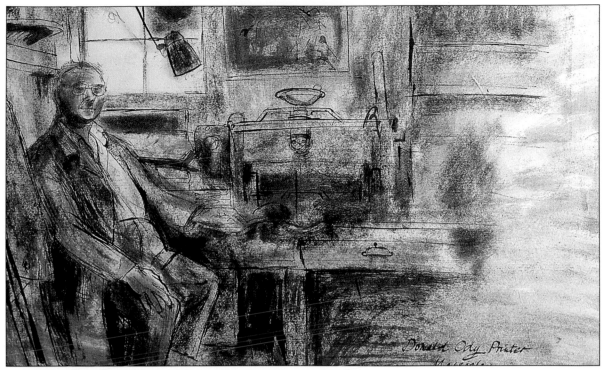

Jane Stanton 'British Rail Worker' 420 × 590mm (16½ × 23in), pen and ink.

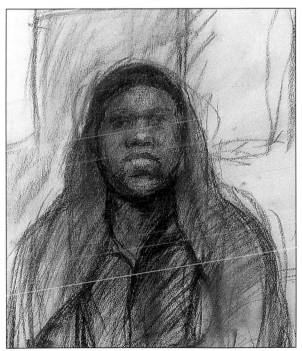

Jane Stanton 'Portrait of Adrian, Boxer'.

Costume

Historical portraits tell us a lot about the fashions and styles of the times. Modern clothes are more simple and the tendency nowadays is to skim over details of clothes worn. But an individual's style of dress tells us a great deal about their character, and what we wear also influences the way we feel and move. A long flowing dress will make a woman feel graceful and this will be reflected in the way she sits. The same woman in jeans and casual clothes will feel entirely different and this will be reflected in a more relaxed pose. Likewise a man in a business suit and tie will tend to sit more stiffly and upright, than one wearing casual clothing.

In the past, costume was painted in great detail, as evidence of the subject's wealth. Today, ostentation in portraiture is unfashionable, but you can still imply wealth – you just have to use more subtle devices, such as jewellery.

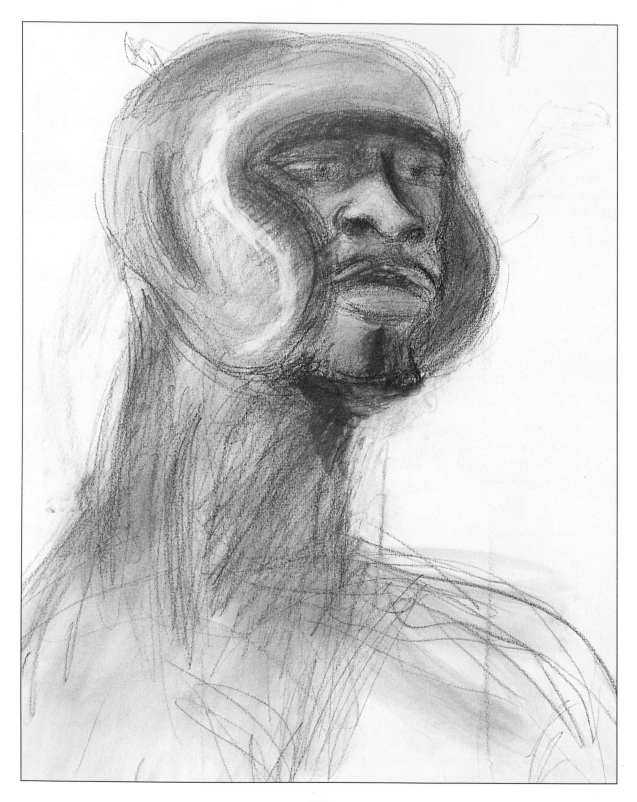

These two portraits are part of a series of works that I made in a boxing gymnasium in London.

Left: This drawing was made very directly as the subject was sparring in the ring. It took longer to make than the posed portrait, since it had to be done in snatches, looking very hard and using my memory as the boxer moved into the required position again. I was sitting below the ring, which exaggerates the length of the neck.

'Horace Notice' 420 × 594mm (18 × 24in), pierre noire crayon. Most of the time, I made very rapid sketches as the boxers trained but I asked Horace Notice to pose for me for half an hour. Sportsmen as fit as this are particularly fascinating to draw as all the muscle forms of the body are clearly defined, even more so with dark skin. For this drawing, I used a pierre noire crayon, rubbing it into the surface of the paper with a tissue to achieve the areas of tone – there was not enough time to do a lot of cross-hatching.

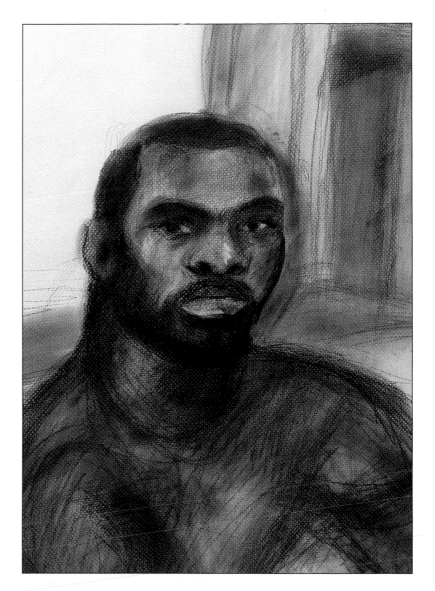

The pose

If you are going to do more than a head and shoulders portrait, consider all the stances that your subject might adopt – sitting, leaning, standing, reclining. Remember that a standing pose is extremely tiring and should not be suggested if your subject is at all frail or impatient. (Also, a lot of people find it difficult to stand still for long periods.) If possible, choose a pose that says something about the model.

I have often found that there is a tendency for people to pose willingly for as long as they can get on with some reading or sedentary work. Since this invariably means that the subject will be at a desk with his eyes cast downwards, it makes an uninteresting pose. On the other hand, if you fix your model up with a portable television, you can at least move it to a suitable position for you to be able to see all their features, including the eyes, and still give you an unimpeded view of your subject.

229

Project: Portrait in oils

The joy of oil painting is that the scope and the possibilities are endless. It is rather like being given a full orchestra to compose for instead of a chamber group. You can apply oil colours as thinly as watercolour to give a translucent quality to the paint, or lay them on thickly for a rich effect. The long drying time involved with oil paints means that you can scrape paint off the canvas, and paint things out and overpaint a hundred times and still the surface does give in; in fact, it will look all the more interesting. This aspect of painting in oils is particularly useful for the portraitist when battling to achieve a likeness, since it gives you the opportunity to paint and repaint any features that do not seem to be working.

You will need
- [] charcoal
- [] cartridge (drawing) paper
- [] stretched canvas
- [] decorator's brushes
- [] bristle brushes
- [] oil paints
- [] cloths
- [] white spirit

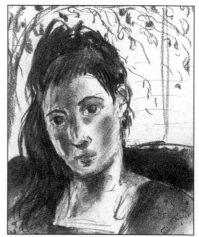

Initial charcoal drawing.

These four thumbnail sketches were done in my sketchbook to help me work out the composition of the portrait.

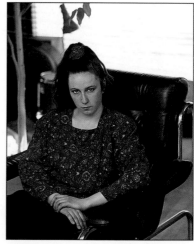

Pose your model comfortably and decide on the background.

Here I am working very broadly over the whole canvas, using thin washes and applying them with a large decorator's brush.

Choosing a sitter

For this portrait I decided to ask my sister to sit. She has been a very patient and long-suffering model for me over the years, and I have made many drawings of her. For your first attempt, it would be a good idea to choose a model you know well and with whom you feel you can relax. Obviously, commissions are a different matter, but even when a portrait has not been specially commissioned, there are so many expectations to live up to that it's better to choose a friend.

My own working method follows no set formula. In fact, it normally takes a chaotic path of experiment and near-disaster that generally works out in the end. I somehow manage to weave my drawing skills into this way of working, and I try to say something of what I feel and have observed about the model.

For me, this is the most honest approach. People who don't quite know what to expect of portraiture often find it hard to accept that the subject has been painted from the artist's viewpoint. You should always be prepared for this reaction; it is useful to develop a thick skin. The pressures of having to earn a living cause the majority of portrait painters to produce rather idealized and unchallenging views of their subjects.

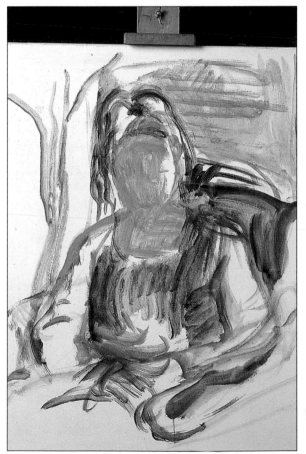

Try to get rid of the daunting whiteness of your prepared canvas as soon as you can.

I am starting to draw in the facial features using a smaller brush.

The flesh tone calmed with a pale rose/white wash.

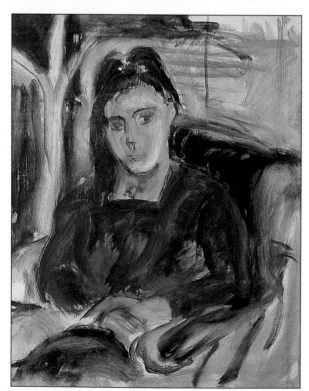

The trunk of the fig is more sharply defined.

Setting up the pose

Before I began, I thought quite carefully about the setting and what my model should wear. I wanted the setting to be natural, relaxed and colourful. So I posed my model in a large black leather chair, in front of a weeping fig tree and with a view of the garden beyond. My sister wore a vivid purple patterned blouse, with her hair tied up. I wanted her personality to come through in the portrait.

Posing is always an arduous task for the sitter, so agree on rest periods beforehand and keep your eye on the clock. If your model seems at all uncomfortable, suggest that you have a break. You can work on the background during these breaks.

I find an easel very useful, but if you don't have one you could always work with your canvas propped up on a chair, or hung on a wall. Don't position yourself too close to the model – this is a common mistake of beginners who are then burdened with the problem of having to reduce the image from sight-size, which is always difficult. Make sure your materials are all close at hand. Don't worry if you haven't got a proper artist's palette – a piece of cardboard or hardboard (Masonite) will do just as well.

Planning the composition

I tend not to make complicated drawings beforehand, especially in this case where the model is very familiar, but I did make several thumbnail sketches to decide on the basic composition. These were done four to a page in my sketchbook. It may not seem at first sight that there could be many variations on a seated figure, but if you look at the four shown on the previous page, you will see how varied the possibilities are.

I like to let my pictures develop quite spontaneously and intuitively, but the basic sense of the composition usually remains roughly as planned.

Making a start

I work very rapidly and broadly to begin with. The bare canvas can seem very intimidating and I try to make the surface my own by covering it with paint very quickly. Many painters underpaint using charcoal or a dark tint, but I use a mixture of the colours that I think will finally dominate, otherwise I find that the drawing underneath and the painting on top become two separate activities.

This is the most important stage. It is the foundation on which you will build and requires a great deal of concentration. I used a very large brush to discourage me from going into detail too early, and to help me think just in terms of colour and shape.

Mixing the colours

I mixed flesh tint with rose madder and white to block in the face and hands. Flesh tint is a useful colour, but it should be used only as a base to work on and to mix with other colours. The skin colouring of your sitter is as important as their proportions. You will often find that dark-haired people (like my model here) have an olive or greenish tint in their flesh tones, particularly in areas of shadow. But there can be no recipe for flesh tones in my view: skin colour is affected by the surrounding light and other colours, and the same person's skin tones look completely different if you change the lighting.

At this stage, I also blocked in the chair and the green of the garden outside. Most of the colours I used were straight from the tube, but they will be mixed and have transparent washes laid over them later on. All the paint was mixed to a thin consistency with white spirit (paint thinner) for these early marks.

I mixed cobalt blue with cadmium red to suggest the purple of the blouse, and began to work with a smaller brush. I then laid a white wash over the flesh tone, since I felt that it looked too orange once the green tones had been laid behind it.

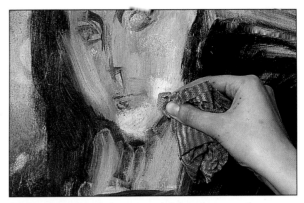

Here, I am smudging areas with a dampened rag.

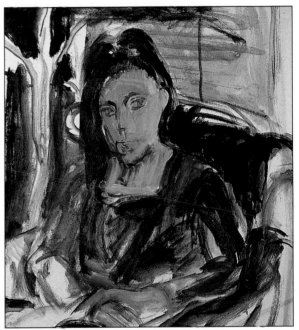

The whole canvas is completely covered.

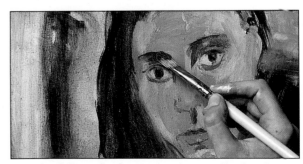

I am modelling the features with a smaller brush.

233

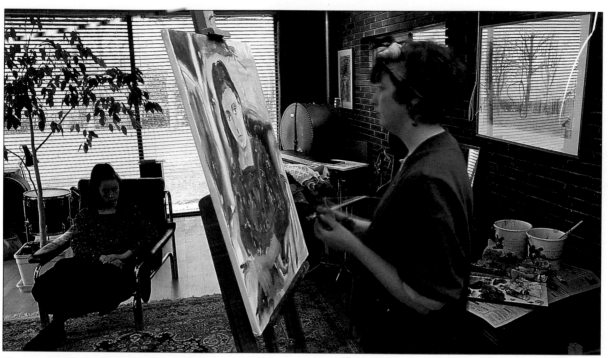

Do not stand too close to your model and have all your materials to hand.

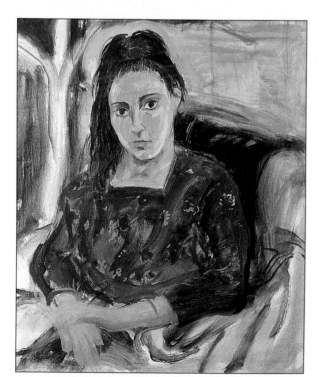

I have indicated the pattern on the blouse.

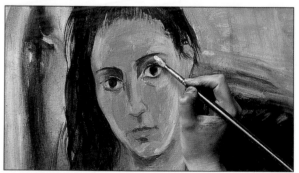

Adding highlights to the brow with a small brush.

The hands are painted in thickly.

Working the picture up

I moved away from the face to the background and painted in the leather chair. You will notice that I have not used black paint for the chair, but a mix of sepia and cobalt blue, picking up on the whole blue-green tone of the surroundings. Black is too extreme to use at this stage, and you should in any case avoid using black straight from the tube. Look at the dark areas of your picture and ask yourself if they are really black. Most of the time you will find they are not.

I went back to the face again and smudged in some areas of the rose madder/white mix to give the skin a pinker tone. You don't have to use a brush all the time – you can use rags, palette knives, pan scrubbers and even your fingers if you wish. Don't be afraid to get carried away!

Now is a good time to have a rest. Stand back, as far away as you can get from your

The left eye is painted out and remodelled.

picture, and take a good long look at what you have done. This is a stage at which major reconstruction is possible if you feel that it is necessary. In my portrait, the hands were not right because I had made the arms too short, so I decided on major surgery.

Developing the details

I now allowed myself to get into more detail. I used a smaller brush to paint in the flowers on the blouse, and relished applying thick blobs of cadmium yellow and alizarin crimson. Keep half-closing your eyes so that you can see the shapes that the print of a fabric makes on any drapery, then you won't make too laborious a job of rendering the details.

Before getting down to modelling the features, you have to look very hard at your model's face. Your model will probably find this most disconcerting, but tell her not to worry. I used a small brush and mixed sepia and alizarin crimson with a large amount of white, then added some highlights over the brow before beginning to 'draw' with a brush.

I became dissatisfied with the left eye at this stage and decided on drastic action. I painted it out with flesh and white, and began again. I then felt that the right eye wasn't working either, so I painted that out too. There was a long struggle to make the eyes look as if they belonged to the same person.

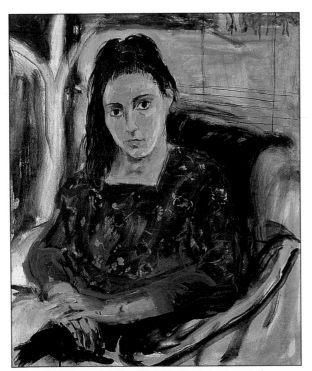

The shape of the hair needs to be reconstructed.

Painting the background

I was always careful to keep the background as loose as possible, because this was how I wanted it finally. But I added a further wash of cerulean blue and white to the sap green, to tone the background down a little, and I worked on the chair. I always find it's a good idea to let the model have a rest while you work on the background.

When my model returned, I went back to the hands, modelling them with the same tones as I used on the face and switching from hands to eyes quite frequently. I painted the reworked hands in fairly thickly and broadly, using roughly the same colours as on the face. You will notice in all portraits that one tends to look at the eyes first, and then the hands – psychologically, these are the two main focuses of attention.

Getting the eyes right

I did some very demanding detailed work on the eyes towards the end; in this portrait I found that getting the correct thickness of the eyelids was particularly difficult. It was important to stop this area looking overworked or contrived. The eyes finally became more life-like, with the addition of the light reflections. If you look carefully, you can actually see another picture in your model's eye. As with black, avoid using white straight from the tube for these reflections – if you look at them closely, you will see that they are not really brilliant white.

As a relief from this detail, I drew more into the background with a brush. I added the blinds against the window, and I decided to make the leaves of the weeping fig more important. My sister returned after her second break and I completed the picture at the third sitting.

The hair tie has been more sharply defined.

Getting the eyes to work is the most laborious task.

The eyes, never identical, must work together.

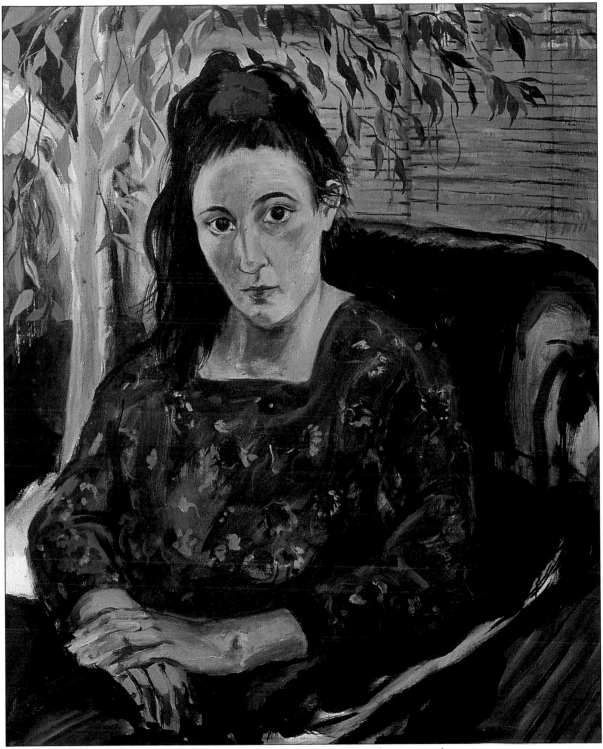

More work was done on the weeping fig, as well as on the hands and eyes, at a later stage.

Index

Acknowledgements

Swallow Publishing wish to thank the following people and organizations for their help in preparing this book. We apologize to anyone we may have omitted to mention.

Unless indicated otherwise, all artwork is by the authors of the respective sections of this book: Richard Pikesley, Charles Bartlett, Trevor Willoughby, and Jane Stanton. All photography by Ian Howes.

7, 8, 11, 12 Ken Howard; 72 Tate Gallery Publications, London; 85 John O'Connor; 101, 121, 122, 123 Olwen Jones; 124 Leeds City Art Galleries; 125 Tate Gallery Publications; 129 Visual Arts Library, London; 165 Bridgeman Art Library; 186, 187, 188, 189 from *An Atlas of Anatomy for Artists* by Fritz Schider (Dover, 1957); 193 from *The Book of One Hundred Hands* (Dover, 1971) and *Constructive Anatomy* (Dover, 1973), both by George B. Bridgman; 194 Peter Evans; 199 Bernadette Coxon; 220 Peter Evans.